About this book: This study puts the icon at the centre of Byzantine culture and life, both as an artistic product already developed in Late Antiquity and as a daily viewing experience in Constantinople and its empire concurrent with the western Medieval and Renaissance periods. Its development as the identifying sign of Christian Orthodoxy, intensively promoted after the failure of iconoclasm between 730 and 843 to ban figurative images, is elucidated. However, the clear-cut notion of the icon as the static and different mode of a conservative Byzantine system is dissolved when the icon is set against parallels in the west, both devotional practices towards the Virgin Mary and Christ and the treatment of other subjects. As both an aesthetic and functional object, the icon served the whole range of Byzantine society, and as different elements emerged to influence the medium, particularly the monks and colonial immigrants into Byzantine territory such as the island of Crete, the appearance of the icon changed.

With the recent explosion of new materials onto the art-historical scene through explorations at Sinai, in Greece, and in Russian collections and with the publications of the notarial archives of Crete that document both artists and patrons, the new challenges faced in the book are to find methods of handling the icon and to reorientate the medium within the history of western art. Cretan icons between 1210 and 1669 integrate eastern and western traditions, and are seen as the key to understanding the ambivalence and flexibility of Byzantine expression and redefining the character of Orthodox art.

About the author: Robin Cormack is Professor of the History of Art in the University of London and teaches in the Classical, Byzantine and Medieval Section at the Courtauld Institute of Art. His books include *Writing in Gold* (1985) and *The Byzantine Eye* (1989).

Painting the Soul

Icons, Death Masks, and Shrouds

Robin Cormack

REAKTION BOOKS

Published by Reaktion Books Ltd
11 Rathbone Place, London W1P 1DE, UK

First published 1997

Cover and text designed by Humphrey Stone
Photoset by Wilmaset Ltd, Birkenhead, Wirral
Printed in Great Britain by
BAS Printers, Over Wallop, Hampshire

British Library Cataloguing in Publishing Data:

Cormack, Robin
 Painting the soul : icons, death masks and shrouds. –
 (Essays in art and culture)
 1. Christian art and symbolism 2. Masks (Sculpture) 3. Relics in art
 I. Title
 704.9′482

ISBN 1 86189 00 1 X

Contents

Preface

The study of the icon, I have now learnt, is extraordinarily intimidating. Research is progressing at speed in the 1990s, yet the subject is still a young one in art history. In other words, the basic materials are still being studied, and even the techniques of icon painters are only just being understood and appreciated. Yet at the same time, the study of the icon is one part of the cultural history of the Mediterranean and so is supported by all manner of interdisciplinary work. Any text you read in pursuit of the icon, whether Medieval or modern, has new references and discussions to incorporate. And not only is the literature immense and potentially incompatible (ranging from the religiously inspired to the sceptical rationalist); the differing demands and interests of the reader are equally formidable, perhaps even sometimes irreconcilable.

To write now about the icon makes you feel you are in the wrong time and place. It is a situation which the Irish joke best describes:

Question: 'What is the best way to Dublin?'

Answer: 'I wouldn't start from here'.

The art historian looking for the icon must likewise feel 'I wouldn't start from here'.

It is not that we lack books and catalogues which record some of the materials or that there has been any lack of recent initiatives in arranging exhibitions which have made icons more accessible. The problem is the fragmented nature of the scholarship of the field added to the unexpectedly large numbers of icons waiting to be viewed (in museums, in museum storerooms, in monasteries and churches, and in private homes). A more radical realignment which is needed is to abandon the notion that the study of Byzantine art is a purely 'Medieval' field, inherently remote and poorly documented and centred on the work of anonymous masters. For a mass of documents in the notarial archives of Venice is currently opening up a world of Orthodox icon painting on Crete that was contemporary with Renaissance Italy, and that

was produced by named artists who offered to their viewers a new art of the icon transformed by the pictorial interests of the west.

This book aims to set out the field of icons as it now appears, a very different subject from the impressions of even a decade ago. Not only does the importance of the icon in art history require re-assessment, but the whole character of Byzantine art needs revision. Any reorientation in art history means an attempt to identify the issues and the strengths and weaknesses of past research. The icon was part of Byzantine culture from the beginning – another case of Christian art inheriting and transforming the traditions of Greek and Roman Antiquity. This means that the icon can be surveyed chronologically in order to disentangle the modern perception of a static medium. This book aims to deconstruct the idea of Byzantine art as a monolith; hence its structure, which looks at the icon over the whole period of Byzantium from 330 to 1453. Such a framework must bow to the long-established biological metaphor of birth, maturity, and decline in the history of the icon, but only to challenge it by seeing an ultimate rebirth and continuity to the present day.

A second paradox in the overview of the icon is that it was seen to identify the Orthodox church and in that church was a symbol of the emphasis on tradition over change. Yet, if Byzantium identified itself as the church which above all others prized the icon, the uses to which art was put in the west before the Reformation are conspicuously similar. We need to recognise that the presentation of Byzantine culture by Byzantines may not be all the truth. The meeting of the two worlds on Crete between 1204 and 1669 is an underplayed phase of European history.

In Byzantium (as in the west), we find that in icons the paramount imagery is that of Christ and the Virgin Mary. This books aims to reflect and emphasise this fact. But it is one thing to explore the character of this imagery in icons (and other art forms); it is another enterprise to explain the reasons and implications, which can only be attempted within a much wider framework. The art historian must always start with the hope that our material offers the key, but in the case of the icon, the immensity of the questions soon emerge. The reaction may be to turn to the circumstances of production and viewing as a basis for further investigation. In the case of

this book, it will be seen that this encourages questions about the nature of art as part of religious experience and practice. The icon emerges as the ambivalent object which stands in Byzantium between heaven and earth, for it is the ever-changing medium which the culture ostensibly used to show the unchanging character of their Christian faith.

My aim in this book has been to find a balance between theory and empirical study. This pursuit has been aided by colleagues and friends, both in practical ways and in discussion, and they deserve thanks. They are in that traditional sense responsible for what I have written, but since none of them will agree with the 'balance' which I have found, they are all exonerated from accountability.

Among those who first alerted me in London to the quantity of the material are Stavros Mihalarias, Yanni Petsopoulos, John Stuart, Martyn Saunders-Rawlins, Dick Temple, and Laurence Morrocco. In Greece, particular help in seeing materials is due to M. Acheimastou-Potamianou, C Baltoyanni, M. Borboudakis, L. Bouras (†), M. Chatzidakis, N. Chatzidakis, M. Constantinoudaki-Kitromilidou, E. Constantinidis, A. Delivorrias, M. Mouriki (†), and P. L. Vocotopoulos; and on Cyprus, to A. Papageorghiou. American colleagues have given me offprints and ideas, especially K. Corrigan, A. Cutler, J. Folda, A. Kartsonis, T. F. Mathews, R. Nelson, N. Patterson Ševčenko, A. M. Stahl, and A. Weyl Carr.

From working together at exhibitions, my vision was enlarged by N. Rosenthal, R. Grierson, G. Vikan, D. Buckton, G. House, R. Loverance, G. Ramos-Poquí, P. Williamson, and J. Durand.

On the side of theory, Averil Cameron, M. Mullett, and my colleague at the Courtauld, Jaś Elsner, have particularly influenced me; so has contact with H. Belting, M. Camille, and D. Freedberg; and I owe much to dialogue with L. James, C. Barber, A. Eastmond, V. Foundoulaki, J. Hanson, L.-A. Hunt, R. Maniura, and B. Zeitler.

Most of all, I acknowledge the substantial practical and scholarly help of Maria Vassilakis. Mary Beard helped me keep the subject in perspective.

Chronology of Byzantine History

324	Constantine I became sole emperor of Roman empire; foundation of Constantinople
325	First Ecumenical Church Council at Nicaea
330	City of Constantinople dedicated on 11 May
337	Death of Constantine
c. 360	Dedication of first church of St Sophia
379–95	Theodosios I emperor
395–408	Arcadios emperor
404	First church of St Sophia partially burnt
408–50	Theodosios II emperor
410	Rome sacked by Alaric the Visigoth
413	Theodosian walls of Constantinople built and city extended
429–31	Vandal conquest of Africa
455	Rome sacked by Vandals
476	Last western emperor, Romulus Augustulus, deposed by Odovar the Ostrogoth
491–518	Anastasios I emperor
518–27	Justin I emperor
525	Antioch destroyed by earthquake
527–65	Justinian I emperor
529	Codification of Roman law
532–37	St Sophia burnt in Nika riot and rebuilt by Justinian
533–54	Reconquest of Africa, Sicily, and Italy
537	St Sophia dedicated on Christmas Day
565–78	Justin II emperor
568	Italy invaded by Lombards
c. 570–632	Muhammad, prophet of Islam
578–82	Tiberios I Constantine emperor
590	Gregory the Great pope in Rome
602–28	War with Persia; Greece and Balkans invaded by Avars and Slavs
610–41	Heraclios emperor
614	Jerusalem captured by Persians
622	Emigration (hegira) of Muhammad from Mecca to Medina on 16 July marked beginning of Moslem era
626	Constantinople attacked by Avars
634–42	Arab conquest of Syria, Palestine, and Egypt
638	Jerusalem fell to Arabs under Caliph Omar I

668–85	Constantine IV emperor
673–78	First Arab attack on Constantinople
c. 675–750	John of Damascus, iconophile theologian
685–95	Justinian II emperor (first reign)
697/8	Carthage, last Byzantine stronghold in Africa, fell to Arabs
705–11	Justinian II emperor (second reign)
717–18	Arab siege of Constantinople
717–41	Leo III emperor
726/30–787	First period of Byzantine iconoclasm
732	Charles Martel victorious over Arabs at Poitiers
741–75	Constantine V emperor
751	Ravenna fell to Lombards; end of Byzantine Exarchate
762	Baghdad founded by Caliph al Mansur
780–97	Constantine VI emperor
787	Seventh Ecumenical Council of Orthodox church at Nicaea condemned opposition to icons as heresy
797–802	Irene 'emperor'
800	Imperial coronation of Charlemagne at Rome by Pope Leo III
802–11	Nikephoros I emperor
811	Byzantine army crushed by Bulgarians
813–20	Leo V emperor
815	Iconoclasm re-affirmed as Orthodox belief
820–29	Michael II emperor
c. 820–93	Photios, scholar (patriarch 858–67, 877–86)
826	Crete fell to Arabs
827–78	Sicily fell to Arabs
829–42	Theophilos emperor
843	Final condemnation of iconoclasm as heresy
860	First Russian attack on Constantinople
863	Victory over Arabs; Byzantine offensive began in east
867–86	Basil I 'the Macedonian' emperor
875–902	Byzantine reconquests in Italy and Sicily
886–912	Leo VI emperor
913–59	Constantine VII Porphyrogenitos emperor
957	Russian Princess Olga received at imperial court
961	Reconquest of Crete
963–9	Nikephoros Phokas emperor
976–1025	Basil II emperor
988	Russian conversion to Orthodox Christianity
1017	Basil II annexed Bulgarian kingdom
1018–96/7	Michael Psellos, philosopher, historian, courtier, and monk
1042–55	Constantine IX Monomachos emperor

1054	Schism declared between Orthodox church and Roman church
1067	Turks took Caesarea in Asia Minor
1071	Seljuk Turks defeated Byzantines at Battle of Manzikert; Bari taken by Normans; Byzantium lost southern Italy
1081–1118	Alexios I Comnenos emperor
1096–9	First Crusade
1118–43	John II Comnenos emperor
1143–80	Manuel I Comnenos emperor
1147–9	Second Crusade
1149	Corfu retaken by Byzantium from Normans
1171	Venetians in empire arrested and properties confiscated
1180	Serbian empire established by Stephen Nemanja
1186	Second Bulgarian empire
1187	Jerusalem captured from Crusaders by Saladin
1189–92	Third Crusade
1202–4	Fourth Crusade
1204	Alexios V Murtzuphlos emperor
1204	Capture of Constantinople by armies of Fourth Crusade on 12 April
1204–61	Latin Empire of Constantinople
1204–1340	Despotate of Epiros
1204–1461	Empire of Trebizond
1204	Boniface of Montferrat sold Crete to Venetians for 1,000 marks
1211–1669	Venetian period in Crete
1261	Michael VIII Paleologos entered Constantinople on 25 July
1274	Council of Lyons agreed union of Greek and Latin churches
1282–1328	Andronikos II Paleologos emperor
1282	Church Union of Council of Lyons repealed
1288–1326	Osman, founder of Ottoman dynasty
1329	Turks captured Nicaea and took control of Asia Minor
1347–54	John VI Cantacuzenos emperor
1354	Turks crossed into Europe
1359	Turks at walls of Constantinople
1389	Serbian empire fell to Turks at Battle of Kossovo
1391–1425	Manuel II Paleologos emperor
1393	Turks occupied Bulgarian empire
1397	Constantinople attacked by Turks
1402	Turks defeated by Timur (Tamerlane) at Battle of Ankara
1422	Constantinople attacked by Turks
1425–48	John VIII Paleologos emperor

1430	Ottoman Turks took Thessaloniki on 29 March
1438	Church Council at Ferrara
1439	Union of Greek and Latin churches agreed at Council of Florence on 6 July
1449–53	Constantine XI Paleologos, last Byzantine emperor
1451–81	Mehmet. II sultan
1453	Siege and fall of Constantinople to Ottoman Turks on 29 May
1460	Fall of Mistra
1461	Fall of Trebizond
1571	Venetian victory over Turks at Battle of Lepanto (Naupaktos) on 7 October
1645–69	War of Candia
1669	Crete fell to Ottoman control

1 Conception

Athenian society was shaped by its male citizens and the dominant ideology, the ideology that guided painters in their choices and defined their view in a system that left little room for individual initiative or what we call inspiration, was chiefly masculine. Thus the images which we will examine bear a double imprint. They are not an objective transcription of reality, but the product of a gaze that reconstructed the real – and that gaze was masculine.

François Lissarrague, 'Figures of Women', in P. S. Pantel, ed., *A History of Women in the West: From Ancient Goddesses to Christian Saints*

As art history changes, so do introductions. When there was a consensus about the nature of art history, introductions – and even the text itself – could be anecdotal and narrative. But with fewer art historians depending without question on that bygone but familiar discourse of artists and patrons, challenge and response, creativity and originality, or progressiveness and retrogression, now everyone needs a preface to evoke (or spell out) their individual 'methodology'. To have opening sentences like 'There really is no such thing as art. There are only artists' now acts less as an insight and more as a critical milestone.[1] More familiar now are statements – there is one by Lissarrague at the head of this page – which signal an approach which seeks explanations for the history of art through the analysis of viewers and the interaction of art with society. This book too was envisioned as a study of a complex culture's response to its art. By means of this approach, one could hope to be more discriminating than if we saw one form of art as an unchanging entity over the period of a thousand years or more. To someone who said all icons look the same, one could show that the viewers differed.

But viewers turn out to be as complicated and speculative as artists, because viewers as a group include artists, patrons, and the audience. Worse still conceptually, viewers include not simply the original audience of art, but its whole historical

audience – even us, its living audience. And 'we' have a further divisive factor, when treating a form of art produced for a religion; some are believers, some are not. In the case of the icon, this means that for some viewers we are dealing with 'art'; for others, this medium is not art at all, but part of the charged mechanisms of worship, materials holy in themselves.

When art historians focus on viewing, their priorities change. If art is seen in terms of 'responses', both intellectual and spiritual, questions about the circumstances and processes of the act of production of each object may begin to lose their relevance. The notion of using the viewer as a channel for understanding how art works can easily undercut interest in some of the traditional (and often speculative) questions of art history; attribution, assigning provenance, and dating, once seen as the prime tasks of the art historian, as activities worthy in their own right, are not always of clear value at all. In this book, while dating and assigning provenance will not be regarded as obligatory exercises, it will become clear that these factors may be of crucial importance in understanding the viewer's response. If someone in the fourteenth century kissed an icon, our historical analysis will be crucially affected by an empirical knowledge of that icon. Did the viewer believe that the panel dated from the time of Christ and had been painted by the evangelist Luke? Was this belief correct? Was the icon old and hallowed in the fourteenth century? Or had it just been painted in Constantinople? Did the artist copy a venerated 'model' or invent a new type? Did the power of the model reside in copies of any later period? This book will attempt to maintain the delicate balance between the historical and ahistorical treatment of viewing that these questions require when dealing with a religious art which goes through a set of radical changes, while at the same time declaring to its audience that art represents unchanging truth.

Another problematic area for any study which deals with viewers and which emphasises the functions and powers of images is how to handle the 'art appreciation' of those images. For there can be no rule that religious veneration will limit itself to 'good art'; indeed, art history has often ignored the material imagery which has been at the intense centre of religious devotion and dismissed it as kitsch. It might even be thought daring to focus on the popular imagery of western art

rather than the works of accepted quality. Writing on Medieval art has regularly emphasised, and frequently agreed, a canon of the significant works of quality – although the untutored eye more familiar with twentieth-century art may admire less crafted imagery. The scholarly literature on Byzantine art too has been remarkably consistent about where quality lies; the implicit rule of thumb has been that the more 'Classical' it looks, the greater the approval of the work of art. The consequence of such a partiality for the Classical has been that any period which looks to have favoured the formal values of classicism has been enthusiastically marked as a renaissance, and so a cyclical pattern has been identified of periodic renaissance and periodic divergence. This period-isation of Byzantine art into a succession of significant moments of renaissance does not fit the stages of change emphasised in this book. And there are other consequences if the pursuit of classicism is reined in. Of course, one can accept that Byzantine culture had infinite links with its Greco-Roman past, and that various individuals at different periods responded in changing ways to that past, sometimes with greater interest in imitating the illusionist forms which we designate as 'classical'. But as a continually renewed religious art, Byzantine art operates as much more than a stage in the recreation of Antiquity, producing a sort of weak renaissance before the *real* Renaissance took over. We shall need to see beyond the classicism of Byzantine art if we want to begin to see the range and power of its imagery. Yet, while one might question whether classicism is the gauge of quality in Byzantine works of art, it would be superficial to imagine that icons were treated wholly as religious objects and not contemplated as objects of beauty, too. Whether Byzantine society had a scale of aesthetic values and how it related to ours remains a major issue.

Such remarks in an introductory chapter are likely to appear both commonplace and too general. But anyone who works in the Middle Ages is acutely conscious that this is a (very long) period of time with a label formulated in negative terms – it is *not* the Renaissance, *not* Antiquity, but what fills the centuries 'in-between'. No doubt, other periods are equally gloomily defined, but few suffer the ambivalence which has haunted the study of the Middle Ages. Should it be studied within the framework of other periods and follow the

aims and patterns of later European art history? Or is it a deviant period requiring different methods? If the discourse of artists and renaissance was formulated in the study of the Italian Renaissance, could and should it be applied to the circumstances of Medieval art? What in any case is the difference between Late Medieval spirituality and the Renaissance?

The study of Byzantine art has its own further obstacles. 'Medieval studies', it soon transpires, do not necessarily include Byzantium. While it may not actually be ostracised, Byzantine art can all too frequently be relegated to the margins.[2] Although the art of Byzantium (as the Middle Ages in the 'Greek East') is sometimes given a walk-on part, more often than not it is seen as an entity apart, opportunely offering explanations for changes in western Medieval art: it becomes a 'source' or an 'influence'.[3] The 'Byzantine Question' is conceived as the role of Byzantine art in the reconstruction of western European art at the beginning of the Italian Renaissance. This is not the 'question' which this book will recognise. In any case, once Byzantine art is conceived in the way the old question encourages – as a separate organism – then the temptation is to describe it as a 'non-western' phenomenon, and so to give it an identity beyond the European norm. This reaction is not entirely without its merits, but if followed to an extreme, it may do no more than set up new polarities and new problems of interpretation. As the argument in this book unfolds, it will become even clearer that any such simple dichotomy of east and west is more a distortion than a help in the study of Byzantine art.

Here, then, emerges one of the aims of this book: to discover how far we can explore the self-identity of Byzantium through Byzantine art itself. How do the objects which we categorise as art work in the construction of that identity? This is not, of course, the same question as the traditional one, 'What is Byzantine art?' The interpretative shift comes as a natural consequence of the move in attention away from the producer of Byzantine art to the viewer. In this culture, the best materials to choose for studying the whole range of society and its experiences are surely in the medium of the Byzantine icon – that at least is the claim made in this book.

The icon as a form of visual representation was developed early on in the history of Byzantium. But its early success and

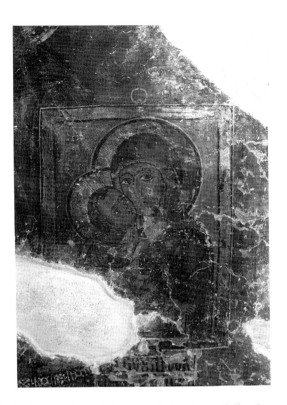

1 Detail of illus 7, showing the Panagia and Child on an icon held by St Stephen.

popularity carried the seeds of its possible downfall; the reliance of the people on icons as a window to heaven was gradually seen as a subversive threat to the authority and control of the state. Iconoclasm, interpreted this way, was a concerted politicised attempt by the ruling establishment to eradicate the figurative imagery of the icon from Byzantine Christianity. Iconoclasm was orchestrated from the capital, Constantinople, from the 720s; but by 842, the movement had failed – the iconophiles had triumphed. From the ninth century onwards, it was irrevocably the prominent parading of the icon in public and private that defined Byzantium. Everyone after iconoclasm had to conform with the agreed church dogma, expressed as a council decision and displayed in art by one of the iconophile saints of the period of iconoclasm, St Stephen the Younger: 'If anyone does not reverence our Lord Jesus Christ and his pure Mother depicted on an icon, let them be anathema' (illus. 1).[4] To declare oneself a Christian in Byzantium was from the ninth century not simply to claim membership of the 'Orthodox' church; it was

to be part of a community which had learned through the refutation of the iconoclast heresy that God expected his church to be framed by icons. One could not both claim to be Orthodox and criticise the icon. To be a citizen of Byzantium was to live in a community shared by people and icons, a community of the visible living and the visible dead. Hence the awesome power of the visual icon, which was confirmed forever in Constantinople in the year 843 and which means that even the modern viewer belongs either to the community of Orthodox viewers of this 'art' or does not. To look at the icon is to enter the highly loaded world of active religious art – a field of emotive art history for committed viewers!

If we understand icons as an integral document of a society, their study involves a method for the study of both that society and its objects – the interdisciplinary situation. This sounds prosaic enough, but what will emerge in this book is that icons remain among the most elusive subjects in the history of art. Icons also constitute perhaps the fastest expanding field in the history of art, for nowhere else, at least in the European context, are so many new materials being discovered, exhibited, and studied. Literally thousands of unknown icons are being found in monasteries, collections, and museum vaults and await investigation. Thus, one challenge of the icon at this time is to react to a whole new range of material and find and justify ways of approach. There is, of course, a current scholarly discourse about icons, but we need to assess its adequacy and ways of developing it. We have, in other words, an awesome situation: a marginal world of art-historical study that is moving into the centre of the arena. How can we cope with so much new material from a cultural world which was defined *before* its central production, the icon, was recognised as important?

While icons may be seen as a domain waiting for extensive exploration, they hardly constitute a new subject. Others have been here before, and they have offered their various approaches and conclusions. They present us with established ways of describing panel paintings, but often give consider- able attention, for example, to the dating of icons. The spotlight on dating reflects a common tradition that this activity is at the centre of art history. But it is the case that for the Orthodox culture in which icons were produced, the date of production of any icon was manifestly of little importance –

the majority carry no date, and the precise moment of production presumably would seem of little importance when set against the eternity of the subject matter. Since the changing nature of the art and its roles will be treated in this book, we do need to work within a chronological framework. While it was clearly an intention to make icons look 'timeless', and while this was indeed achieved, this very success may make the contexts of production necessary to find. How was timelessness achieved at different times? This was not just a matter of suppressing fashion. Was an icon regarded as an old and venerated object actually 'old'? How far is the instant impression that Byzantine art gives of an unchanging culture maintaining the eternal values of Christian truth an impression that was created in the society or through hindsight? Why do icons appear to be stereotyped productions? Does the recognition of a chronology offer a key to answering such questions?

Although the value of finding a chronology for icons ought to be a subject of controversy and debate, this book does intend to identify both changes and continuities in the functions of icons over the course of time. Its structure is therefore chronological, and dates will be given for icons, since they are the props which illuminate change and development. There is, of course, no agreed way of dating icons – or, indeed, agreement on many of the details of chronology, and this is not a handbook on dating. No doubt, more objective ways will be developed in future – more technical information, such as databanks of pigments and media, would certainly help. Since icons are painted on wood, one might also expect dendrochronology to offer a sequence of dated panels based on the analysis of tree rings – a profile of the Byzantine period has already been painstakingly constructed from the collection of samples from the wooden tie-beams of Byzantine churches.[5] At present, the normal strategy followed in dating icons is traditional stylistic analysis (which always privileges experience and intuition over reasoned justification). One must surely be sceptical about the sentiments on the dating of icons expressed by David and Tamara Talbot Rice (in 1974) in an apparently didactic book – *Icons and Their Dating* – in which they say that dating depends 'on a feeling for style which, in its turn, is the result of long practice', and in which they appeal to 'that

intangible element which determines a style' in order to date any specific icon.[6] From our perspective, these are the old mystifications of style and iconography, but no doubt the decision not to produce a primer in dating icons will result in equally unjustifiable decisions.

It seems only yesterday that no one used the word *icon*. Today, it is one of the commonest (misused?) words in the media. This book will take you behind this façade into the 'real' world of icons. This means entering the early centuries of Christianity before it was agreed how God was to be worshipped and how a universal religion could express truth and convert the unbeliever. But while these images may have been developed in a momentous Christian context, the solutions for the uses of art are not unique to Byzantium. To confront the icon is to examine the use of symbolism by any society.

This book also has a purely empirical intention: to show the opportunities and values of this field. Suddenly, we can all encounter great hoards of icons, not just in the remote monastery of St Catherine's on Sinai, but equally in monasteries and churches all over Greece and on Cyprus. Crete in particular has been the site of major discoveries. As knowledge of icons develops, so the extensive collections in museums in Russia are becoming more conspicuous; these are collections not just of icons from Russian churches, often brought into museums during the Soviet period, but also large collections made in the west in the nineteenth and early twentieth century by private individuals. Today, due to restoration for the first time since their original production, we can also *see* paint surfaces in all their brightness and subtlety. These surfaces may not, of course, be in exactly the same condition as at the time of production; pigments may have changed their appearance, and worm infestation and other damage and deterioration of the wood may have taken their toll. Yet new restoration work has suddenly presented us with literally hundreds of fresh icons which have emerged from a covering of dirt, candle grease, and old varnish. And this work differs from the norm of restoration work done before around 1970. Until then, to restore an icon typically meant to repaint and slick it up. Expectations of restoration are now much changed; we are prepared to accept the sight of an icon in the state in which it has survived, not the state we

might have preferred or imagined (see illus. 8). The consequence of this work and changed taste is that we can view icons as never before in this century. With this new vista, we may be forced to unlearn the old expectations. Already in 1929, readers of the introduction by Sir Martin Conway to the exhibition catalogue of *Ancient Russian Icons* at the Victoria and Albert Museum, London, were warned of the difficulties of knowing what they were looking at:

> One of the consequences of the Russian revolution was to make all the icons in Russia the property of the Soviet Government. Sacred pictures, many of them of great historical interest, though most, of course, commonly inferior, were gathered together to certain centres for examination, classification, and repair. The two main centres were Leningrad and Moscow. It was immediately observed that the condition of the more ancient of these pictures was very bad indeed. They were not only foully dirty, but they had also been crudely repainted, often more than once. The pictures being regarded as objects of devotion rather than as works of art, it was more important that the nature of their subject should be discoverable from a certain distance, than that their artistic merit should be revealed to a pious spectator. An ancient ordinance of a Russian Metropolitan decreed that icons in churches and monasteries should be brightly repainted whenever they grew dull. The consequences may easily be imagined.

Few will agree on what icons can tell us – or how we should speak for them. One recent study is adamant that the term *art* should not be applied to them, and the author felt confident enough to declare this in his title: *Likeness and Presence: A History of the Image before the Era of Art*.[7] A different view is taken here: the icon is seen as 'art'. This will remind us that art objects are infinitely complex and both help viewers participate in the contemplation of the 'sacred' and appeal to their aesthetic sensibilities. In other words, one of the processes involved in the operation of 'religious art' is the sense of beauty. In dealing with Byzantine art, this book assumes that the experience of the visual in religion is inextricably linked with the operation of the visual in everyday life.[8]

We cannot literally go back in time and follow a group of

Byzantine viewers of, say, the twelfth century as they enter a church and watch them in front of the icons. But we can discover Byzantine practices from texts which discuss icons and their audiences and we can see and describe what happens in an eastern church today. From Byzantine texts which discuss devotional practices before the outbreak of iconoclasm, we find out that by the seventh century there were already accounts of the Christian faithful bowing and kneeling in front of icons and in front of the cross (see illus. 9). This was described as *proskynesis*. The practice of kissing the images, *aspasmos*, is likewise mentioned by this period.[9] By the twentieth century, one can say that from the moment of entrance into the church, the route was essentially controlled by the location of the icons and the reverence made to them.[10] A visit to any church involves a *proskinima* – lighting a candle, making the sign of the cross, and touching and kissing the icons. This entails a circuit around the church from one chosen icon to another, from the icons in the *proskynetaria* in the narthex and in the church up to the iconostasis, which divides the nave from the sanctuary. On the occasion of a special visit to church or pilgrimage to a particular shrine, the viewer may additionally make a request for the future (perhaps because of illness or infertility or oncoming examinations) or offer thanks for past favours. In the course of the visit, the devotions may involve the offering of a *tama*, which can be anything from a candle or flowers or food to a small metal plaque which most frequently represents a person or the part of the body involved in the prayer (illus. 2). Quite often, the prayer is also written down on a small piece of paper, which can be posted in a box provided or attached to an icon – some even write directly on the icon!

The visible interaction between the faithful and icons is a central part of a private visit to a church; icons also feature in communal services during which they may be censed like other holy objects in the building. Just as the visit is the outward sign of the visitor's faith and piety, so the icons operate as part of the highly visible actions of the private visit or of communal worship. It is the visibility of the saint's icon that makes the holy person available and accessible to the faithful. Just as Classical Greeks spoke of their statues in a 'shorthand' as if the god or goddess was present in the image, so the Orthodox faithful may speak of going to the Panagia

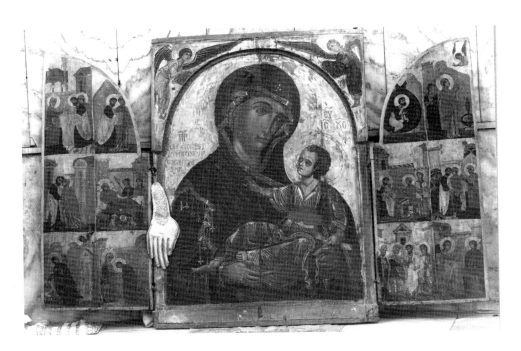

2 Triptych of the *Panagia*, 13th century. St Catherine's Monastery, Sinai.

when they intend to go to the church of the Panagia or to reverence the icon of the Panagia.[11]

Contemporary practices in the Orthodox church in front of icons must tell us something about the remoter past, and anthropological studies have assumed just this. Observations made of the practices of a Coptic community in Egypt showed consistent attitudes towards icons, and so these practices can be assessed for their historical value. (Some allowance needs to be made for possible anachronism and also because this church is Monophysite, not 'Orthodox', as Egypt diverged from Byzantium over the definition of the nature of Christ and so was not a participant in Byzantine council decisions on icons.) The Coptic community was questioned on its practices. On entering the church, the reason given for greeting the icons was 'to bring reverence and greetings to the saint depicted on the icon'. The next stage of response between the viewer and the icon was one of private inner meditation: 'When we look at the icon of a saint, we do not just see a beautiful piece of art, but in one glance we actually read his whole life story.' The icons, 'these pillars of the church', offer models of the ideal life to the devout viewer. The images of the saints on the icons stimulate appreciation of the particular virtues of each – this

25

may be love for God, obedience, humility, strong faith, patience, mercy, or generosity. The viewers ask themselves how far their own lives and situations compare with the successes of the saint.

The icons in these Coptic churches therefore initiate individual meditations about proper life styles and the models for the ideal Christian life. But they also supply the community of viewers with a range of public witness to their powers, including their testified powers of making miracles, even in very recent times. Interviews with both laity and clergy showed that a communal conviction from earliest childhood was that the icons in the church represented the *presence* of the saints. Their living souls were understood to be present during the celebration of the eucharist, so that the whole community of the church, both past and present, celebrated the liturgy together. A bishop explained that as a priest burnt incense in front of an icon, he was greeting not the icon, but the spirit of the saint represented: 'Through the intercession of the Virgin Mary, forgive us and bless these people. Oh you spirits who fill the house of the Lord, join us so that He will forgive our sins.' In Egypt, people also have representations of the saints at home (most often commercial reproductions or photographs). These have not normally been consecrated in a church ceremony and so are regarded as 'pictures' rather than 'icons'. Consequently, although the Coptic Christian is a person who lives 'with the saints', it is only in the charged atmosphere of the church itself that the devout viewer can achieve close contact with the saints in their icons; the communal belief is that requests made in church 'in true faith and which do not contradict the will of God' are granted immediately.

This book is too 'relativist' to suppose that the beliefs and attitudes of the modern Coptic believer might be 'identical' with those of the Medieval viewer of icons – the history of viewing and spirituality is more complex than that.[12] Yet the history of icons since the ninth century has been a continuous one, and there must be overlaps in responses between the Middle Ages and today.[13] The clearest empirical evidence of continuity is the touching and kissing of icons; this means, of course, that all icons from past and present show the signs of wear and tear. These signs of use have recently been pointed out as a factor which intrudes upon the modern connoisseur-

ship of Byzantine ivories, for parts of their surface may be heavily worn down by the devotions of the Middle Ages.[14] They also graphically document the practice of *aspasmos* (with its meanings of 'greeting', 'kiss', 'embrace') as the regular action of Byzantines on entry to a church.

Although the devotional practices in front of icons may reveal apparent continuities from the Middle Ages to the present day (and mean that we can make contact with people who will have a view on how their spirituality connects with the past), it does not mean that the same behavioural acts reflect unchanging inner beliefs and doctrines. We can hardly assume that there is a constant match between practices and spiritual beliefs, or that stated theological justifications for the Christian practices of the Middle Ages were always obediently in the mind of the individual in the Medieval church. Some of the best-known statements on the nature of the icon were formulated by iconophile intellectuals in the face of the polemics of iconoclasm and so had to be phrased in careful terms which were most likely to gain consensus in a vote at a church council. As we read them, some of the pronouncements may seem so bald as to be open to all sorts of interpretations, and others no doubt were sufficiently ambiguous to cover a range of interpretations. When we wonder how Byzantines understood the relation between an icon of a saint and the soul of the saint, we have to handle and often read between the lines of carefully worded official statements. They may often represent a committee decision of the establishment in power. One nagging problem of interpretation is how far these official statements might diverge from a cruder, more hidden, popular set of beliefs in which icons take on magical and animistic powers. While it is tempting to dismiss the idea of popular religion in Byzantium – indeed, it is the common view that the concept should be eliminated from discussions of this period – the actual Medieval world of religious art was no doubt highly complex, with all shades and levels of responses to icons (on both the iconophile and iconoclast sides).[15]

The key church council which defined the Orthodox case for the legitimacy of the figurative icon in the church met in 787. This Second Council of Nicaea produced the theoretical pronouncements which the Orthodox church reckoned to be final – so final that when iconoclasm ultimately came to an

end in 842, no new council was called, and the definitions made at Nicaea had only to be recalled and reiterated in a Declaration (*Synodicon*) of Orthodoxy.[16] The western church was never so sure about the ecumenical legitimacy of Nicaea as church dogma; indeed, theologians in the west were apparently never entirely clear what the final formulations were, particularly those who relied on the Latin translation of the acts known as the *Libri Carolini*. The Greek records of the council do however give us the Byzantine flavour of the theological formulations. For example: 'The Church ... accepts icons as a reminder of the prototypes' (Mansi 12, 1006A); 'In accordance with the affection and love which we have for the Lord and the saints, we depict their countenance in icons; we venerate not the wooden boards and colours but the persons themselves whose names the icons bear' (Mansi 12, 1063A); 'It is not by bestowing veneration on matter and colours but by being guided through matter by our spiritual eyes towards the prototype that we render him honour' (Mansi 12, 1146A).[17] These are examples of the character of the decisions recorded, which aimed to define for once and all the relation between an icon and a saint represented on an icon – between the signifier and the signified, as we might put it. These are also part of the attempt to eliminate the iconoclast attack on icons as idols. The idea that there was anything idolatrous in the practices of veneration connected with icons had to be firmly rejected; there was no way that a Christian could admit to be an idolater (icons can be venerated, but only the uncreated God can be worshipped).

Other statements were more ambiguous in their formulation and perhaps remained ambivalent to later readers, who, like us, might have taken them out of context. One such pronouncement came in the sixth session of the council (Mansi 13, 252B, C). Art historians have consistently taken this as a general statement and legitimation of church control over artists, the confirmation, it was supposed, that in Byzantium there was official church censorship of art in which its content was to be prescribed by the church and artists were dependent on these prescriptions.[18] The standard interpretation has been that the Council of Nicaea decreed that the church should choose the content of art and the artist should do no more than carry out the representation; this interpretation has nourished the superficial idea that there is a

straightforward dichotomy between iconography and style.[19] More radically still, it has cast a shadow on the interpretation of those rare discussions of art in later Orthodox church councils, most notoriously perhaps those of the Russian councils of the sixteenth century. Maybe it is the belief that Nicaea laid down powers of censorship over artists that has led art historians to suppose that the Moscow council of 1551 (the Hundred-Chapters Council or Stoglav Council) intended to control artists by introducing into circulation official iconographic manuals (*podlinniki*) which would set down guidelines for correct iconic compositions and representations which artists were required to copy. This again has all the hallmarks of a romantic distortion of the situation. The council actually went no further than repeating the obvious injunction within the Orthodox framework: that good models should be followed and that icon painters should maintain the traditions and memory of the church.[20] No doubt, drawings and records would help in this, but that does not make them sinister witnesses of ecclesiastical domination.[21] Nor can the *Painter's Guide of Mount Athos*, a compilation of the eighteenth century by Dionysius of Fourna, be projected back as an ominous document of the Middle Ages demonstrating the power and control of the church over religious art. It is better understood as a painstaking attempt to record and promote the good artistic practice of earlier centuries. This was stated as his personal intention by Dionysius, who was an artist who lived between c. 1670 and c. 1746. Documented through a number of extant paintings, he worked for a time on Athos. Dionysius emerges as a traditionalist who praised past masters, above all the artist Manuel Panselinos, and offered to help others by passing on his own hard-learnt expertise. He effectively demystified the production of icons, while drawing attention to the high level of technical ability and knowledge their production demanded. The discovery of a copy of his *Guide* actually being used by painters in the Athonite monastery of Esphigmenou, showing that this was a practical compendium of technical information and iconographic prescriptions, was publicised by the French scholar A. Didron, the first to publish the document in the west. His 1845 book is, revealingly, dedicated to Victor Hugo.[22] It thus entered the reading world of French Romanticism, offering to this audience the opportunity to find a Romantic image of the artist in

Byzantium, who was constrained from the expression of his own personality by the controls and prescriptions of a repressive church.

The deliberations of Nicaea on the role of the artist in the creation of church decoration are more constructive than sinister and do not need be taken as an official attempt by a closed society to curtail artistic freedom. The intellectual intentions of the council in this session were defensive about the past production of icons, not prescriptive about future procedures. The intentions of the key passage can be better understood if read within the full context of the council deliberations. The aim of the passage turns out to be the refutation of one of the iconoclast arguments which had been agreed in the previous council of Constantinople in 754. The adversarial scheme of debate at Nicaea was first to quote the offending passage and then to set down its refutation, thereby demonstrating that it was heretical. The passage is a refutation of the argument that artists were the sole effective agents in the production of icons and that in claiming to be able to make images of Christ, artists fell into heresy. The following translation[23] shows how this text was intended as a constructive refutation of the iconoclast attack on artists, not a programme of artistic censorship:

> The making of icons is not an innovation of painters, but an approved legislation and tradition of the catholic church. Whatever is ancient is worthy of respect, as St Basil said. Our testimony is the antiquity of the objects and the teaching of our inspired Fathers that when they saw these icons in the holy churches, they were glad. When they themselves built holy churches, they had icons painted in them. In these churches they offered up to the Lord of all their prayers which were pleasing to Him and their bloodless sacrifices. Assuredly therefore the concept and the tradition come from the Fathers, not from the painter. Only the workmanship belongs to the painter, while the decision is clearly from the holy Fathers who built the churches [Mansi 13, 252B, C].

These texts can, perhaps unexpectedly, help us to clear the air and engage with Byzantine art and icons from a fresh perspective. We can risk throwing aside explanations for the undoubted traditionalism and conservatism of the imagery of

icons as due simply to church- or state-imposed control over the artists and producers. We can instead go far deeper into the world of icons and assess what exactly 'unchanging' might mean, and the icon might be the index of greater cultural complexities. No one can claim that icons are just ordinary paintings to decorate architecture; they are objects on which a whole range of human emotions was – and is – continually bestowed. In the eyes and mind of the Orthodox and eastern Christian believer, an icon is not simply a physical image; it is, in our words, an interactive medium between this world and the other. In Christian terminology, it reflects and contains universal truths, and it evokes the spirits of the saints in heaven. Of course, pictures are never innocent, and we always have to learn the nature of their powers. The most familiar image over the centuries in Christian art is probably the Crucifixion, and we have learnt to see how its visual effectiveness can be heightened by all manner of compositional devices; our understanding is also changed by remembering the varieties of the viewers of any image. The meaning of a Crucifixion may change when it is treated as a special object for contemplation by a whole community or as a private icon used for the meditations of the silent monk in his cell. Another level of pictorial intensity is created by those Crucifixion panels of early Modern Europe painted for the purpose of display to a condemned criminal at the moment of his execution.[24]

The Byzantine icon has come down to us as a silent witness of a huge range of emotions and experiences. In the course of the centuries, it will have been the subject of prayer and contemplation and meditation as well as extremes of anguish and joy. Sometimes, icons were 'working' images at moments of the greatest emotion; sometimes, they were the delicate invitation to aesthetic experience. If we are to study the icon, the process will be one part demystification, one part appreciation of its mystifying power. It is a demanding adventure.

2 Birth

Ghika discovered that his rejuvenated philosophy of Cubism already had deep roots in Medieval Greek painting: reversed perspective, dismissal of the horizon line, economical use of colour and colour used emotionally rather than descriptively. These aesthetics were to be found in Byzantine art. What was dismissed in the 19th century as primitive, was now accepted as an escape from the tyranny of photographic representation. Painters were now free to find joy in transformation instead of being restricted by imitation.

Obituary of Nikos Ghika (1906–94) by John Craxton in *The Independent* newspaper, 7 September 1994

Text and image, even when presented as a whole, do not match, do not overlap; they can neither do with nor do without each other.

The study of images supposedly meant to illustrate well-known stories (eg Biblical episodes) shows the same obvious fact. Although those images, especially when painted on walls or windows of churches, did function as a replacement for texts in partly illiterate societies (Margaret Miles, 1985), they did so on the basis, not of total redundancy, but, on the contrary, of overwriting the previous text. Images are readings, and the rewritings they give rise to, through their ideological choices, function in the same way as sermons: they are not a retelling of the text but a use of it; not an illustration but, ultimately, a new text ... The image does not replace a text; it is *one* ... Images function by means, also, of an appeal to the already established knowledge that enables recognition of the scene depicted. And paradoxically, this recognition of what is already known is an indispensable step in the communication of a new, alternative propositional content of what is not yet known.

Mieke Bal, *Reading 'Rembrandt'*

It is forbidden to write on the icons and on the walls. He who obeys this will be truly blessed.

Notice in the monastery of St George in Ar-Ruzaiqat, south of Armant, near Luxor, Egypt (recorded in Nelly Van Dorn, 'The Importance of Greeting the Saints', in H. Hondelinke, ed., *Coptic Art and Sculpture*)

The past is unfamiliar country, and we know we delude ourselves if we think otherwise (illus. 24). Anyone preparing to enter the world in which the icon was born should expect to require some guidance and light. They might have seen the headline in a recent British newspaper, 'DARK AGES OVER FOR MEDIEVAL STUDIES'. Of the many possible readings of this phrase, the most literal would be unreasonable, as Medieval art has never lacked its supporters and commentators, and the Dark Ages are only as dark as we want them to be. The literature is full of reactions against the definition of this period as no more than the passive occupant of the space between the peaks of Classical Antiquity and the humanist Renaissance. The 'Dark Ages' can be seen not as a negative period marked by the decline of the ancient world, but as a positive time of transition and transformation into a new Christian world, distinguished in Byzantium by the development of an effective religious art. From this perspective, the Byzantine icon emerges as one of the success stories of the Middle Ages.

It is not only our terms like *Dark Ages* that offer problems of interpretation; so do the Byzantine texts themselves from the period, so often described as opaque and vacuous by modern commentators. When Byzantine writers do mention art, they appear in our terms to be extraordinarily reticent, if not inarticulate; we complain about their presentation of art as much as we complain about their silence about it.[1] These complaints have been overdone, partly because the full extent of writings on art is only now emerging, and partly because we can forget that the art history of any period depends on more than the texts. It may be that future observers of British culture may also claim to find evidence of 'visual blindness'. Londoners may allege to be sophisticated viewers of art, yet in London every day thousands of commuters pass beneath the main entrance arch of Waterloo Station without ever looking up to see the highly emotional sculptures which make up the Memorial to the 1914–18 war. One of the most striking public expressions of the agony of death in war, this is a work of art that remains invisible to most of the population.[2] The silence of Byzantine texts about their visual environment simply means that we need a broad strategy to uncover the experience of the icon in the Middle Ages, and this will also involve facing the question of whether the visual was more or less influential in their period than ours. This is as difficult a

question as asking whether any one society or historical moment could be deemed more or less 'religious' or 'rational' than another.

Another ambivalence in the literature on Byzantine art exists regarding its relation to Europe.[3] A recent treatment of the pictorial arts of the west from 800 to 1200 found the monuments of Norman Sicily to be too Byzantine and 'non-western' to merit full treatment in such a survey.[4] The history of Constantinople, which was the Ottoman capital too from 1453 to 1924, and its location on the Bosphorus at the boundary of Asia make its European identity particularly contentious. Constantinople was the 'other' within an 'orient-alist' paradigm.[5] Add to this the general suspicion about the Middle Ages, and one can see why although some might suggest that the Middle Ages invented Modern Europe, others reverse the equation and argue that 'Middle Ages' is a convenient modern label invented to cover a fragmented period.[6] Here, the art historian at least has no need to be defensive. The fact is that an enormous amount of Medieval art has survived, particularly from Byzantium, and it still needs to be exploited within these debates; it may be easier to define Europe as a cultural sphere through its artistic traditions than through its politics. Art would seem to offer an answer to the question of how far the history of Byzantium is isolated from or connected with developments in western Europe. Ironically, our justification for using the word *Byzantine* in the first place has caused some of the trouble. When 'Byzantine' is taken to mean 'obscure', 'impenetrable', 'enigmatic', 'intricate', or 'undesirable', it must be more tempting to accept Vasari's proposal that Renaissance art originated in a rejection of Byzantine art, effectively making it a period apart. The term was always paradoxical, since what Constantine did in 324 was to refound the city of Byzantium and in 330 to rededicate it as Constantinople or New Rome. The empire which lasted from 330 to 1453 was centred there. The value of retaining the name *Byzantine* was the belief that it offered a flexible description of the culture without insisting that it was a continuation of the Roman Empire in the East or that it was, although predominantly Greek-speaking, thereby a Greek empire. In the event, the term may have caused more problems than it solved and may actually have marginalised the period in historical studies.

If *Byzantine* as a descriptive historical term was from the beginning meant to be vague, the Greek word *icon* has suffered the opposite fate, moving from an originally precise technical term – a religious image painted on wood – to a colloquial cliché. Opening my newspaper today brought some of its current uses. The obituary page records the 'death of a gay icon', another page looks at computer 'icons', and a third reports a contemporary composer's 'ikons in sound'. Let us, therefore, before we are drowned in misuses and overuses, remember that a world once existed where an icon was an *eikon* and where people saw more icons than they ever read books. If *icon* is now a common, everyday concept, this increases the task of clarifying our viewing of the Byzantine icon. To help the process along, let us now work through one example and its implications (illus. 8).

Few would fail to recognise this image as an *icon*, and it has the familiar subject of the Virgin Mary and the Christ Child. Most when asked to describe it would call it highly stereotyped, but not without a strong impact. Very soon, the question of how 'good' it is would come up. It would not surprise us if the art historian presenting this icon would speak of it as 'using gentle and careful brushstrokes to build up an impression of rounded flesh within the broad, sweeping delineation of the main facial features'; or that 'it has a warm and bold portrayal of figures set in a shining celestial golden light'; or that 'the strong modelling of the faces is achieved by the combined use of tones, shadows, and hatching.' Within these descriptive remarks are indicators of an aesthetic judgement – the presentation of style. Style often underpins a critical judgement. This formalist handling of an icon sounds very twentieth century and not too different from the connecting of Cubist and Medieval art espoused by Ghika in the passage quoted at the head of this chapter.[7] But to say that implies that a Byzantine viewer would have thought differently. Ironically, an example of this 'modern' approach emerges in a Byzantine text. Michael Psellos, one of the great intellectuals of Byzantium, wrote in the eleventh century: 'I am a most careful viewer of icons: but one icon astonished me by its indescribable beauty, paralysing my senses like a thunderbolt, and vanquishing me of my power of judgement in the matter. Its subject was the Mother of God.'[8]

This aesthetic response to an icon of Mary offers a

Byzantine viewing in which an appreciation of artistic quality was the overwhelming emotion. The distinctive feature is that Psellos did not indulge in the common Byzantine critical statements about the 'realistic' and 'lifelike' qualities of the work of art (art as *mimesis*).[9] In writings on art, the Byzantine author was usually engaged in writing a complementary essay rather than analysing the work in question. Art criticism in Byzantium was more a literary exercise than a record of the viewing situation. *Ekphrasis* had become a highly complex and intellectual undertaking, for which the work of art was only a springboard to literary virtuosity.[10] For Psellos, then, to write about his icon in terms of a direct response to artistic quality was unusual, and probably carefully considered. It would be going too far to see it as clear evidence of a 'formalist' discourse among the viewing public of Byzantium, however.

Most Byzantine texts which speak about art rely on the 'standard' *topoi* of Medieval art criticism.[11] They frequently speak of art as imitation (*mimesis*), despite our impression that this was not the aim of the artist. Texts about art are therefore a literary genre in their own right, and as such need to be treated obliquely. The study of Byzantine art, like any period in the history of art, needs texts; it also needs to find ways of understanding art that were not necessarily even articulated in the period in question.[12]

The response of the modern viewer of the icon, as reconstructed above, soon moves to a critical assessment of the quality of the individual icon, if not of its ranking in the general history of art. There is nothing new about this – already in the nineteenth century, writers such as Walter Pater encouraged the idea that in the presence of good art (and even more in the presence of 'great' art), the commentator should rise to the occasion and match the artwork in the verbal response.[13] If it is true that the icon is growing in popularity in the late twentieth century, this would no doubt be due in part to our appreciation of the formal qualities of Byzantine art through our experience of the art of our own times. But to appreciate the formal qualities of the icon in illustration 2 is only a prelude to asking about its content and meanings. It would be difficult to argue that its power as an image comes only from its composition rather than from its spiritual references. Yet this 'secular' response to the 'art' of any culture is common in 'western' art history, connected (we suggest)

with the rhetoric of the artist struggling for liberation from the dominance of the church. The modern abstract artist can argue that while we can paint 'yellow' if we wish, the inhibited Medieval artist could only introduce colours as the attribute of some object or person. Following this argument, the icon as an art form seems to be appreciated as hovering between the abstract and the realistic. The challenge is to decide how far our viewing habits are a help or a hindrance in approaching the icon.

The issue is precisely clarified in a British educational document which was drafted in the 1990s as a preliminary to prescribing a national curriculum for schools.[14] This report set out a curriculum for art and music. Its radical aspect was to recommend that teachers instruct children in visual literacy from an early age. The committee, chaired by Colin Renfrew, worked in great detail and envisaged that a reconstructed teaching profession would teach the viewing of icons and modern art together. It was to be in primary schools that children would 'investigate themes such as the "Mother and Child" through looking specifically at icons, Henry Moore and Mary Cassatt'. The committee members were obviously optimistic that the art of these various periods was compatible. They were equally optimistic in believing the artistic portrayal of the theme of the Mother and Child to be unproblematic and easily accessible to children in the very first stages of education at infant school. The British school-child was to be exposed to the icon between the ages of five and seven, before moving on to Renaissance or Impressionist landscapes or Dutch interiors. While we may welcome the initiative, is the icon so simple? This piecemeal use of it shows how the medium has failed to find a place in the conceptual framework of the western art historian. This must be a failure of understanding of a medium which stands between 'western' and 'non-western' art; a firmer place for the icon in art history is yet to be formulated. This is timely because of the relative neglect of the medium even by Byzantine specialists until the last few years. We have the excitement of exploring what is to all intents and purposes a new subject. What is the icon? How are we to view it?

We can come back to the icon in illustration 8. The habitual viewer of Christian imagery knows that the mother and child are the Virgin Mary and her son, Jesus Christ, and I suspect

that few viewers would even think to take the group in a more abstract sense as a representation of the theme of maternity, reproduction, and family, although they would not deny these as implicit meanings. It would probably be difficult to find a viewer of art whose background precluded their immediate identification of the Christian content of this painting. We can assume that it would be seen as an object with deep religious connotations, part of the apparatus of worship and devotion connected with Christianity through which the church linked a 'historical' narrative of the birth of Christ with the dogma of the incarnation of God.

There is a contradiction here in our ways of approaching the icon. As art, there is the formalist approach, but as a religious object, the reaction is reverence. This painting is so clearly a work of religious art that some Christian viewers may object to the formalist response. As we shall see later, the question of how this particular icon is seen may be linked to its present location. So far, we have seen it as the illustration in a book, and nothing has been said about the place where it can be viewed in actuality. Is it displayed in a museum, a home, or a church? A problem about the viewing of icons is therefore highlighted by illustration 8. Treating it as an art object seems to limit our understanding. Its original functions and devotional value seem to be more essential aspects. Is there a right and a wrong way of viewing icons? Must an icon be treated in the terms in which it was created, or is that a 'historicist' aim which is now unachievable? What does visual literacy mean in the presence of religious art?[15] How are we to handle pictorial meaning in Byzantine icons? In Christianity – a religion of the book – what is the role of the pictorial image? These are some of the immediate questions which any study of icons quickly encounters.

The point made so far is that the figures shown in illustration 8 would be universally identified as the Virgin Mary and her son, Jesus Christ. This is not really accurate. Only some of this icon's viewers would naturally use these names, for they reveal religious affiliations and are far from objective. Similarly, the shortened form – 'The Virgin and Child' – would not be everyone's choice. Some will say 'Our Lady' or 'Madonna', thereby offering a signpost to their personal religious background, more Catholic than Protestant. Both labels are in fact inadequate for an icon. The modern

Orthodox Greek viewer would more naturally describe the key figure as the Panagia (*Panayía*), the 'all-holy one', and so put more emphasis on the sacred status of Mary, and less on the dogma of her Virginity.[16] Her usual title on an icon is 'Mother of God', abbreviated in Greek as *MP ΘY*.[17] Perhaps we might consider avoiding the ubiquitous (in western art history) shorthand of 'Virgin and Child' if we want to convey the icon's viewing aura.

The icon in illustration 8 has been chosen as a work which clearly belongs to the Byzantine world of the Christian *eikon*. If we now look more closely at its surface, there are a number of signs of its individual history – it carries the scars of its treatment by a viewing audience. The paint surface shows considerable damage and loss, although the main figures still emerge as strikingly 'monumental'. Mary retains her presence as the central figure, meeting the eyes of the viewer; the child is equally poised and dominant, but remains the 'secondary' image in the panel. There were two other figures painted on the icon, although by virtue of their scale and separation into circular medallions in the upper corners of the panels, they have become minor and secondary participants. These are the tiny figures of the two angels. Despite their scale, their function and role in the picture are clear enough; together they visually frame and symbolically guard the two central figures. We can imagine that Byzantine viewers saw a parallelism between the heavenly guards of Christ and the earthly imperial court; the emperor was regularly represented in art guarded by his retinue, usually consisting of eunuchs, sexless like the angels.[18] Thus, all the figures on the icon can be identified, and their meanings depend on a context which every Medieval viewer would have known. Mary nevertheless complicates the evocations of the imperial court, as Byzantine society had expectations of how a woman ought to appear. The agreed ideal lay in her wearing a style of dress that does not attract attention by either its splendour or its ostentatious poverty. If a virgin, a woman was advised 'not to raise your face to human being, but only to God'.[19] Any icon of the Virgin Mary is therefore in a sense subversive, for it represents a woman who would be the subject of intense gaze. Artists had to create a formula which both concealed and declared her feminity. In this icon, does she gaze at God or at the viewer? The damage to the eyes obscures the answer, but

she does appear to make contact with the eyes of the faithful viewer. Other icons of this subject show that the artist had a choice in making this decision. Similarly, the compositional devices, by invoking the imperial court on earth, transform Mary from a humble 'Mother of God' into a figure of great charisma. The use of a gold-leaf background is equally symbolic, cross-linking the wealth and richness of earthly royalty and the golden light of heaven. One sees how the icon was a place where heaven and earth met, just as the Incarnation and birth of Christ it shows represent the historical moment when divinity walked on earth. One of the symbolic functions of this icon is to act as a witness of a historical event and convey an eternal and unchanging Christian truth about the existence of God.

Another function of this icon was certainly to demonstrate the truths of the Bible and to help and inspire its viewers. Its intended Byzantine viewers were so familiar with the Bible that they inevitably saw and expressed their knowledge of their world through its language and parables; icons were additional parables of the faith. But the problem remains of how to corrrelate Medieval perceptions of the icon with our own expectations in viewing art. Any modern catalogue entry about this icon would be expected to offer a basic empirical description, something like the following: 'A late fourteenth-century icon, painted in egg tempera over gesso and linen on a wood support. 93 x 53 cm'. Because of its substantial scale – nearly a metre in height – the catalogue would go on to suggest that this was the major icon in a church, placed either at a special location – probably in a *proskynetarion* or a *stele*, a stand where it could be kissed and adored and set up either in the narthex or through the door and inside the nave, or in the *templon* or *iconostasis,* which acted as the decorated screen between the nave and sanctuary, separating the congregation from the 'Holy of Holies' (see illus. 3, 35, 36). The icon's size is important because it implies that it was destined for a public setting in a church and would have been out of place in a small private chapel or home. This location in a church makes it one of the 'standard' productions of the icon painter, the kind of image a painter would make several times in a career, even if smaller works were the everyday product. We assume that a work of large size was a specially commissioned object. There are cases of commercial traders purchasing works of art

3 George Klontzas, Sanctuary of a Cretan church, icon, late 16th century.

from artists in need of cash, but it seems that they knew that the speculative profits from such transactions would be meagre.[20] The world of icons must have been one of individual commissions and specifications.

Not only the size but also the composition is a 'standard' one. The Medieval viewer was put in no doubt about the iconography, for it is affirmed by accompanying Greek texts. The figures are identified as the 'Mother of God' and 'Jesus Christ', and the format in which they are represented is declared as that of the *HODIGITRIA* (the Greek letters are partially preserved). The Hodigitria was one of the most common types in which the Panagia was represented. It is identified by Mary's gesture: she points with her right hand at the child. Since this was the iconographic type used here, one

can fairly confidently reconstruct the lost parts in the lower section of the panel. In its original setting, this icon might have been free-standing as the main icon in a church dedicated to the Virgin, or it might have been one of the icons on the sanctuary screen, probably the pendant to an icon of Christ Pantocrator.

In a museum display, a slightly fuller label would be expected for the icon:

The Hodigitria
late fourteenth century
From Crete (artist unknown)
Tempera, 93 x 53 cm
Provenance: Church of the Panagia at Méronas, Crete.

This indicates that there is a little more information about the object's history than has so far been revealed. The first point is the use of a title – *The Hodigitria*. Although this inscription appears prominently on the icon, we do not know if the artist would have considered it to be a *title*. We are so accustomed to titles as an artist's prerogative and copyright and as a way of identification that we may overlook the Byzantine setting. When the icon was first installed in a church, there is no reason to assume that its audience was particularly concerned to know its date, medium, painter's name – or title in our sense. We may take the inscriptions on the icon to be part of a 'title', but for its original viewers the importance of those inscriptions lay in their authentication of the figures.

This account has so far been purposely ambiguous about the modern viewing setting of this icon. It has indeed appeared in a museum catalogue and indeed was displayed in a large exhibition of Cretan icons organised in Iraklion in 1993 (although the building where it was exhibited was a church used as a gallery). This is not its usual setting, however. The place where the icon still permanently belongs is in a church on Crete – the church of the Panagia in the small mountain village of Méronas to the south of Rethymnon (illus. 4, 64).[21] The modern viewer might recently have seen it both in a museum setting and in the church; the icon was first found in use in the church and then taken for restoration to the studio of the government department of Byzantine antiquities. It is now back in place displayed near the sanctuary screen of the church. Icons were similarly mobile in the Middle Ages: they

4 View of the 15th-century church of the Panagia at Méronas, Crete, from the west.

might have been carried in procession on special days, moved around different settings within the church, or sent as special gifts to distant monasteries. It is hard to call an icon a static object in these circumstances. The impression of this icon is to create and reflect stillness, yet one has to anticipate that as it moves to different settings, its meanings for different viewers may change.

Although more has now been said about the physical context of this icon on Crete, it is also a photograph in this book.[22] Here, any icon must lose its protective religious environment and become one of a series of images put together.[23] Some Byzantine works of art are now known only through photographs – this is the case for the mosaics of the church of the Koimisis at Nicaea (Iznik) in Turkey, destroyed in 1922, which can now only be experienced through reproductions (illus. 5). Yet, although the Byzantine viewer could never have had this sort of viewing experience, there is some common ground. We are familiar with photographic copies; Byzantine viewers had an expectation of seeing icons, like that of the Hodigitria, copied many times. The icon in illustration 8 is not a unique or original composition. The Byzantines too expected their artists to manipulate their viewing perceptions.

Look at illustration 8 in comparison with another panel (illus. 10). The painting in illustration 10 was very likely also produced on Crete (and it too is damaged). We can compare

43

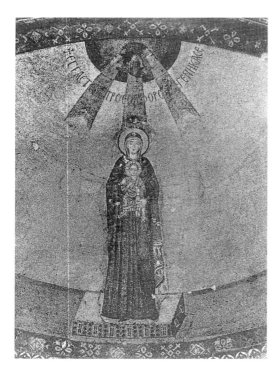

5 *Panagia and Child*, 8th and 9th century, apse mosaic. Church of the Koimisis at Nicaea, Turkey.

the subject matter. Illustration 10 is, in narrative terms, a more 'historical' treatment of the 'story' represented in illustration 8. What it shows is the invention of the Hodigitria image, and it does this by recreating the moment when the original painting came into being, henceforth to act as a model for all later copies. We see the artist's studio at the moment of painting the portrait icon of the Virgin and Child from life. This icon represents an icon within an icon. The professional-looking artist is the first Christian artist, the evangelist St Luke, who Byzantines said painted Mary from the life, holding the child Jesus. In this rendering of the occasion, the sacred figures themselves are not shown – they are to be imagined 'off-stage' to the right of the picture space. We see the finished icon, the painted portrait, not the whole historical moment. In viewing the picture, we need to remember that St Luke was believed in Byzantium to have been equally significant in the production of text and image; he combined both media in recording both the story of the New Testament in words and the face of the Virgin Mary, painted from the life, in art. Our illustration 10 is only one of many versions which record this important truth –

6 *St Luke Painting the Panagia and Child*, 11th century, manuscript of the *Homilies* of St Gregory Nazianzus. Monastery of the Holy Cross, Jerusalem.

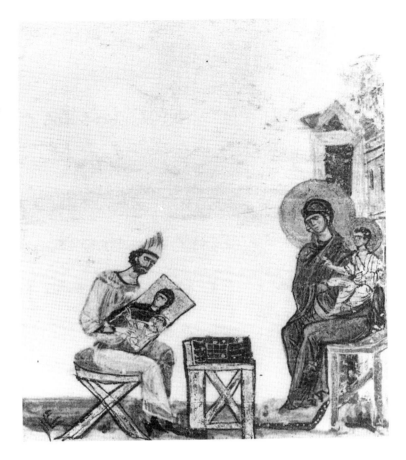

that an authentic portrait of Mary was painted in her lifetime, that it existed in the Middle Ages in Constantinople, and that it could be accurately reproduced in copies sent for visual contemplation and verbal prayer in churches all over the Orthodox world. The belief that St Luke painted Mary and Jesus was not limited to the Orthodox world. Rome in the Middle Ages claimed to have several of the originals, and the theme remained popular in western European art through the Renaissance period. So, although illustration 10 shows St Luke painting the type of the Hodigitria, the story was (at least in due course) that he painted Mary in various poses or iconographic types. Claims were made that the originals were to be found in all sorts of locations throughout the Orthodox and Catholic world – in addition to those versions that supposedly ended up in Rome, there were others in

Russia, and at least seven in Ethiopia, where they remain to this day, each one totally wrapped in a textile covering which hides the representation.[24]

One conspicuous feature of the painting in illustration 10 is that the artist signed the panel in Greek: 'By the hand of Domenikos'. This inscription adds a significant dimension to our knowledge about the painting, for it identifies the artist. This is one of the early works of the young El Greco (Domenikos Theotokopoulos of Crete), most probably done on Crete between 1560 and 1567 before he left Candia (now the town of Iraklion) and went to Italy and, ultimately, Spain.[25] This information about the artist will affect our viewing of it. But for the moment, the issue is how the comparison between these two paintings alters a viewing of the Hodigitria (illus. 8). The icon on the easel in illustration 10 shows the same Hodigitria pose as in illustration 8. Thus, we have a copy of the actual painting by St Luke, made centuries later. This was how a Byzantine viewer would have approached the icon at Méronas.

In the fourteenth century, every church was filled with icons (illus. 35). Earlier in Byzantine history, between 726 and 842, there had been a move to ban images entirely from the Orthodox church. Once this movement of iconoclasm failed in the ninth century, the Byzantine world never again tried to ban the use of figurative icons in the service of Christianity. From 843 onwards, the position was that to deny the icon was to deny the identity of the Orthodox believer. The icon was not just a tolerated object; it was the sign and symbol of Orthodoxy, a distinguishing feature of the full, agreed dogma of the eastern church. One of the strands which led to the official decision to accept icons in the church, most fully set out in the Ecumenical Council of Nicaea in 787 and confirmed in 843, was the exploitation of the role of St Luke as an artist. The idea that St Luke – in addition to writing his Gospel – was also an artist who painted Mary seems to have emerged in the eighth century, perhaps as one of the more desperate suggestions of the iconophile side to support their case. The neatness of the idea is that in an instant it demonstrated that the writing of the Gospel text and the production and visual record of Mary and Christ were exactly contemporaneous. It was assumed that St Luke sent Theophilos not only the Gospel and a portrait of Mary and her child from the life but also

included copious illustrations of the Life of Christ.[26] The icon by El Greco may seem to tell a narrative, but of course it encapsulates an ideology. It shows how integral the production of icons was in Byzantine thinking and how their production was made legitimate by a past event. Since this event involved a saint, no doubt this added to the sacredness of icons as well. The story of St Luke must have helped to enhance the importance of the artist in Byzantium as a communicator of Christian truth.

The promotion of the idea of St Luke as a painter of icons was therefore an audacious strategy for iconophile writers during the period of Byzantine iconoclasm in the eighth century. It supplied one of the most obvious and direct justifications for the legitimacy of the production of icons that there could ever be. If iconoclasm is to be understood as a debate about the correct form that Christian art ought to take, what better answer than the solution offered by St Luke himself, that Mary and the child Christ were the proper subjects of icons? If St Luke painted an icon, and Mary assented to her portrayal with Christ, what more had to be said? Once accepted as historical fact, supported by the surviving evidence, the icons of St Luke could rescue all figurative icons from attack. After iconoclasm, the image was a favourite subject, with an example in an eleventh-century manuscript being one of the earliest to have survived; it was also a major image in the art of western Europe.[27] Centuries later, the icon of the Hodigitria might be portrayed as one of the actual objects which influenced the course of iconoclasm and the triumph of the iconophiles. This is how the late fourteenth-century icon of the Triumph of Orthodoxy in the British Museum uses it (illus. 11). The Hodigitria icon is the pivotal symbol in this painting; it is at the centre of a gathering of famous figures and theologians who were glorified as the champions of the Restoration of Images in 842. These historical personages are shown together with the icon which legend decreed was in Constantinople from a very early date. This is another variation on the theme of an icon within an icon to confirm Orthodox belief.

The pictorial theme of St Luke as the painter of an icon portrait of Mary and Jesus offers an example of a narrative used to communicate a fundamental dogmatic reference. The same icon appears within the Triumph of Orthodoxy com-

position, and it is again portrayed as if we saw the original. The copy masquerades as the archetype. Medieval attitudes towards copies differed from ours, partly no doubt because printing was invented after the Middle Ages. However, theologians, particularly during iconoclasm, were well aware of the conceptual differences between a holy person and an icon representing that person. More difficult was the status of multiple copies. Illustration 8 sheds some light on these issues. First of all, we have noticed that El Greco in his treatment of the subject decided to exclude the figures of Mary and Jesus from the picture space – they are merely to be imagined by the viewer as standing off to the right. This was a definite decision, as other renderings of this scene do sometimes include the figures. This means that the only person in the icon is St Luke himself, who is viewing and putting the finishing touches to his portrait on the easel. The painting achieves its basic purpose of reminding the outside viewer of the authenticity of the Hodigitria as a record of the appearance and sanctity of Mary, but it also offers a meditation on viewing, and indeed on the painting of copies. In iconographic terms, the icon on the easel is the work of St Luke, and it is his hand which wields the brush for the final touches to the panel. Yet we know equally well that it is not St Luke's hand which is making the last touch to the panel; the real hand is that of the artist El Greco.

The play between the real and the imaginary permeates the painting. One distinctive detail is the inclusion of the Angel of the Lord swooping down to place a laurel crown on the head of the evangelist. Why is the crowning made so conspicuous? Who is gaining the prize? St Luke or El Greco? The historical figure or the 'real' artist? As a matter of fact, artists on Crete in the sixteenth century belonged to a professional guild – naturally, its patron saint was Luke! The subject is an ideal foil for the self-conscious artist. There are other signs that this is a self-conscious and sophisticated product by someone whose whole subsequent career paraded the artist as 'stylist'. While the style of the Panagia and Jesus icon on the easel within the picture seems stereotypically 'Byzantine' and traditional, except for the cunningly designed foreshortening to match the perspective of the easel, the rest of the picture is strikingly different. There is the dramatic three-dimensionality in the easel, bench, paint box, and artist's chair. As for the two

7 *St Stephen the Younger holding an Icon of the Panagia, with Monastic Saints,*
late 12th century, wall painting, Enkleistra of St Neophytos, Paphos,
Cyprus.

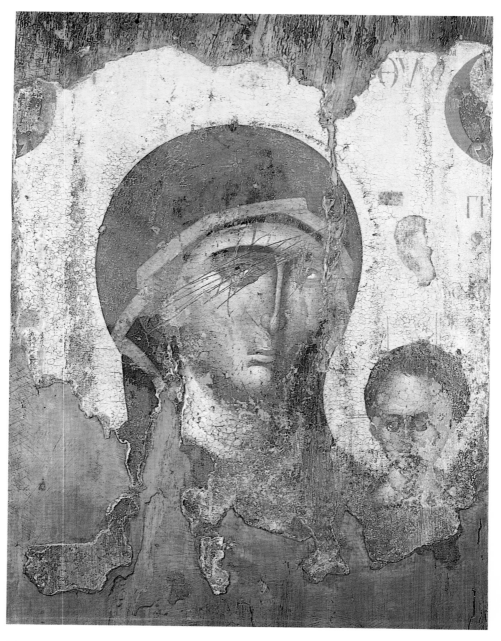

8 *Panagia Hodigitria*, *c.* 1400, icon. Church of the Panagia, Méronas, Crete.

9 Devotions before the Icon of the *Panagia Hodigitria*, *c.* 1300, manuscript (the Hamilton Psalter).

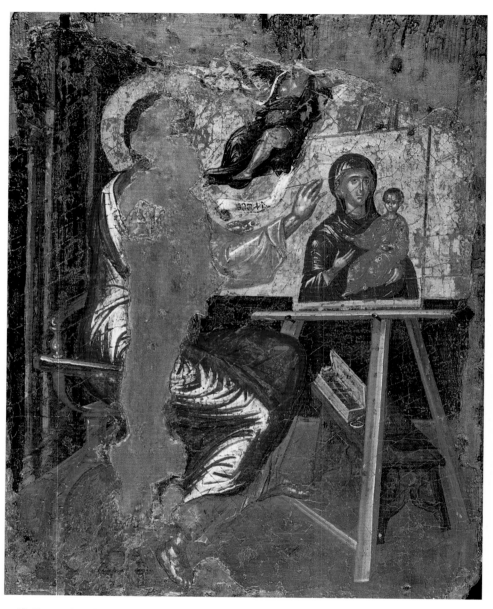

10 El Greco, *St Luke Painting the Virgin and Child*, 16th century, icon.

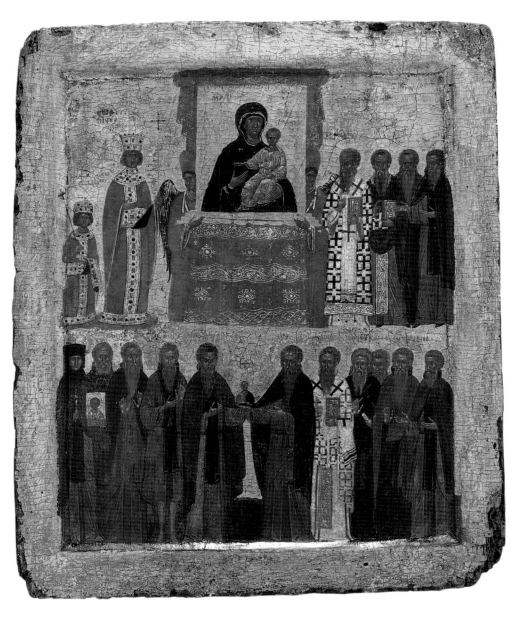

11 *Triumph of Orthodoxy*, *c.* 1400, icon.

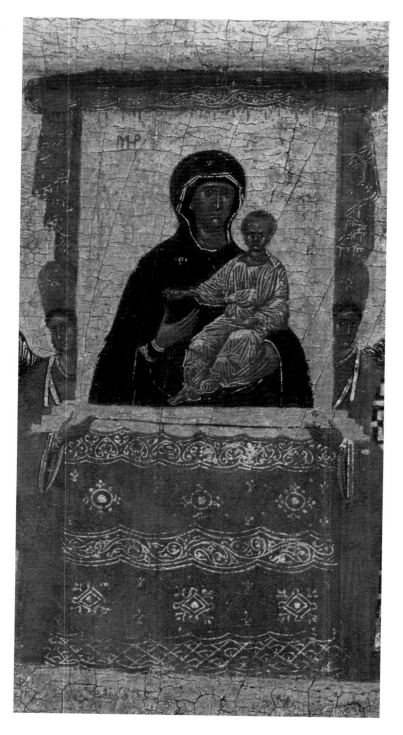

12 Detail from upper register of illus. 11.

13 Detail from lower register of illus. 11.

14 El Greco, *View of Mt Sinai*, 16th century, icon.

figures of the evangelist and the flying angel, they too are in a fluid figural style which acts as an affirmation of the virtuosity and stylistic range of El Greco. When the painting was shown in an exhibition at the Royal Academy, London, in 1985, one newspaper critic, Marina Warner, astutely saw the panel as deliberate satire, commenting on and contrasting the old and new ways of painting religious iconography. In one small picture, El Greco does not simply parade two quite different styles; the icon shows the possible range of viewing conceivable among the audience of the icon. The conventions of Byzantine art are here framed within a western manner, yet the icon was probably painted on Crete, in the east.

The first viewers of the icon in illustration 2 lived well over a century before El Greco, but they too would have instantly picked up the symbolism of a Hodigitria image. To find out more about public knowledge of this image, we must consider the situation in Constantinople. There, anyone could go and see and even hope to touch the actual icon painted by St Luke in the first century. It was so famous that a manuscript painter of the early fourteenth century was commissioned to record the icon in its tabernacle (illus. 9). To see the original in Constantinople, pilgrims from near and far flocked to the monastery of the Hodigitria. This popular complex had been developed near the church of St Sophia at the eastern end of the city above the waters of the Bosphorus.[28] The monastery was built around a miraculous fountain famous for curing blindness. The (later) tradition was that the icon was brought there in the middle of the fifth century from Jerusalem.

By the fourteenth century, whatever the actual date of the icon, it had become the centre of an elaborate cult. The icon was very large and very heavy. Perhaps it was, as one witness (Pero Tafur) claimed, double-sided with a Crucifixion on the back.[29] The production of double-sided icons with Mary and the Christ Child on one side, evoking the Incarnation but foretelling the Passion of Christ, and the Crucifixion on the other developed in the twelfth century. Such objects were ideal for use in the elaborate rituals of Good Friday. An icon of the Hodigitria combined with the Crucifixion or Christ of Sorrows would have formed an emotionally overwhelming image to display in church at Easter and to carry in procession.

At some date, the community of the Hodigitria monastery

developed a shrine for their famous icon of St Luke with a special tabernacle for its display. Most likely, this was done after 1261, since the icon had been removed from the monastery by the Venetians during the period of Frankish rule of Constantinople from 1204 to 1261 and had been sent to a (temporary) home in the Pantocrator monastery.[30] After 1261, it went back to the Hodigitria monastery, and it is then that we have the clearest clues about its functions and use within the processes of faith-healing. This information comes from pictures and texts. Most striking is the miniature (in the Hamilton Psalter now in Berlin; illus. 9) which shows the Hodigitria icon venerated by the faithful. Tempting though it is to use this miniature as a description of the actual setting of the icon, it was itself presumably made around 1300 (and added to the manuscript) as a special picture for private devotional purposes. Without forgetting that it is a representation designed for prayer and contemplation, it can be used with care as descriptive evidence of the importance of the cult of the Hodigitria.

If read as a piece of realism, the miniature implies that the Hodigitria icon was kept inside a tabernacle (in the shape of a *ciborion*) and behind a grill; lamps hang on each side of it, and the panel itself is draped with a textile cover drawn back to display the image – modern processional icons are similarly draped with a *peplos*.[31] On the wooden stand below the icon is a smaller panel, most probably a small replica of the icon, a duplicate which would have been both easily accessible for the faithful to kiss and distanced from them.[32] Above the ciborion, we see a representation of Christ, symbolically present to receive prayers, in this case presumably from those figures (inside and outside the grill) who are venerating the image. A man and a woman kneel in front of the grill; the other five figures seem to be inside the holy enclosure. The background figures are sometimes identified as the children of the married couple in the foreground, but an alternative proposal is that they are members of the religious community which kept the icon. We can clearly see that the icon on the stand represents the Hodigitria Virgin and Child with angels; it is the same iconography as our icon in illustration 8.

The Hodigitria icon was perhaps the most prominent cult object in Byzantium and constantly reappeared over the centuries in Byzantine history and faith after its initial

appearance in the eighth century.[33] Just one of these appearances was its display at a turning point in Byzantine history, as a focus of popular and imperial worship in 1261. The Hodigitria icon was carried at the head of the procession to mark the re-entry of Byzantine power into Constantinople after the period of Frankish rule following the attack of the Fourth Crusade on Constantinople in 1204 – the emperor of the time gave precedence to the age-old icon (illus. 16 shows John I Tzimiskes [969–76] entering Constantinople in triumphal procession behind an icon of the Panagia that he had captured in a victorious campaign against the Bulgarians). After 1261, when the icon returned to the Hodigitria monastery, the evidence of the Hamilton Psalter picture is that it displayed on a special stand. From there it could be lifted up and carried in procession both in the monastery and outside. The highlight of the cult of the icon was its regular display in public, and this weekly event is described by a number of spectators. This ceremonial was so famous that not only did foreign visitors to Constantinople go specially to see it, but in a monastery near Arta in north-western Greece a fresco was made around 1300 of this weekly procession (in the narthex of the Vlachernae church; illus. 15). An inscription on it read: 'Celebration of the Virgin of the Hodigitria in Constantinople'; the icon and its powers of healing were known far beyond the walls of Constantinople.[34] Its fame no doubt accounts for the final fate of the Hodigitria icon. It was cut up into four pieces when the city fell in 1453. Any artist who represented the Hodigitria after that date no doubt was well aware that the original was no longer in existence.[35]

The combination of pictorial evidence and several spectators' accounts provides a good sense of how this Byzantine icon operated. The spectacular communal worship of it offers many insights. The fullest description is that of the Spanish traveller Pero Tafur of 1437, who tells us: 'Every Tuesday twenty men come to the church of Maria Hodigitria; they wear long red linen garments, covering up their heads like stalking clothes.' In this account the great weight of the icon is emphasised and becomes part of the lore of the display:

> There is a great procession and the men clad in red go one by one to the icon; the one with whom the icon is pleased is able to take it up easily as if it weighed almost nothing. He

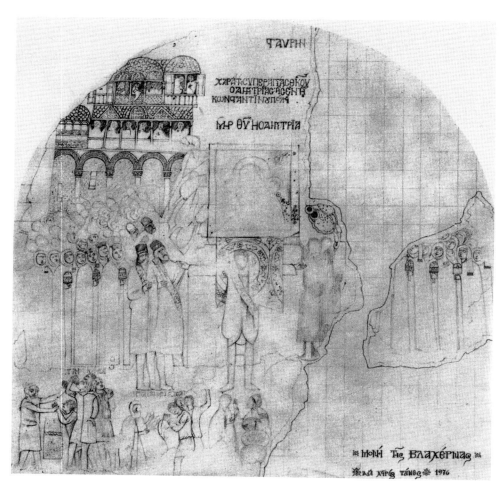

15 The display of
the *Hodigitria* icon
in Constantinople,
13th century; copy
of a wall painting
in the Church of
Vlachernae, near
Arta, Greece.

16 The Emperor
John I Tzimiskes
entering Constan-
tinople, 12th
century, from a
manuscript of the
History of Sky-
litzes.

places it on his shoulder and they go chanting out of the
church to a great square where the bearer of the icon walks
with it from one side to the other, going fifty times around
the square. When he sets it down, then others take it round
the square in turn.[36]

The Arta painting (illus. 15) shows the icon with its peplos, the
men in red (perhaps they were members of a lay confraternity
rather than monks), the clergy in white, and the great
gathering of men and women in the public square.

In another account (this time by Clavijo, the Spanish
Ambassador), the man carrying the icon staggers around
under its weight, and the lucky ones among the onlookers are
those towards whom he lurches, forced spontaneously to do
this by the weight and will of the icon.[37] This movement is
interpreted as a sign of the favour of the Virgin. In the
accounts of Russian pilgrims who travelled to Constantinople,
there are various miracles recorded through the agency of the
icon – miraculous healings of the blind and of women
possessed by the Devil.[38] Pero Tafur adds: 'There is a
market in the square on that day and a great crowd always
assembles; the clergy have pieces of "cotton-wool" and touch
the picture and distribute the pieces among the people. Finally
the icon is taken back to its place in the church in procession.'
The Arta painting shows the bustle of market stalls selling
food and provisions in the public square – the texts on the
picture record *phokadia* (pots and drink), *lachana* (vegetables),
and *oporika* (drinks). The sacred mingling with the profane –
the accessibility of the powers within the icon – was among
the complex evocations of the weekly ceremony.

All this sensational celebration of the Hodigitria icon
depended on its legendary status and origin. To the laity, an
actual work by St Luke may have seemed as impressive as, if
not more impressive than, a copy of the Gospels; that too was
a familiar spectacle as a processional object, carried around
the church every time the liturgy was celebrated. The
Hodigitria icon was a direct witness of the time of Christ,
and like Christ the icon had healing powers; furthermore, it
reposed in Constantinople, enhancing the status of a 'sacred'
city. There were other images and fabulous relics in the
imperial palace, but they were much less accessible to the
people than this icon. Even though the great church of St

Sophia became a kind of museum of sacred treasures and relics in addition to its function as a place of worship, as the home of the patriarch it was in the control of the secular clergy while the Hodigitria icon was in the custody of monks. The icon's public accessibility and devotional location in a monastery may have helped its popularity. Few other sites in Constantinople could conjure up the awe of the Hodigitria icon, and it was all the more impressive by its familiarity. It was an object so much copied that you *knew* it before you ever saw the original. It is not so difficult to imagine the intense feelings of the faithful who went to see the icon and in confronting the familiar imagery saw the moment of the greatest religious paradox of Christianity – Christ in the form of a human child and his Mother, recorded during his lifetime.

The fourteenth-century representation of the Hodigitria icon on the British Museum Triumph of Orthodoxy icon has already been mentioned briefly, but its resonances can now be further recognised (illus. 11). Most likely, it was made for special display during the annual commemoration of the ending of Byzantine iconoclasm. The first celebration was in 843, and the feast was probably commemorated every year thereafter on the first Sunday in Lent. We have seen that the Hodigitria panel occupies the centre of the upper register of the icon, where it is set on a draped stand between two winged custodians (see illus. 12). This is the main icon shown in the panel, but not the only icon included; there are also two smaller portable icons, both of Christ, which are held in the hands of the iconophiles in the lower part of the composition. These figures rank below those in the top register, where we see at the top left the empress Theodora, who as regent for her young son Michael III was on the throne in 843 at the time of the declaration that icons were essential to the Orthodox faith. On the right side of the icon at the head of a group of churchmen is the patriarch Methodios, who was in office in 843 (he was famous as someone tortured by the iconoclasts, who broke his jaw). In the register below are the other iconophile saints, and it is here that we find the two small icons of Christ; on the left is St Theodosia with her icon, and in the centre a circular icon of Christ is held by a pair of monastic saints (illus. 13).

It is interesting that the feast of Orthodoxy, as portrayed in

art, promotes the Hodigitria icon. This must have been due to its spiritual significance rather than to its powers of healing. The icon represents a pictorial definition of Orthodoxy through the representation of portraits of the theologians and martyrs who established it. The inclusion of the icon painted by St Luke is part of their theological case: St Luke painted figurative icons, and this fact is the subject of another figurative icon. The other icons represented on the panel are there for a reason, too. We know that the icon held by St Theodosia of Constantinople is to be read as the image of Christ from the Chalke Gate of the Imperial Palace, which was smashed by the iconoclasts at the outbreak of the heresy in 730. The iconophile story is that Theodosia was one of the martyrs who died trying to save the image. Unlike the icon of the Hodigitria in the upper register, the Chalke image did not survive iconoclasm, although it was replaced with a 'copy' during the reign of Theodora.

The Hodigitria icon and its many copies and versions are key witnesses to the working of images in Byzantium. It is highlighted here for introducing a vital Byzantine example of how a religion can implicate material objects in the presentation and validation of its central mysteries. The icon clearly cries out to be treated as a powerful religious object, made more complex by its aesthetic qualities.[39] The value of icons lies in their apparent 'clarity', which gave them a key role in the process of making Christian paradox and mystery appear to lie in the sphere of reason and intelligibility. A miraculous icon like that of the Hodigitria, on the surface an image so direct and clear, turns out to carry along with it some of the most complex elements of Christianity: the observed *fact* of the Incarnation, the present witness of a past moment captured in art, and the power of God to bring about miracles through mediation. These Christian convictions are just a few which can be contained within a single image, one which could in this case be infinitely replicated, circulated around the Byzantine world, and witnessed. It is therefore no exaggeration to say that any icon which we would group as a member of the Hodigitria series typifies quite explicitly the powers of the Byzantine icon: it works as religious symbolism; it gives aesthetic pleasure; it is seen to operate miracles of healing.

The Hodigitria image from the church of Méronas is one

such icon which is attributed to around 1400 (illus. 8). It belongs then to that mythological history of icons that depends on the idea of the charismatic personality of the evangelist St Luke, which, it has been suggested, was an invented idea of the iconophiles during iconoclasm to find support for their case for the production of icons. Through Byzantine eyes, the Méronas icon would have been understood as a copy of that archetypal image. This helps us to see how there might be a Byzantine way and a different 'modern' way of viewing the icon. If we want to look back from the late Byzantine period and track how the icon gained this charismatic status, we need to look at the 'birth of the icon'.

The modern debate about the 'formation of Christian art' has embraced the fact that, although there is evidence and agreement that Christians were producing art by the third century, we have difficulty in recognising anything as Christian art before then.[40] It is equally difficult, and perhaps fruitless, to speak of the 'invention' of the *icon*. Debate also continues on the question whether the early Christian mentality was in favour of or opposed to the use of art in the church, the difficulty here being to balance the theoretical positions – represented by early Christian texts, which are often by theologians and often prescriptive – and the extent of the production of art, for which the evidence consists of both texts and surviving works of art. Christian art was certainly produced, but was this with the support of the whole church, or was it the piecemeal interest of some churchmen and some laity? We know with hindsight that the extent of production of Byzantine art was phenomenal. We also know that there was to be the violent episode of Byzantine iconoclasm in the eighth and ninth centuries and the attempt then (and later in the European Reformation) to ban images outright. This raises the question whether opposition to the icon was a chronic concern among some Christians and never far from the surface, or whether iconoclasm was an acute and isolated crisis, bound up with all sorts of other historical circumstances, and perhaps the politicisation of a religious situation.

The emergence of Christian art is a historical fact, even if it was not an inevitability. Although no one believes any longer that Christian art began in the catacombs around Rome in the third century, those funerary paintings offer a considerable repertory and perhaps the best idea of the nature of the first

Christian art. One sees that this Christian art is not visually much different from contemporary Roman art – on the contrary, it uses the same forms and visual devices. What is different about Christian art is its development of Biblical subjects and its translations of the classical mythological repertory into new meanings. Consequently, the discussion about early Christian art has been one about the ways in which art can change its meanings more easily than its forms. Gradually, the subjects and styles of Christian art did become increasingly different from Late Antique art; one clear case of the distinctively Christian mode of thinking about society and its ethical values can be said to account for the increasing imagery of the Virgin and saints.[41] The formation of Christian art, then, involved many media and regions; it will be an advantage to look at the origin of the icon, defined as painting on a panel, to sift out a number of stages.

A small number of painted panels of various types have been identified from the Roman world, including a third-century tondo with imperial portraits painted in tempera and a triptych with images of the Palmyrene gods in the Staatliche Museen, Berlin, and two tempera panels in the J. Paul Getty Museum, Malibu, with Serapis and Isis (illus. 17).[42] These are sufficient examples to make it clear that in developing art in the service of the new faith, Christians had in their sights an effective medium already in religious use. When we look at the empirical evidence for the first icons (much of which comes from the large collection of panels now in the monastery of St Catherine's on Sinai), it transpires that there

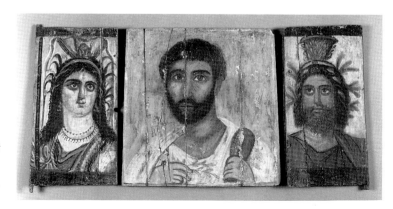

17 *Mummy Portrait of a Bearded Man, Serapis, and Isis,* 3rd century pagan triptych.

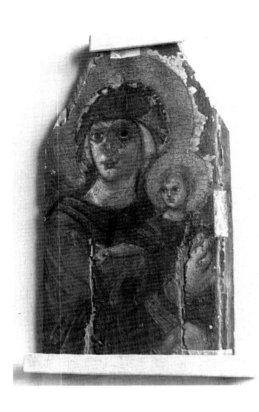

is a continuation of the same techniques and forms – the use of wax or tempera as a medium, with a base of gesso on a textile over the wood, and the employment of single panels, diptychs, and triptychs (illus. 2, 14, 50, 54).[43] The study of the early icons of Sinai has shown a familiarity with the technical and carpentry skills needed to ensure the long-lasting life span of the icons. Several of these early objects, like the icon of Christ and the Mary and Christ icon (previously at Sinai and now in the Museum of Eastern and Western Art, Kiev), had reached a venerable age by the thirteenth century and were renovated for further use around that time, perhaps because of their phenomenal antiquity (illus. 18). It has been suggested that the carpentry of the original frames of some of them had grooves intended to fit a protective sliding wooden lid – they were, in other words, genuinely 'portable' icons for use in travel. This is however only a deduction made from limited evidence, and it needs to be treated with caution.

If what happened in practical terms was that the earliest Christian icon painters carried on the workshop routines of Antiquity, a glance at their predecessors and 'masters' must broaden our frame of reference, since some at least of their workshop practices might have continued. The common view is that it is quite probably fortuitous that Mount Sinai, the site of so much pilgrimage and monastic habitation and the repository of so many icons (illus. 14), is so close to the area from which we have, thanks to archaeological discoveries, the greatest number of painted panels from Antiquity – the region of Fayyum in Egypt. Clearly, Egypt was not the exclusive place of manufacture of painted panels in Antiquity, but the abundant materials from the desert probably offer the best insight into the parallel features of Antique panels and early Christian icons. As a repertory of information about tech-niques of production of panel painting, the several hundred mummy portraits from the Fayyum region offer the best insights (illus. 20).[44]

The majority of these Fayyum portraits were dug out from cemeteries in 1887 (about three hundred of them were acquired by the Austrian dealer Theodor Graf) or more carefully and systematically excavated from Hawara, the Roman cemetery of Antinoe (Crocodilopolis), in two seasons in 1888 and 1911 by the British archaeologist W. M. Flinders Petrie (who recorded 146 portraits, but suspected that the site had been looted between his two permitted seasons). Flinders Petrie's findings were well published and submitted to careful study on the basis of his observations as they were excavated. He believed that the purpose of the panel paintings was to act as portraits and to be placed over the faces of dead Romans who had been mummified according to current Egyptian practices. The portraits were dated primarily on the basis of hairstyles and jewelry, and the conclusion was that the paintings dated between the first and fourth centuries. The end of the series came, he thought, when the practice of mummification was abandoned and replaced by simple interment, perhaps a change encouraged by the spread of Christianity. Recent study has submitted these dates to some refinement, arguing that production began in the late first century and ended by the middle of the third.

Flinders Petrie was an elegant and persuasive writer, whose conclusions moulded the subsequent interpretation of the

Fayyum portraits. They still stand out for their freshness and clarity, but the evidence for his conclusions was often slender. His excavations uncovered large numbers of mummies in the cemetery, and something like one in every hundred had a painted portrait. Generally (but not in every case), the mummies with portraits were buried in plain ground without markers. Their state was such that Flinders Petrie deduced that they had stood elsewhere for some considerable time before burial; some were damaged in these locations, and that was taken to account for signs of maintenance and repair. He identified evidence of mummies exposed to rain and of portraits scratched or damaged by blows and one which was patched up; on some, bits of the gilt cartonnage was broken or lost, and one mummy had a nose which had been knocked off and replaced with plaster. Flinders Petrie reckoned that what had happened to Fayyum mummies was that groups of them had been collected piecemeal from time to time and buried together in a pit. Before their burial, the mummies had stood in the atria of Egyptian houses; after a generation or two of display, they were collected for mass burial in a common grave, with expensive and rough mummies all mixed up together. The implication is that the cemetery reflected the particular pattern of Roman aristocratic burial customs that developed when the Romans had control of Egypt: the use of mummies replaced Italian procedures of ancestor 'worship' in the home, but each generation replaced and updated its ancestors. This remains a persuasive interpretation of the evidence.

As for the portraits, the basic questions have also been discussed in terms of archaeological deduction. Here, Flinders Petrie and his collaborators were less unanimous. The contentious issue is whether these portraits were made before death, perhaps years before death in the flower of youth, or whether they were made as a record immediately after death. This debate depends on the archaeological interpretation of the procedures observed in the fixing of the panels to the mummies. They were certainly sometimes cut down. Does this mean that they were made years before the mummies and then adapted, thus supporting the theory that the panels were made for a picture display, or was the manufacture of panels and their rough fixing onto mummies all part of the same complicated operation? Flinders Petrie

himself decided that the panel paintings were made from the life and displayed in the house until the time of death, when the images were taken down and fixed to the mummies. Since the publication of the Fayyum materials, the theory which has been widely accepted is that the painted panels went through three stages: portraits in the house; portraits on the mummies displayed in the house; and final unceremonious burial when they became redundant.

This theory has considerable repercussions for the inter-pretation of the character and style of the portraits. Many have been tempted to treat the Fayyum portraits as simply that – portraits of the multicultural inhabitants of Egypt in the Roman imperial period, the ancestors of people one might still meet there. Art-historically, the Fayyum images differ from the 'veristic' sculptures of Late Republican Rome, for unlike those images, the Fayyum portraits show few of their 'sitters' in old age or 'with warts and all'; many are seen to be youthful, beautiful people. While there may be a temptation to call both types of portraiture 'realistic', the existence of the different stylistic categories is an obvious warning against the interpretation of realism, especially if it implies that Romans in Italy in the Republic lived to an older age and status than the ruling classes of Egypt under the empire.[45] The comparison points to differing artistic and patronal taste and is a warning against assuming that the Fayyum portraits owe less to artistic stereotypes than to the personal features of the model.

Because the Fayyum portraits come from actual mummies, one might see the whole production of paintings in the region as an enterprise in funerary art, although this may be a distortion of the real extent of art in the Roman period. This is where the evidence of one panel becomes particularly important. This is a painted panel, now in the British Museum, which was unusually found not attached to a mummy, but framed in a wooden casing (illus. 19). Flinders Petrie found this panel at Hawara in the season of 1888 and described it carefully as a portrait in a picture frame.[46] The frame is of painted brown wood, rectangular in form, slightly higher than wide. The inner sides of the frame contained two grooves; the back groove held the flat border around the painting, and the front groove was, as Flinders Petrie argued, meant to hold a glass cover. He thought that if the cover had

been of wood, it would have survived with the picture; the absence of a cover suggested that it was originally clear glass and that it had been broken and lost in Antiquity. There is even a cord surviving at the top of the frame, indicating that it once hung on a wall. The painting itself (an encaustic work) is poorly preserved. It was found in the cemetery lying on its edge, with its face turned towards and against a mummy in a grave.

The interpretation of this find is important. For Flinders Petrie, it proved that the mummy portraits went through an initial public stage of display. But there is an alternative deduction, that these were framed pictures in houses, and that the British Museum painting was never destined to be a mummy portrait; it is not necessarily funerary art. The difficulty is that it *was* found in a grave, but since it was not used on a mummy, that could mean that it was buried there for some other reason. Undoubtedly, the portrait was for a time framed and hung on a wall. Thus, it does document framed pictures on the walls of buildings in Egypt.

The evidence from Fayyum is obviously crucial for illuminating the uses of painted panels in the international world of Late Antiquity in which the character of the early

Christian icon was decided, but the evidence is visual and as such can be ambivalent. It seems to support the idea that Egypt followed Roman households in Italy in taking care to preserve the memory of ancestors through the preservation of funerary orations and ancestral masks.[47] This makes the argument that Egyptian practices were a modification or development of Italian rites among the immigrant Roman population reasonable enough. But the social history of Egypt had very different traditions from Rome, and in that cosmopolitan world the nature of the interactions between the Roman ruling class and native Hellenised aristocracy in the shadows of Alexandria would have been quite special. This complex social and racial world has been seen by some reflected in the facial features of the Fayyum images. The decision to use painted panels in the mummies of the Roman period at Fayyum may have several sources, but it depended on one special and unique feature, the Egyptian expertise in the mummification of corpses. In front of one of these mummies – for example, the early second-century case of Artemidorus (illus. 20) – it is difficult not to feel that we have entered the world of the portrait 'icon'. The mummy of Artemidorus was found in a brick-lined chamber with two other mummies rather than in a mass burial. This chamber was surely a family vault: the other mummies were of another Artemidorus and a woman named Thermoutharin. It seems that the first Artemidorus died of a fractured skull at around the age of twenty.[48]

The portrait of Artemidorus is still attached to his mummy; it is on a thin wooden panel (probably of cypress wood imported from Syria). The gaunt face with fleshy lips and large eyes is painted in encaustic (with wax as a medium to bind the pigments), and a bright gold wreath around the hair glistens like the Egyptian divinities on the case. Another gold ornament frames the painted face, by pure chance with a cross shape at the top. The two gold hawks' heads at the end of the necklace are a traditional Pharaonic decoration, and the religious symbolism of the case is traditional Egyptian. Fayyum painters used encaustic or egg tempera, and while sometimes the impasto appearance of the encaustic paintings makes it easy to identify the technique, it is not always possible to decide instantly which medium was employed. The study of Byzantine icons has shown that in the early

20 Mummy portrait of Artemidorus, *c.* 100 AD.

period, encaustic was still used. The technique, described by Pliny, lasted into the Middle Ages, becoming a specialist technique useful in special circumstances – it was convenient, for example, when marble was to be painted. Although early Christian icons exploited encaustic, the normal medium of the icon from the eighth century was egg tempera, which predominated throughout the Byzantine period and afterwards.

Egypt gives us a major insight into a tradition of recording faces and respecting the dead, but there seems to be a chronological gap between the evidence from Fayyum and the birth of the icon. The link is the Roman expectation of portraiture. Romans all over the empire were totally familiar with an environment of portrait art, with sculptures in the street and the cemetery and portraiture in private and public. Early Byzantine holy men from St Antony of Egypt onwards expected records to be made of them, however much the language of humility interfered with the arrangements for the icon to be made. So at least by 400, Christians were familiar with an environment of portraits of saints and of Mary, both in churches and in other structures built for the commemoration of saints and the holy places visited by Christ – the so-called *martyria*. Within the community of the church, these portraits represented ancestors. Living Christians were able through icons to share their worship and devotions with the dead in Paradise, and to use the images (or those saints who might be felt to 'inhabit' them) as vehicles for the mediation of their prayers upwards towards God.[49]

The understanding of icons as a way of reaching out to the heroes of the faith in the 'other' world might seem tantamount to a cult of the dead, but Christian thought about time, eternity, and everlasting life makes this too simple a characterisation of the icon and its status.[50] The comparison between the display of the mummy portrait for the commemoration of ancestors and the portrait icon in the church shows that Byzantine society did not have to invent the icon; instead, an artistic form which was already in existence was extended beyond the family to the community (illus. 50). The icon supplied the whole congregation of Byzantine Christians with the real presence of a heavenly family inherited in common.

To see connections between Roman Egypt and East Roman Christianity through art would account for a fraction of the circumstances in the birth of the icon, leading to its full symbolic and spiritual powers. The world in which the early Christian icon emerged was that of the culturally diffuse Greco-Roman empire. The church and its communities had many pasts, not just one. Above all, the Jewish experience had to be incorporated into classical thinking, just as Christians had to assimilate the Old Testament into their history. A letter

of Jerome (c. 342–420) helps us to visualise the impact of an early Christian shrine in the Holy Land on a visitor from the west, in this case the Roman pilgrim Paula visiting the tombs of the prophets. This may be a literary piece, but the writer wanted to convey the power of the emotional experience:

> She shuddered at the sight of so many marvellous happenings. For there she was met by the noise of demons roaring in various torments, and, before the tombs of the saints, she saw men howling like wolves, barking like dogs, roaring like lions, hissing like snakes, bellowing like bulls; some twisted their heads to touch the earth by arching their bodies backwards; women hung upside-down in mid-air, yet their skirts did not fall down over their heads.[51]

Studies of Late Antiquity have illuminated with great care the precise stages through which the institutions of the church were built up in the first centuries of Christianity. The evidence for tracking the stages of the icon is too sparse to be so discriminating, as the first surviving pieces belong to the sixth century and come mostly from the monastery of St Catherine's on Sinai. One icon, however, the sixth-century icon of St Mark the Evangelist (identified in Coptic), is said to have been found in Fayyum (illus. 21).[52] Evocative also is a Byzantine manuscript of the ninth century that records the early use of icons by Christians and speaks of the purposes of saints' portraits (illus. 22 is fol. 328v of the manuscript known as the *Sacra Parallela* in Paris). One of its pages shows an icon painter at work, engaged in the process of reproducing another icon. The picture shows the painting of a portrait icon not from the life, but through the copying of a model. This illustration refers to a text written beside it: 'As painters when they paint icons from icons, looking closely at the model, are eager to transfer the character of the model to their own work, so he who strives to perfect himself in all branches of virtue must look to the lives of saints as if to moving and living images and make their virtue his own by imitation.' The verbal message is that the imitation of role models among the saints is the key to living the most virtuous Christian life. This is one of thousands of uplifting quotations collected in this manuscript of the *Sacra Parallela*, an anthology assembled in the eighth century from dozens of sources. This kind of

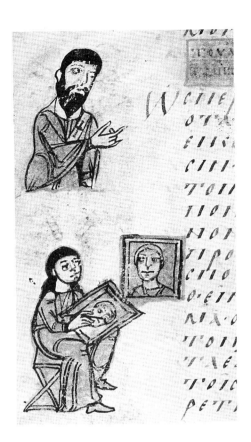

21 *St Mark*, 6th
century, icon.

22 *Artist Painting an
Icon*, from a 9th-
century manuscript of
the *Sacra Parallela*.

encyclopaedic compendium was popular in ecclesiastical
circles in Byzantium. The interest of the text just quoted is
that it is not from eighth-century Byzantium but is much
earlier, coming from the writings of the fourth-century Father
of the Church St Basil. Therefore, it is a very early mark of the
importance of icons in the Byzantine church. The repetition of
a fourth-century text in an eighth-century anthology, and the
highlighting of its message with an illustration in a ninth-
century manuscript, not only inform us that the production of
icons was taken as commonplace already in the fourth century
but also let us know that in Byzantine art, literature, and life,
the expressed convention was the imitation of role models.

Although art history has taken a cautious line on the
significance of the Fayyum material for the icon, this was not
the immediate reaction when mummy portraits surfaced in
the late nineteenth century. In London, an exhibition at the
Egyptian Hall in Piccadilly immediately following Flinders

Petrie's 1888 season had a great public impact. The portraits' scholarly impact was less direct. In England, although the National Gallery was presented with the majority of the portrait panels which were allowed to come to London by the Egyptian authorities, this collection, except for three, was moved on to permanent loan to the British Museum in 1936, and the remaining three feature in a minimal way in the Gallery catalogue.[53] They moved, so to speak, from the domain of art history to that of archaeology, and this may explain a little their (past) marginality in scholarship. The icon is similarly emerging from the wings and moving onto centre stage after years of treatment as almost an epilogue in the history of Byzantine art. A century ago, when the Fayyum icons were first seen in numbers, the predominant interest in Byzantine art was manuscript illumination (many illuminations were conveniently found in western European libraries).[54] My own experience as a student at London in the 1960s was to be told that there were classes on manuscripts; the rest of Byzantine art was a subject for self-exploration. Manuscripts were seen to offer the best art-historical framework of the field (often they were dated and supplied with precise information about the patron and artist). Indeed, their study had been promoted since 1876, when the Russian art historian Kondakov brought out the Russian edition of *Byzantine Art, Studied Chiefly Through the Evidence of Manuscripts*, translated and republished in 1886. This book stimulated descriptions of Kondakov as 'the real founder of Byzantine art history'. Among the output of Byzantine artists, the illustrated manuscript appears in fact to be one of the rarer forms. Byzantine libraries were very small indeed – to have as many as thirty books in a Byzantine monastery library appears to have been exceptional, and of these only one or two would have been illustrated. The luxury book was the preserve of the rich élite, notably the emperor or the court, and is hardly likely to represent the visual experience of society as a whole.

Side by side with the study of manuscripts was the growing attention given to church monumental art. Considerable energy in fieldwork, helped by the collapse of the Ottoman empire in the early twentieth century, resulted in major discoveries of new material. Russian, French, German, and British fieldworkers ranged widely, and a new phase was

inaugurated when Thomas Whittemore got permission in the 1930s to uncover the mosaics of St Sophia. The media of church mosaic and fresco emerged as the new channel through which to enter the culture. On the whole, the icon remained neglected. It was as if it was assumed that the *interesting* period of Byzantine art history began with Justinian in the sixth century and ended with the sack of Constantinople by the Crusaders in 1204. The mosaics of St Sophia or, more recently, the newly cleaned wall-paintings of Cyprus, for example, were felt to embody the public art of Byzantium and to represent the culture at its best. Icons in comparison were known mostly from late Byzantine art, from a period of decline, or else were felt to belong to the different history of Orthodox Russia or the local art history of Greece after the fall of Constantinople to the Ottomans in 1453. This outlook has been changed by recent discoveries. Not only is it clear that the icon was a form of art produced over the whole period; it may be regarded as the one medium to which the mass of the population had direct access.

Recognising the importance of the icon is only a step towards realising how far this evidence may lead to a rewriting of Byzantine art history.[55] If all members of society were viewers and users of icons, both in public and in private, and if the icon was available to the widest spectrum of patronage, the icon must be seen as a key element in the culture. Anyone in Byzantium could enter a church and find themselves in the presence of an array of icons. Some were familiar from repeated visits and had perhaps been the subject of veneration for more than a thousand years already, thus becoming saturated with associations and perhaps miraculous powers; others might be new commissions and unfamiliar, possibly even disturbing to the viewer through their unfamiliarity. Since Byzantine icons therefore constituted a continually accumulating resource, they offer at any point in time a complex arena of viewing. The transition into this area from the open street of a Byzantine city as one went into the interior of a Byzantine church was interpreted by Byzantine theological commentaries as the entry into 'heaven on earth'. Since a common element in Byzantine icons of all periods was a stylistic concern which in various ways denoted the 'timeless' nature of their Christian content, their ubiquitous presence would have helped to suggest

that the church interior too existed outside normal cosmic time.

While the individual icon can be studied as a unique production, the existence of ensembles in the church is a reminder of a key feature of Byzantine art history: if the common viewing activity in Byzantium was of clusters of works of art from several different periods experienced simultaneously, then our art history needs to take this into account. It affects our reliance on the chronological sequences of objects. A continual interaction in Byzantium between the contemporary icon and ancient and venerated icons may undermine our sequential divisions; it certainly makes the notions of periods of revival or renaissance seem even more specious. The notion of renaissance as a special moment would be difficult to apply to the continual reproduction of copies of the Hodigitria icon over the centuries, unless clear distinctions could be made between ways of returning to the past. This is again a problem of balancing the sources of style against the theological influences on art. The system of Orthodoxy based its truths and standards on the events of Christian history, part of God's plan; Byzantium had a place in the world order for historical reasons, not by chance. Icons could express this thinking through the representation of Christian events and participants. At the same time, we have seen that they did need to be aesthetically satisfying. This adds up to a form of art in Byzantium which we recognise as reliant on repetition and tradition, just as the image of the Orthodox church rested on its maintenance of eternal, unchanging truths.

From its birth in the fourth century (or before), the icon exemplified the nature of Byzantine religious art. We must accept that as we view icons we are influenced by their styles and tend to judge their success in aesthetic terms – and justify looking at them because of their 'quality'. This element of subjectivity has not greatly favoured the Byzantine icon or, at least, what was known of it. Icons have been consistently eclipsed in public esteem by Italian Renaissance panels or French Impressionist canvases, a judgement confirmed by market forces. This may change. We may wonder if Duccio will always eclipse the Cretan painter named Angelos (compare illus. 23 and 51). It may be true that Duccio's compositional perspective is the more familiar and that the constructions of Byzantine and Early Medieval art shock our

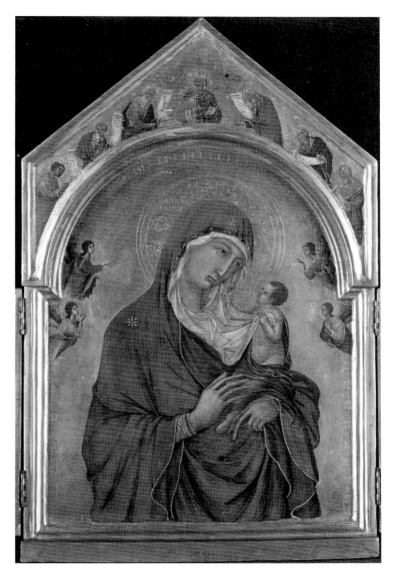

habits of seeing; but do we really interpret what we see in the manner of illustration 24?

The evidence shows that the icon was part of Byzantine art production from the beginning, even if not as early as the times of the evangelist St Luke. If we are going to use the term to describe objects from over a thousand years of production, its usage needs a little further attention. When the inhabitants of Medieval Constantinople and its empire used the Greek

24 'It's the way they draw these wretched tables', cartoon by 'Harvey'.

word *eikon*, they may simply have meant an image in any medium, as they had other words at hand if they wanted to describe a panel. This suggests that *eikon* in Greek texts may have a broad set of meanings and will need more than one translation into English. One common rendering is 'likeness' as a translation of the word *eikon* in the Greek text of the Bible (the Septuagint). Modern English usage of the word *icon* is seldom purely descriptive; it means most often a pictorial image in which we see the concentrated quintessence of some thing or person. A search for other definitions will soon produce many. For example, an icon is an image which 'achieves compelling prominence through frequent repetition'; 'it encapsulates ideas and actions of central importance in human life.'[56] If the birth of the icon is connected, however loosely, with the tradition of the Fayyum mummy portraits, we might favour the rendering of *eikon* as a portrait picture and then see the development of the medium as one which encouraged different meanings.

The art-historical usage of *icon* is operational: an icon is a painted panel of the Orthodox Christian world, showing any Christian figure or scene. This is a limited definition, and it leaves open all those sorts of evocations for European culture, especially after the iconoclasts in the eighth and ninth centuries failed to stop the practice of painted icons, and the medium thereafter came to denote and characterise eastern Christianity in schism with the west. It has been said (with

increasing frequency) that Byzantine icons are 'theology in colour'. But for the nineteenth-century rationalist and Protestant Christian, the respect given to icons in the Orthodox churches represented little more than idolatry and superstition. Such practices as the kissing of icons looked like the worship of idols instead of the veneration of the unseen Christ and could be deplored with the same vehemence as that of the original Byzantine iconoclasts – who could be saluted (entirely anachronistically, of course) as the true rationalists in a superstitious world.[57] This Enlightenment rhetoric discouraged deeper questions about how religious art actually operated in any society. The icon in Byzantium offers a perfect case study which allows us to investigate just this.

There is more to be gained now from returning to the Méronas icon of the Hodigitria (illus. 8). For us, identification of the figures, helped by reading the short texts written beside them and on the icon, is an essential element in the viewing process, for meaning would be too general without knowledge of the figures and their connotations. The Medieval viewer too must have gone through the process of identifying the holy figures in the icon, and equally the inscriptions must have had a function in their understanding of the religious and theological nuances of this image. By the time the Méronas icon was made, many images of Mary, although they were of the Hodigitria type, had also been given additional appellations which sometimes identified the place or the dedication of the church in which they were kept and sometimes added special meanings for the patrons.[58] One fifteenth-century icon from Crete, for example, shows Mary and the Christ Child embracing – the type often categorised as the Glycophilousa or Eleousa (see illus. 51). This icon has the title *Kardiotissa* emblazoned on it, and clearly this would have added much to the evocations of the basic iconography. Perhaps it merely indicates a connection with one of the monasteries on Crete dedicated to the Panagia Kardiotissa, but maybe there is more to it than that – with the reference to the 'heart' (*kardiá*), it may have had more spiritual overtones.

Our contention is that however simple and direct the composition of the icon was, Byzantine responses were psychologically complex, and partly intellectual and partly emotional. The Méronas Panagia icon inherently contains in its composition a number of Christian truths, but many of its

viewers will have been moved in front of it less by its didactic components and more by emotion. The viewer may have come to the icon for help in trouble and in prayer may have been less concerned with Christian theology than with the hope of favour or salvation. The viewer would have known that a Hodigitria icon ensured that one was looking into the actual face of Mary as recorded by St Luke; this may have seemed less a theological nuance than a possible guarantee of the efficacy of prayer and hope of mediation. The particular value of the Méronas image is that all this emotion on the part of the Orthodox viewer can be clearly detected in the physical history of the icon. The 'deterioration' in the lower part represents the tears and hopes of the Medieval viewer. As we have seen, at the moment of *proskinima,* this icon was illuminated by the lighting of a smoky candle in front of it, and it was touched and kissed and the surface worn away and darkened by smoke. Furthermore, the front of the icon was over the years also 'damaged' by the fixing of the offering of a *tama* (see illus. 2 for this practice on a thirteenth-century icon from the collection at Sinai). We see the signs that many plaques, representing a person or part of the body, were once fixed to the lower section of the icon. Thus, the meanings and functions of an icon go far beyond the reading of the iconography. Looking at the Méronas icon can lead us as directly as is conceivable into the imaginations and memories of Medieval viewers.

The regular art-historical classification of an image as either 'narrative' or 'abstract' becomes more and more evasive as one looks into the Méronas icon; it cannot be described happily as either one or the other. Yes, it shows the 'shell' of the figure of Mary, depersonalised and correspondingly accessible to each different viewer. This aspect of accessibility has been seen to encapsulate the 'abstract'.[59] But it is also the case that the imagery must be taken to represent Mary at the very moment when St Luke painted her, and this makes it one moment in a narrative. One argument here is that this does not make this a 'narrative' icon, but rather reflects a 'pre-text' embedded in European Christian culture. Hence the absence of texts on the panel to refer more openly to the Luke story. In the study of the icon, it may be that these 'opposing' terms are superficial and that we need to progress by improving on them. The way to supersede them is through conceptual

discussions of narratology and semiology, which, when applied to the Byzantine icon, indicate how far this dichotomy is limited in interpretative value and is likely to simplify and limit the full spectrum of overlapping meanings and functions. The quotation at the head of this chapter from *Reading 'Rembrandt'* is a pointer to a narratological dimension for the interpretation of icons.[60]

The Méronas icon includes image and text, and these work together in a surprisingly complex way. In the Byzantine period as in any other, the relation between the words and the pictorial image sets up all sorts of permutations of meaning.[61] What is distinctive about Byzantium is the generally limited repertory of portraits and scenes – certainly more limited than the pictorial imagery of western Europe, thus constituting one of the differences between strands of Medieval Christianity. Yet in this Byzantine repertory, any scene may relate to numerous texts, and numerous kinds of texts, to the extent that a major debate in the interpretation of Byzantine art is about whether the references might be to ecclesiastical or political interests – which kind of verbal thinking, in other words, lay behind the conception. The main festival scenes represented on Byzantine icons ultimately depend on Biblical sources, but these may often be so well known and so frequently pictorialised that they are better described as the implicit text. Almost invariably, other texts, such as sermons, commentaries, anthologies, saints' lives, poetry, and so on, will overlay the Biblical source in the deliberations of the producers of the icon. Some of these texts may be topical at the moment of production and more explicitly in the mind of the patron and artist. If the verbal sources of the icon are considered in this way, it helps to expose the dynamic of the imagery and to dispel the prejudicial perception that all icons contain traditional and unchanging imagery – that all icons of the Crucifixion are the same. Beneath the surface of a conventional Biblical scene, we may begin to detect carefully nuanced references in many of the representations, with different emphasis given to the various protagonists or different theological concepts being conveyed about the nature of Christ.[62]

The method of approach that regards the narrative imagery of an icon as a 'shell' which contains all manner of inherent pictorial messages can help to break down the narrative/

abstract dichotomy. This allows one to specify the Biblical texts which acted as the originators of Christian 'mythologies', and to ensure that these are taken into account, rather as Classical Greek tragedy relates to the texts of the myths which acted as the basis for poetic interpretation and reinterpretation. Maybe some Byzantines 'knew the Bible backwards', but recognising the Biblical sources of an icon offers us a starting point in an interpretation and no more. We cannot read a picture without knowing the texts on which its contents depend, but knowing the 'story' is only a start towards understanding how Byzantine icons could, although working through a limited and traditional set of pictorial themes, develop and convey new meanings within the traditionalism of Orthodox Christianity. Our viewing of modern art gives a sort of parallelism when we find it feasible to interpret a specific landscape, for example, as a symbol of something general about our world, or interpret the portrait of a specific, named woman in terms of her significance – say as an early twentieth-century suffragette.[63] A constructive use of this methodology has been developed by Mieke Bal in the context of the political expression of Rembrandt's art.[64] She shows how the overt iconography in his work carries and controls meanings, but a reading of the picture involves interpretation, not simple description. The problem is how to control these verbal readings, which derive from the handling of pictorial elements. In the case of the Byzantine icon, this approach would accept that meanings do not reside in what the narrative text tells us, but in the choice and handling of the story. In the field of overt Christian art, the possible range of meanings may be more controllable, although the danger of this method lies in searching for hidden meanings (or for meanings which elude the simple narrative interpretation) which cannot be checked. In Bal's terms, iconography has a pre-text which is a pretext for conveying meaning; myth is an empty vessel; the meaning is in the transference; 'a myth is a screen for transference.'[65] So we should not expect the innocent description of the iconography of an icon to expose its meanings. The basic story may come from the Bible, but a different message may emerge from the picture – the text is a pre-text for a message.

Instead of returning to the Méronas icon, this methodology can be illustrated with another icon subject which features

Mary. The Annunciation as a subject offers a clear pictorial 'narrative' (illus. 52). This example is a striking icon of the late twelfth century from the monastery of St Catherine's on Sinai which since its publication has often been quoted as one of the best examples of the 'over-expressive' style characteristic of this period (when the figures seem to swirl and move in the picture plane in a totally exaggerated fashion). The icon is well preserved, except that its range of colours has been obscured by a thick layer of yellowing varnish. The icon is a superb technical production and was no doubt intended to occupy a prominent position, most likely as the *proskynesis* icon on the festival of the Annunciation. The chosen figural style does enhance the narrative aspect of the icon by defining the particular moment of the angel's descent from heaven into the presence of Mary, but many details are included which have no mention in the Biblical texts. The story of the Annunciation to Mary is found in the Gospel of St Luke (1:26–38). The key elements in the text are the greeting of Mary by Gabriel at Nazareth; her alarm; the message that she has found favour with God and will conceive a son who is to be called Jesus and who will reign on the throne of David; and her response that she is a virgin. The choice of the scene for the icon certainly indicates an intention to pictorialise the Gospel text and to represent the mystery of the Virgin birth. But the iconography is manipulated to make more than the fundamental theological points. Since the festival day on which such an icon would have been specially displayed in the narthex or nave was 25 March, its lush references to the mating and fertility of the animal kingdom heavily suggest the control of God (and through him the church) over nature, time, and the seasons through the implied linkage of the event and the festival of the Annunciation with fertility and the beginning of spring. This example includes other details which are unusual in icons of this scene, mostly to give great emphasis to nature and gardens. The enclosed garden (*hortus conclusus*) in the building behind Mary is a motif generally interpreted as a symbol of her virginity, although the presence of nesting birds might seem anomalous.[66] The Annunciation marks the moment of the Incarnation, the same mystery shown more symbolically in the Méronas icon. Theologically, this moment marks the replacement of the Old Dispensation with the New Testament, and the choice in this icon of a kind of Paradise

setting suggests a pictorial allusion to a return to the Garden of Eden, overflowing with life, with a new cycle beginning around the figure of Mary. In the garden is flowing water, a 'grace-giving stream' in the language of a Byzantine hymn, inviting the viewer to see Mary as the Fountain of Life.

While the Gospel text supplies the story and the context of this Annunciation icon, that narrative is only a 'shell' in which meanings are developed, altered, and refined. In the pictorialisation of the basic text, we encounter all sorts of additional elements which make a description of this icon's subject as the 'Annunciation' clearly incomplete. The examination of the 'sources' of this icon is necessary, asking for example how much the Gospel text was 'supplemented' in the planning of the icon by other Christian texts (sermons and hymns, for example) and, equally, how far the visual sources can be specified (did the artist somehow know an early Christian 'Nilotic' model for the construction of the teeming river scene?).[67] This icon helps to define methods of approach since it illustrates a common subject, but in an uncommon way. Other details are unusual and so presumably were noticed by the Byzantine viewer (the descent of the Holy Spirit in the form of a dove in an oscillating golden disk towards Mary rather than as a beam of light). Other aspects, such as the fertility imagery, are given particular emphasis. While we can highlight these and discuss their meanings within a religious subject, we do not have any documents about the icon which reveal the exact circumstances of its production or the personalities involved. It is always attributed to Constantinople rather than to Sinai itself (although there is growing evidence of artists having worked there).[68] The position of ignorance on our part is the familiar one in this field, and it limits also a history of viewing. The audience of this icon, whether in a monastery or in the literary circles of Constantinople, must have had a different viewing perspective. The method of Bal is productive in going beyond description, but opens up more questions about the range of discourse and meanings that could be envisaged by its various viewers. What is clear is that icon imagery is not mere illustration of Bible texts.

Compared with the Sinai Annunciation, the pictorial signs of the Méronas icon are more limited and conventional. If the Annunciation icon was specially displayed only once a year in

a church, it would never have become a 'familiar' image to its viewers. It may have been almost shocking in its strident impact. The larger Méronas icon must have remained permanently in some prominent position, the familiar image for its community over many years and for many generations. Indeed, that is what it is today (in a garish blue frame to the right of the entrance doors to the sanctuary: illus. 64). This type of icon may vary the details for particular meanings, but it conveys an impression overall, that of majesty and intensity. The Annunciation icon might engage its viewers in the exploration of many ideas and emotions; the Méronas icon had to hold the full attention of the faithful in their devotions through sadness and joy alike. It too has its theological content, the Incarnation of Christ and his childhood with a mortal mother; we have already noted that this imagery might be taken as a general reference to motherhood and maternal affection within the Christian family. But this would ignore the Gospel text with its clear forebodings about the outcome of Christ's life on earth. We have suggested that for Byzantine viewers the key connotation was the pictorial source of the imagery, painted by the evangelist himself. The Gospels offer the texts about Mary and Jesus; the icon acts as both story and commentary.

Icons of the Virgin and Child like the Méronas icon must have been the most familiar visual experience for the Byzantine viewer. One feels that such icons trained the Byzantine viewer from childhood visits to church into visual and spiritual devotion and meditation. This seems a very 'European' element in the culture. It was in front of a painting of the Virgin and Child – Raphael's Sistine Madonna – that the young Freud observed other viewers in silent meditation and transferred his own thought into the persona of Mary. It initiated him into the experience of art.[69] Perhaps after all the proposed British national curriculum for schools was culturally sound in exposing the infant mind to this experience of art.

The Méronas icon is a stark image, an unlikely candidate to decorate a family home. It parades its remoteness, its hieratic character, however much it is potentially an intimate evocation of a mother and child. It remains now, as in the Middle Ages, an object which is poised symbolically between earth and heaven. Like the Fayyum portraits of the dead, it

evokes Mary as she was when alive. This power to offer the 'living' saint to the viewer is an effective one. A close look at the Méronas icon confirms that for some it was too powerful. The icon has been very sensitively restored, leaving visible the clues to its physical history. No attempt was made to hide its scars, deep scratches on the surface of the panel. A moment of iconoclasm has left a permanent record. We see that the eyes of Mary were viciously scratched out with a sharp instrument (illus. 8). Her right eye (at the centre of the composition) was dug out and both eyes mutilated with long, swinging strokes. This either indicates a belief that eyes held the key to the living, and marks an attempt to 'kill' Mary, or shows that for someone, at least, the icon contained the 'evil eye'.

There is no record of the attack; its date and perpetrator or perpetrators are unknown. The history of Crete offers more than one possible context, however. The church in which the icon is kept was founded in the fourteenth century and decorated at the expense of an Orthodox family. Crete at this time was part of the Venetian empire, and this village is one of many which had a mixed population of Greeks and Italians. Both groups worshipped together in the churches in the countryside. Although we have consistently emphasised the Orthodox character of the image, in Crete in the fourteenth century it was not a foregone conclusion that an icon would have been displayed in a church exclusively peopled by Orthodox viewers. This was a busy village church; later in its history, it was enlarged and extended. It might be suggested that the damage to the face of Mary marks some episode of Christian sectarian violence or iconoclasm. This is perhaps the less likely scenario, however. Between 1669 and 1898, Crete was part of the Ottoman empire, and the present villagers say the culprit was a Muslim. The identity of the iconoclast matters less than the statement he or she made. It shows up the regular grammar of the iconoclast or graffitoist – the desecration of the eyes of one of the key figures, in this case the woman, to annihilate the power of the image. This act proves the power invested in the icon.

3 God/Man

I know the present only through the television screen, whereas I have a direct knowledge of the Middle Ages.

Umberto Eco, *Reflections on The Name of the Rose*

There is a sense in which it may be said that no one but a mediaeval man could possibly understand mediaeval society. But there is also a sense, and the statement is no less comprehensible to us, in which we may say that mediaeval man had little or no chance of ever understanding mediaeval society – and certainly far less prospect of doing so than has modern man. Obviously to make this latter statement is to claim that there are ways of interpreting the data about one culture into the terms employed in another, and the implication is that these are in some respects more comprehensive methods than have been available in earlier periods of history or in other cultures.

Bryan Wilson, *Rationality*

The British Museum icon of the Triumph of Orthodoxy is filled with figures as a celebration of the successful conclusion of the fight against the iconoclasts. Yet the most prominent image is not that of the famous iconophiles but the (representation of the) famous Hodigitria icon painted by St Luke (illus. 6, 10, 11, 12). When this icon was painted in the fourteenth century, the actual archetype painted by the hand of the evangelist was of course still preserved and visible in Constantinople. It is this precious panel which is represented in pride of place at the centre of the upper register of the icon, where the eye naturally starts its viewing of the panel. We can appreciate the importance of the argument that icons were legitimated from the very moment of the birth of Christ when we see the Hodigitria icon treated as history and offered as a paramount document of Orthodox teaching on images.

Yet the imagery of this icon is something of a paradox. Every Byzantine viewer's gaze would surely, like ours, have gone first to the central image of the Panagia. The day of its particular display was at the festival of Orthodoxy on the first

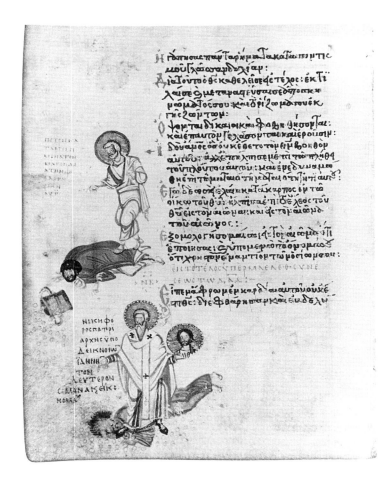

25 St Peter trampling Simon Magus and Patriarch Nikephoros (with an icon) trampling the Iconoclast Patriarch John the Grammarian, from a 9th-century manuscript (the Khludov Psalter).

Sunday of Lent. The paradox is that this festival was not specifically connected with Mary. Its importance was to proclaim the triumph of the True Faith over all the heresies of the past. It was to celebrate the central triumph of Orthodoxy – the final agreement in Byzantium that Christ could and should be represented in art in human form. The iconophile side had been engaged in fighting for the images of all the saints, including the representation of the Panagia, but the fundamental triumph was to win the argument over the representation of Christ himself (see illus. 25 for a battling but triumphant iconophile holding an icon of Christ).[1] It was part of the iconophile case that the historical fact of the birth of Christ to Mary in human form gave Christians a new dispensation and a New Testament: the Incarnation legiti-

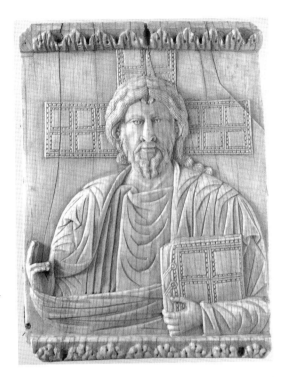

26 *Christ*, 10th century, ivory.

mated the representation of Jesus. The iconoclasts had accepted the fact of the Nativity, but not this reasoning.

As the iconophiles articulated their arguments, they said that the primary image in the church should be that of Christ: its importance (and his importance) should be marked by a location physically above all other imagery.[2] This conception of hierarchical status entered thinking on art early on in Byzantine history under the influence of the mystical theology of the fifth-century writer known as Pseudo-Dionysius, or so it is often claimed.[3] In this respect, the importance of Christ is certainly marked out in the British Museum icon, but effectively the eye is caught by the Panagia and the ecclesiastical emphasis on the Hodigitria. According to histories of the period of iconoclasm written in Constantinople, the first symbolic action after the triumph of the iconophiles was to set up in public an icon of Christ. The chosen location was the facade of the Great Palace of the Byzantine emperors, over the Chalke Gate. This symbolic gesture had been made before – after the Council of Nicaea of 787 had initially restored the icons – but the icon would have

been taken down after the renewal of the movement in 815.[4] Soon after 842, the icon of Christ and the sign of the cross reappeared on the Chalke Gate (perhaps in the form found on an ivory plaque with the bust of Christ; illus. 26).

When iconoclasm failed (after more than a century's debate) and the icons were firmly established in proper Orthodox practice, the distinguishing sign of the Byzantine church became the representation of Christ as much as the representation of the cross. The victory of the iconophiles established that from the ninth century, the churches of Byzantium would be distinctively signified by the display of figurative images: in the Christian church, unlike and indeed in opposition to Jewish synagogues and Islamic mosques, the heavenly host would be seen on earth (the representation of God was forbidden to the Jews by the Book of Exodus [20:4], while in Islam it was understood that the Koran forbade the representation of God and any living creature). In Constantinople, the use of icons was finally established by a council on 19 February 843 (the first Sunday in Lent) and a festival service in St Sophia on 11 March 843, followed by the conspicuous display of the image of Christ at the entrance to the Great Palace.[5] In the key church of the capital, St Sophia, where the clearest sign of the new position might have been expected to have been displayed, the first monumental image after the ending of iconoclasm was, however, the image of Mary and the Christ Child in the apse. It was inaugurated only in the year 867 (on Easter Saturday), a full twenty-five years after the defeat of iconoclasm.

In the British Museum icon of the Triumph of Orthodoxy, the prominence of the Hodigitria means that only the well-versed viewer will notice that the famous Chalke image of Christ is included, too. There are two representations of Christ in the lower register of the icon – one at the centre, one at the extreme left (illus. 13): both represent Christ in the form of an icon, in line of course with the subtle imagery of this panel. One of the icons is in the hands of the saint on the extreme left; she was identified (and the letters are still readable) as St Theodosia. This is a rare figure in art, but she must be St Theodosia of Constantinople in view of her inclusion in this group of figures.[6] Her story can be found in a number of (edifying) Byzantine texts, where she appears as a significant martyr during iconoclasm. As we have seen, she was violently

murdered while defending the icons in Constantinople. As history, the story is full of problems: one is whether in the early eighth century there actually was an icon of Christ on the Chalke Gate (this may have been a convenient story to bolster the antiquity of icon-making); another is whether St Theodosia was involved in its attempted protection – she may well be a fictional character whose name entered the story as one of its later embroideries. Nonetheless, in the fourteenth century any Byzantine who noticed the detail and saw the name of the saint could have been expected to remember the story and identify the icon. By that time, St Theodosia was a cult saint in Constantinople. But whereas in the 840s in Constantinople, the immediate icon to be displayed was the Chalke image, it is no longer at centre stage in the British Museum icon, but has been moved down below the Hodigitria.

The Byzantine history of the representation of Christ is in fact surrounded with as much mystery and mythology as the Hodigitria panel itself. These myths, which are an essential influence on viewers' reception of icons, must be a major guide to the modes in thinking of Byzantine culture. In treating icons of Christ, the artistic materials are even richer than for the representation of Mary, and the theological issues even more pivotal for the church.

With the attribution of the Hodigitria and other representations of Mary to the hand of St Luke, a clinching case was made that icons were permissible in the Christian church. The actual icons could also resolve a major empirical question – they supplied a perfect set of portraits of Mary. However, Mary, despite her special role in history, was an ordinary woman; thus, her portraits offered an authentic record of a sanctified human being. In the case of Christ, the problem of portraiture is far more complex. It is one thing to describe in words in the Gospels the charismatic appearance of the Son of God, but another thing entirely for the artist to provide an acceptable visual version of the verbal concept. The problem was not exactly unique to Christian artists; the artists of imperial Rome had faced a similar problem. For the Romans too it was one thing to describe the appearance of the emperor Augustus in words – whether eulogistic or not, as in some cases – but it was another to portray the leader to his public in the form of a permanent visual record. But Roman artists and

image-makers were set one further challenge. When Augustus died, they had to answer a more difficult question: How do you convey through art the external appearance of a man who has become a god (*Divus Augustus*)?[7] This is a dilemma which mirrors the challenge to the Christian church in the imagery of Jesus. How could we know how he looked when on earth, and how do we portray the heavenly image? This question was as much a difficulty for the Byzantine world as the broader question of the legitimacy of any figural art. It would hardly be surprising to find again that in the imagery of Christ both these strands are inextricably linked. The Roman experience, which we have seen in the case of the Fayyum portraits, lies behind the Byzantine solutions (illus. 21). The portraiture of Mary and Christ likewise looks 'realistic', but this can be no more than a stylistic device (illus. 50, 54). The Fayyum portraits supplied for their clientele in Egypt a memento of their dead in the style of the living. Early Christian saints were recorded in similar ways, but had to convey the added components of their sanctity and power, and their life after death. Icons achieved the impression that there was an agreed portraiture for all the saints, and this was supported by stories that they were represented while still alive, stories which can hardly be verified.[8]

As in the case of Mary, we find Byzantine legends of the production of portraits of Christ made during his life. It is no surprise to learn that the most famous were painted by the evangelist Luke, but Luke was not the only 'artist' involved. The Piacenza Pilgrim when in the Holy Land around 570 was able during his time in Jerusalem to pray in the Praetorium of Pilate (also known as the church of St Sophia). In this building where 'the Lord's case was heard', he saw the stone on which Christ stood during the trial, marked with an imprint of his foot, and he was also shown a picture painted while Christ was alive. This picture of Christ is described: 'He had a well-shaped foot, small and delicate, but was of ordinary height, with a handsome face, curly hair, and a beautiful hand with long fingers, as you can see from a picture which is there in the Praetorium and was painted while he was alive.'[9] The Piacenza Pilgrim continued his pilgrimage by travelling on through the Sinai desert to Egypt, and there he came across another type of image of Christ, one 'not made by human hands' (*acheiropoietos*). He describes this too:

27 Pictorial Map of the Holy Land, 6th century, floor mosaic. Madaba, Jordan.

In Memphis was the temple (now a church) which had a door which shut in the Lord's face when he visited it with Blessed Mary, and until this day it cannot be opened. We saw there a piece of linen on which there is a portrait of the Saviour. People say he once wiped his face with it, and that the outline remained. It is venerated at various times and we also venerated it, but it was too bright for us to concentrate on it since, as you went on concentrating, it changed before your eyes.[10]

This text is only one which documents some of the imagery which could be seen in the Holy Land by impressionable pilgrims who had made the hazardous journey, in many cases from western Europe, to see the locations of the historical events of the New Testament (illus. 27).[11] The spiritual experiences of this particular pilgrim can be duplicated in other accounts; the pilgrims travelled in a charged atmosphere of prayer and vision.[12] Another example of the experience is given by the full record of Bishop Arculf, who went from Gaul to the Holy Land a hundred years after the Piacenza Pilgrim and whose story was written down (between 679 and 688) after their meeting in Scotland by Adomnan, Abbot of Iona. The text (written by Adomnan in his own style) was illustrated with a number of sketch plans and is obviously not an eye-witness version, but it can still be used as an evocation of the sights of the Holy Land in the late seventh century.[13] Arculf is reported as having spoken of a number of artefacts from the time of Christ. One striking story is about a

95

sacred linen cloth 'of the Lord's, which was placed over his head in the tomb'. The recovery of this cloth some three years before Arculf's visit was the talk of the city of Jerusalem. The story is recounted at some length to explain the continuous tradition of the cloth from the time of its secret removal from the Sepulchre immediately after the Resurrection by a certain Jew who was a true believer; it passed down through his descendants until it fell into the hands of unbelieving Jews. At this point, the Christians of Jerusalem claimed it and the Umayyad caliph intervened in the dispute by lighting a bonfire and throwing the cloth into it. It rose into the air undamaged and fluttered into the hands of the Christians: 'Our brother Arculf saw it. He was one of the crowd present when it was lifted out of its box, and with the rest he also venerated it. It measures about eight feet in length.' The next section reports that Arculf also saw a work of art:

> He saw in the city of Jerusalem another linen cloth, a larger one, which is said to have been woven by Saint Mary, and it is for this reason preserved in a church, and venerated by the whole population. Pictures of the twelve apostles are woven into it, and there is also a picture of the Lord. Part of this cloth is red in colour, and part, on the other side, is green as grass.

By chance, we too might have an idea of the appearance of this tapestry, if a textile in the Cleveland Museum of Art is from the same period (illus. 28).[14]

Pilgrims' accounts are just one among several of the sources which demonstrate the importance for Christians, both eastern and western, of material remains which had been directly in touch with Christ. The range of needs these objects served in the Middle Ages is immense; the accounts of them were sometimes used to support abstruse theological arguments, and sometimes they show the depth of the devotional experience in the presence of material actually from the time of Christ. In this chapter, the aim is to show how the conceptual and emotional value of images of Mary was surpassed in the icons of Christ.

The sacred places of Jerusalem were highly evocative sites, enhanced by their mention in the Gospel narratives (illus. 27). The same mystique around the figure of Christ was also to be achieved by Medieval artists working outside the Holy Land

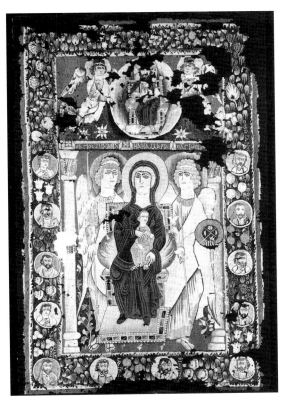

28 Panagia and Child with Apostles, 6th century, wool tapestry.

29 Christ, 12th century, central panel of a triptych.

itself. An attribution to St Luke was one of the most effective agencies. Several paintings of this category are now in Italy, some produced there, others probably originating in Byzantium. One of these paintings attributed to St Luke must have been painted in Italy, despite its 'Byzantine' look; this is the tabernacle of the enthroned Christ the Redeemer from Tivoli cathedral (illus. 29).[15] Art-historical study has concluded that the panel was produced early in the twelfth century, probably in Rome, and the most likely model was the image of Christ in the Lateran. It is certainly an extraordinary object which dominates by its scale (1.5 metres high). This makes the figure of Christ 'life-sized' (as was the model in the Lateran). The public did not normally see the figure of Christ, however, as the tabernacle was kept in an underground chapel in the cathedral, and it was kept closed. This means that there was high drama on the special occasions when it was opened. It was then that the viewer was confronted with the great figure of Christ and on each side of him (on the

wings) the standing figures of Mary and St John the Evangelist. One of the public displays of the Tivoli Redeemer was in a procession (maintained regularly up to the eighteenth century) through the streets of the city to Sta Maria Maggiore to meet an 'icon' of Mary.[16]

This great triptych is an important document from the west of the rites and ceremonial connected with the display of images of Christ in the Middle Ages. The atmosphere must have been very similar in Byzantium, and it is hard not to use the term *icon* for the Italian images. Strictly speaking, the Roman church did not accept the decisions of the Council of Nicaea of 787 as binding, but despite the lack of a western formulation in Byzantine terms, many practices (and attitudes) were similar. Against this background, the attraction of icons – like that of the Méronas icon to both the Catholic and the Orthodox communities on Crete – becomes clearer. It was not anomalous for easterners and westerners to worship together in front of the same images. While the sanctuary arrangements of the churches differed, when the icon was carried in procession in the street, public responses in east and west must have been very similar. When an increasing number of Byzantine icons were imported into the west after 1204, the familiarity of customs of viewing in all parts of Europe must have intensified. Practices in Rome can certainly help to explain some of the attitudes of Byzantium.

The nature of the extraordinary ceremonial in Rome connected with 'icons' is recorded in a number of texts.[17] Among the most remarkable practices, at least to our eyes, are the rites connected with the Lateran Christ, the Roman model for the Tivoli image of Christ, and an icon of Mary. We know of the activities connected with the Hodigitria icon in Constantinople when it was brought out of its shrine and displayed in procession in a public square. Something similar happened in Rome around the two images of Christ and Mary, although on occasion it seems that things were even more dramatic. One icon was the full-size image of Christ (142 by 58.5 centimetres) that was kept during the Middle Ages in the pope's private chapel of the *Sancta Sanctorum* in the Lateran complex. When it is mentioned in texts, it is described as an *ycona* (illus. 30); in addition, it is said to be *acheropsita*, manifestly a corruption of the Greek word applied to a number of early icons, *acheiropoietos* ('not made by human

30 *Christ*, icon from the Sancta Sanctorum, (?)6th century with a later silver cover. Church of S Giovanni in Laterano, Rome.

hands'). This was a significant group of icons; all came with a story that their manufacture was not human but miraculous – in other words, some kind of divine intervention meant that they were in principle protected from iconoclast criticism that earthly materials were implicated in the representation of the being of Christ.

The appearances of such icons are described in legendary terms; the history of the Roman panel has several versions. One is that the panel came from Jerusalem at the time of Titus' conquest and that it had been started by St Luke, but had actually been completed by God through the hand of an angel. The panel was until recently almost totally obscured by later covers, but is now being investigated; the consensus is that the work was produced around 600. Its history might be clarified if technical analysis could identify its original surface and distinguish the character of the substantial restorations during the Middle Ages, which seem to have included a total repainting of the head. It was covered in a silver casing by Pope Innocent III (1198–1216), thus leaving only the face visible; the feet were ceremonially exposed to view when two small silver doors were opened. This happened every year at Easter: the pope kissed the feet and called out three times 'The Lord is risen from the grave.' The doors were opened a second

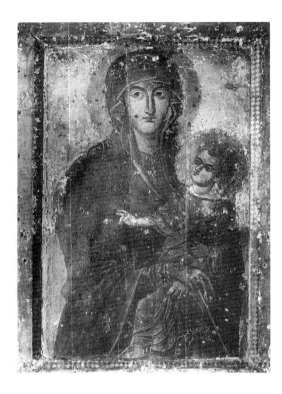

31 *Panagia and Child*, (?)6th century. Church of Sta Maria Maggiore (the *Salus Populi Romani*), Rome.

time every August in another ceremony when the panel was taken to the Forum and the feet were ritually washed.

This was only one part of a very elaborate celebration in which the icon of Christ was carried from the Lateran in order to meet another icon, one which represented Mary with the Christ Child and which also had supposedly been painted by St Luke. This August celebration was one of the major Marian events in Rome. In time, it came to last through the whole night before the festival of the Assumption of Mary on 15 August; it was only discontinued in 1566 as a Counter-Reformation gesture. This particular icon of Mary, kept in Sta Maria Maggiore, had acquired the name *Salus Populi Romani*; the panel was large (117 by 79 centimetres; see illus. 31). This panel too has been repainted during its history, but may have been produced in the sixth century. As this rite continued through the Middle Ages, it became more and more enriched. The highlight had once been the meeting of the two icons at the church of Sta Maria Nova in the Roman Forum; in time, this became just one of several such encounters, and the chosen

route included visits to other panels of Mary in Rome said to have been painted by St Luke. Obviously, this claim of the antiquity of the images and the miraculous production of the icon of Christ gave the rite its special evocations. Only a few icons could offer this special proximity to Christ and the Virgin.

The processions with icons in Rome and Constantinople point to some of the moments of greatest emotional impact in the Middle Ages (illus. 16). But every liturgy in the Orthodox church had such processional moments when the Gospel book was carried in procession and when the bread and wine for the eucharist made their entrance. At the annual commemoration of the saint or festival to which a church was dedicated, the 'patronal' icons would be carried in procession. Another time when icons were carried was at the moment of death, when icons would be taken into the presence of the person about to move to the 'other world' (illus. 33). Icons would be used in many special civic events. It was the Hodigitria icon which was at the head of the processional return of the Byzantines to Constantinople in 1261. There was a whole public organisation of liturgy and processions in the streets of Medieval cities.[18]

However static the imagery of the icon may now seem, in the Middle Ages icons moved and were sometimes the subject of private devotion in the church, sometimes the focus of communal veneration.[19] Icons in the Orthodox church today are equally dynamic.[20] The interior of the Orthodox church changes continually. The major icons might move between church and street, but on every day of the year a new calendar icon or festival icon may be brought out and displayed. Every church has several sites for the placement of icons in addition to a screen near the sanctuary. From the twelfth century onwards, as the church filled up with icons, they encroached on all sorts of spaces. But the idea of special shrines goes back to the early Byzantine period. A special silver ciborium was set up in the nave of the church of St Demetrios in Thessaloniki already in the sixth century and was several times renewed, finally in marble (illus. 32).

Apart from special shrines and tabernacles, the key location developed for the display of icons was around the altar and sanctuary of the Byzantine church, until by the end of the Byzantine period the modern iconostasis which dominates the interior of any Orthodox church had probably been devel-

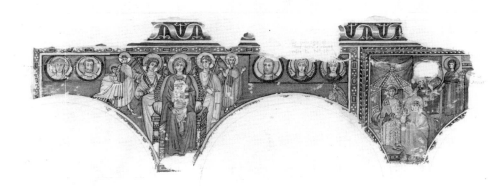

32 Copies of the 6th-century mosaics of the *Panagia and Child* and *St Demetrios in front of the canopied ciborion* (right), since destroyed, formerly in the Church of St Demetrios, Thessaloniki.

33 *Funeral of (?)St Isidore*, 16th century, icon.

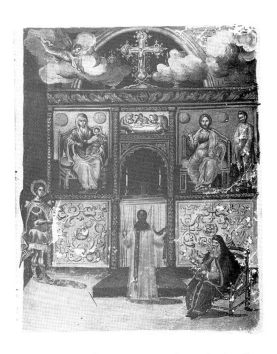

34 George Klontzas, Sanctuary of a Cretan church, 16th century, manuscript (Paterikon).

oped. Such a screen, covered with icons, was the culmination of the proliferation of icons in the church and gave a way of controlling their display and veneration. It supplied a prominent visual focus in the church which was both devotional and symbolic (illus. 3, 34).[21] But it had a radical impact on the character of the Byzantine church, since it made the once open sanctuary and altar invisible to the congregation, except at the moments when the so-called Royal Doors at the centre were dramatically opened. The iconostasis changed the character of the church environment. It added intrinsically to the secrecy of the church rites and enhanced the distance and barriers between the clergy and the laity. Women had never been allowed to enter the sanctuary of the Byzantine church; now they were excluded from even a viewing of the whole sanctuary area.[22]

The early Byzantine church had no more than a low chancel between the congregation and the sanctuary, and so effectively the sanctuary was open to view and the clergy fully visible throughout the service. Any images in the church would have attracted their own focus of attention.[23] Changes in the chancel barrier arrangements probably began to develop from the sixth century; by the ninth century we

find a higher *templon* screen, which seems the standard arrangement between sanctuary and nave after iconoclasm (illus. 35, 36). This *templon* supplied a doorway in front of the altar, which could be closed with a curtain or with decorated doors (soon to be called Royal Doors). The *templon* continued to evolve, and by the twelfth century the idea of setting icons on a beam over the top of it had been developed; perhaps by this time too the insertion had begun of intercolumnar icons on each side of the central doorway (illus. 35).[24] With increasingly elaborate screens from the fourteenth century onwards, the power of each icon in the hierarchical sequence was not limited simply to a reading of its imagery. The panels were incorporated into the ritual; they were censed and venerated, and they had a function in symbolising the liturgy, which was celebrated in front of and behind them (illus. 34).

As we have seen, all the icons on the screen or in special stands around the church could be removed for any special ceremonial in or around the church. Similarly, any icon to be found in a monastic cell or in a home could be moved or replaced. Pilgrims travelled with icons, both as talismans and for protection, and to act as gifts on their journeys. Some of the hundreds of icons in the monastery of St Catherine's on Sinai may have been carried there by pilgrims. The clergy who arrived from Rome in the sixth century to preach the Gospel at Thanet in Kent brought an icon of Christ with them.[25]

Icons of Christ and Mary were the key to many processions, but other icons could be venerated in the same ways – icons of saints and feast icons were equally charismatic.[26] Many large icons can be seen to have been made with fittings for stands and processional poles (illus. 37, 38). Icons of the Annunciation were not only needed for such processions, but were often the subject chosen for Royal Doors between the nave and the sanctuary, the doors which were seen to stand between earth and heaven.[27]

A culture which used icons in so many ways was distinctive and offered its members a strongly spiritual outlet for emotions, both private and public.[28] The use of icons in processions offered society definite benefits and experiences (see illus. 39).[29] They might assist the communal experience and help to promote the cohesion of the society through shared emotions. A procession organised by the local church offered a communal experience through an occasion when a

35 *Templon* screen, Protaton Church, Karyes, Mt Athos, Greece, 11th century and later.

36 *Templon* screen, 12th century, church at Episkopi, Santorini, Greece.

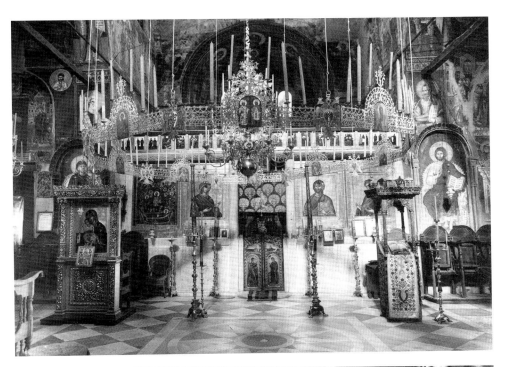

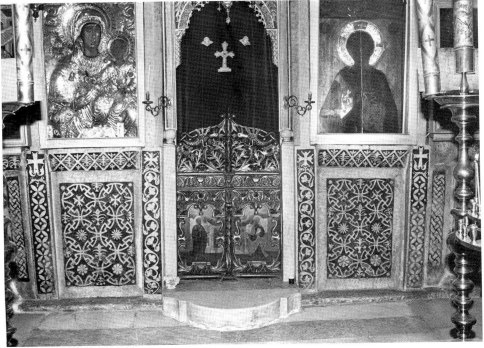

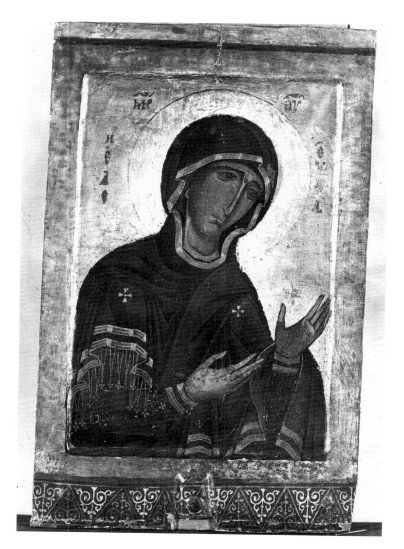

37 Panagia Eleousa, 12th century, icon. Monastery of St Neophytos, Paphos, Cyprus.

community was defined and united, bringing together laity, clergy and monks, the civil and the military, men and women, old and young. The procession linked the community and could elevate even the secular marketplace into a special holy environment. Of course, the outward social harmony might conceal all sorts of differing individual emotions and reactions. The recognition of the charismatic role of icons brings with it doubts about whether all Medieval viewers can be understood to have had the same group experience. Should we accept a difference of attitudes and belief between the

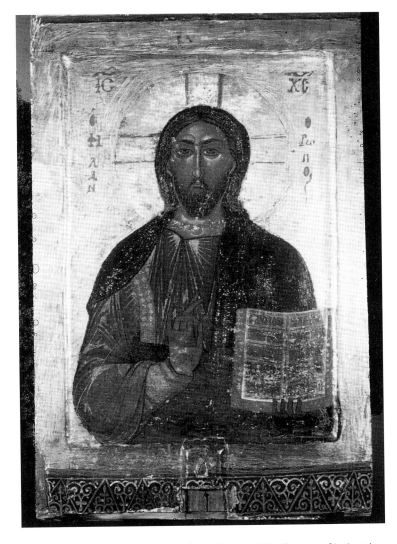

38 *Christ*, 12th century, icon, companion piece to illus. 37. Monastery of St Neophytos, Paphos, Cyprus.

participants in a public display of icons? Is there a distinction between the popular and the official experience? These are perennial questions asked in the history of religions, and the phenomenal importance of the icon in Byzantine society means that we have in this medium the possibility of approaching these issues through this material. This means defining the nature of the evidence. The Byzantine material offers the possibility of quantifying the audience and to some extent the patronage. In fact, though, we have seen that the viewing audience of icons was fairly universal – the whole

39 George Klontzas, Corpus Christi procession in Candia, 1590–92, from the *Historia ab origine mundi.*

Byzantine community of believers, as well as visitors, such as those from abroad who went to St Sophia at Constantinople.

The patronage of icons seems to represent a greater cross-section of society than any other artistic medium in Byzantium; even the exclusive bibliophile in Constantinople needed icons. The tenth-century emperor Constantine VII Porphyrogenitos (913–59), so often seen as the intellectual scholar-emperor by historians, may have commissioned an icon now in the Sinai collection which features the famous and popular relic of the Mandylion of Christ from Edessa (illus. 53). He certainly arranged the transfer of this 'relic' to Constantinople (see illus. 40). The Mandylion was one of the most famous images 'not made by human hands' and was from the sixth century believed to be an imprint of the face of Christ which he had sent personally to the first-century king of Edessa, Abgar, who was seriously ill. The Sinai icon has lost its central image, no doubt the representation of the Mandylion itself; on the wings which do survive, we see King Abgar (who 'uncannily' resembles portraits of Constantine Porphyrogenitos himself) holding the napkin with its imprint of the face of Christ. This cloth, according to the legend, miraculously healed Abgar's illness.

The Mandylion was one of the great 'popular' relics of the Middle Ages, yet its promotion among the people of Constantinople in the tenth century came from the imperial

40 *The Mandylion
arriving at Constan-
tinople*, 12th
century, from a
manuscript of the
History of Sky-
litzes.

circles of Byzantium. Among its viewing public was the
emperor, the people of Constantinople, and the monks and
pilgrims of Sinai. The case of the Mandylion offers a popular
relic, represented in thousands of copies in Byzantium, and the
subject of a special icon in the tenth century. Is this a case of the
development of a cult promoted from the top downwards? Or
do we have to admit that the dynamics of society are too
complex to decide? Perhaps the question is helped if we move
outside the capital city and ask about the promotion of
particular icons there. For example, in the painted churches of
Cyprus, we find icons of saints that are rare in, or even absent
from, other regions of the empire. Some of these portraits are of
local bishops from Cyprus, and one explanation for their
choice is the special ecclesiastical concerns of the clergy,
promoting their predecessors in an attempt to raise self-
awareness of local history and champions, for example. Yet the
popularity of these local saints might conversely have been
promoted by the local community itself, by people familiar
(say) with the tombs of these figures and with stories of their
actions and beliefs. It is not possible therefore to decide
between patterns of belief and practice at various levels of
society. Yet the question whether the uses of the icon
correspond with different types of piety in Byzantium cannot
be easily dismissed. The corresponding question of 'popular'
belief has been frequently discussed by historians of Late

Antiquity; the implication of a 'two-tiered' model of belief involving a 'dialogue' between the few and the many has found very few supporters.[30] Rejection of any distinction in the belief structures of various levels of society may alternatively predispose historians to see the Christian experience of icons and relics as a continuation of old superstitions and customs somehow transformed into new practices. This would give an explanation for an apparent rise in the increase in the use of icons in the sixth and seventh centuries as a movement 'so deeply rooted in ancient beliefs and practices and so obviously carried by broad masses of people' that the official church had to accommodate it and find theological justification for 'the naive, animistic ideas of the masses'.[31]

The opportunity offered by the study of icons from the whole range of Byzantine history is the possibility of refining this debate, especially by bringing into play underexplored icons and texts about the responses of viewers. But some well-known texts which document the spirituality of a broad spectrum of Medieval society have already been brought into play in this discussion, in particular the sixth- and seventh-century inspirational texts of the *Miracles of St Demetrios of Thessaloniki* or the *Miracles of the Bishop St Martin of Tours*, with their accounts of the interplay of relic, icons, and miracles (illus. 32). Both these texts were written down by the local bishop, a member of the 'élite', and communicated to the whole cross-section of society in either spoken sermons or written books. Bishop Gregory of Tours, in his prolific writings about Gaul in the sixth century, comes up with any number of miracle stories, many about miraculous healings and one even about the miraculous repair of a broken work of art, a chalice.[32] These were clearly of considerable popular interest. One of his stories describes his own illness in 573, when he fell victim to dysentery and despaired of his life; the miracle cure in this case came from an infusion of dust from the tomb of St Martin (not the first time it had worked for him). This is exactly the sort of story that is difficult to designate as an example either of élite or of popular religious attitudes.[33] For we do not know what the bishop or his audience actually believed, since there must have been an element of the collusion of faith between a sensitive bishop and his flock. The direction in which ideas run in a small society is not simple to deduce.[34] Some Medieval writers were no doubt able to convey that they were 'in touch

with the people'; others may have been more intellectually orientated. Texts seem to bias us towards attributing new spiritual developments to élites, whereas the clear and direct power of icons may encourage the attribution of cult practices to the 'conservatism' of the 'masses'.

The crux of the problem remains how to approach the visual in any remote culture. We can see the centrality of the icon in Byzantine life, but we have difficulty if we want to see the individual response.[35] Texts help to reveal the nuances of theological reasoning embedded in any one icon and may explain contexts, but the icon as a visual object is an ambiguous witness to the practices and actions of its audience. We have already seen the limitations of the Byzantine *ekphrasis*, which offers a literary counterpart to the visual experience, but not necessarily linked to the object described.[36] So we do have potential information about the religious profiles of Byzantine viewers, yet we have no way of quantifying the relative level or quality of their 'spirituality' or their emotions. Since processions and the enhancement of processions like the Hodigitria display are not unpremeditated occasions, but are stage-managed and prepared by the 'authorities', not everyone is an innocent bystander. All the miraculous events involving icons and relics that produced blood or holy oil likewise operated in a prepared theatre intended to ensure results. As outside observers of this type of occasion, how could we measure whether the audience experienced different levels of involvement?

Another Medieval culture – the Islamic society of Cairo – has been investigated with this comparison of popular and high culture in mind.[37] The conclusion reached about the dynamics of the procession in Cairo was that audience reaction was multi-directional: however much they were intended to manipulate the popular audience, the participants themselves were unable to act passively and so were caught up in a dialectic of approval and disapproval of the various strategies. One case, the cult of the Sufi saints, offered a cult with supposedly popular origins. But even here, every level of society was involved in their veneration, and the interplay of social activities was found to be too complex to support the dichotomy of 'high' and 'low'. The conclusion of this study was that the cult of saints 'created a cultural common ground for the people and the élite'. The same problem emerges as in

Late Antique studies; there is no easy way to deduce levels of belief in these societies.

If 'popular religion' is a concept inapplicable to the Middle Ages, the art historian is left in difficulties. The highly charged atmosphere around the veneration of icons encourages the interpretation that there was a range of response among participants. Furthermore, the cult of icons expands as time passes. One reaction is to suppose that this reflects an increase in spirituality, but the idea of periods of greater or lesser spirituality is distinctly unlikely.[38] This means that the development of icons, their increasing 'popularity', was not due to any changes in spirituality or the development of different attitudes among various segments of society. It must have been due to an acceptance of the value of the particular powers of the visual; icons were accepted as a mode through which one reached closer to an explanation of God than any verbal definition could ever do. This would explain the triumph of the iconophiles and perhaps the proliferation of the medium. But this conceptual explanation of the need for icons in the Orthodox church is still uneasy. Any explanation has to address the popularity of the icon among disparate groups in the society, and these included in Byzantium the theologians with their abstract metaphysical interests, the more pragmatic monks and the hermits, and a range of civil and public personalities. Can all these levels of society have been encouraged in their use of icons by the realisation of the powers of the medium in communicating truth rather than, for example, in their satisfaction of emotional needs? Over the course of the Middle Ages, there were many shifts in apparent popularity of different spiritual practices; for example, some periods recorded more visions of the Virgin Mary and Christ than others. One would therefore expect that belief in the 'presence' of the saint in the portrait icon might be stronger at some periods than others. There are ways in which such an indication might be detected; theological writing might react to shifts in attitudes, and this could be picked up by noting their changing discourses. An insistence that the viewing public should recognise a distinction between the veneration of images and their value as educational aids can be understood as a response to observed practices, and accordingly as an important indicator of current trends and interests. The much quoted 'clarification' about art sent by

Gregory the Great to Bishop Serenus in Gaul must therefore be seen as an indicator of attitudes around 600 and of the times when art became the subject of discussion:

> It is one thing to worship a picture, it is another by means of pictures to learn thoroughly the story that should be venerated. For what writing makes present to those reading, the same picturing makes present to the unedu-cated, to those perceiving visually, because in it the ignorant see what they ought to follow, in it they read who do not know letters. Wherefore, and especially for the common people, picturing is the equivalent of reading.[39]

This view of art, seen to be justified as a functional didactic tool, marks an attitude formulated by and for the élite. It might satisfy certain interests, but as a complete description for the uses of art it obviously is insufficient. It scarcely begins to account for the nature of devotional icons like those of Mary and Christ or even of portraits of Christ himself. But the character and date of the formulation is historically valuable in showing how attitudes expressed towards icons may be used to indicate possible differences between levels of society and periods of Medieval history.[40] Similarly, the analysis of the changing popularity of particular subjects and expressions of subjects at different times may help us to pinpoint changes in the culture; the key example of such change in Byzantine art is the rise in the eleventh or twelfth century of the representation of Christ as the Man of Sorrows.[41] In the west, the importance of imagery at one particular period can be judged from contracts; these can be interpreted to show that an expansion in the cult of saints occurred in both Spain and Zürich between 1500 and 1518 and was documented by the sudden and vast increase in artistic commissions.[42]

A qualification is necessary, however. Theological delibera-tion and the production of images were not necessarily conditional on each other, even if they might sometimes have had the effect of mutually stimulating each other. The icon, once produced, may operate in all sorts of independent ways. An icon of Christ might contain all sorts of particular theological references, but during its centuries of display in a Byzantine church it may stimulate many kinds of responses, both psychological and intellectual, shared and individual. Anthropological distinctions might help here. The distinction

between 'religion as prescribed' and 'religion as practised' clarifies the distinction in the cult of icons between a possible élite formulation of the nature of Christ and the response to the same image by an emotional viewer, perhaps on the point of death.[43] This offers an escape from the conceptually simple dichotomy of élite/popular and opens the way to more fluid distinctions in describing the production and functions of art, with a more multifaceted account of the nature of the spirituality involved in the production and viewing of icons. In a model of this kind, the distinctions between the aims of authority and the pragmatic outcomes become clearer. It helps to see how Byzantine iconoclasm might be regarded as a reaction by authority to a loss of control over public practices of the use of icons and as an attempt to reassert control over them in a 'reformation' movement. Tension resulted in the attempt to limit previous ritual and devotional practices.[44]

Tension in the Middle Ages between authority and public is likely to have been at its highest in disputes over the proper imagery of Christ and its allowable practices. Iconoclasm centred on fundamental disagreement over the proper representation of Christ, and the story (however mythical) that Byzantine iconoclasm began with the destruction of the Chalke icon of Christ in Constantinople and ended with the act of its restoration is a persuasive account of the central conceptual issues of the period. There is however an episode in the Medieval representation of Christ which is in its implications as dramatic as iconoclasm. This case takes us away from Byzantium, although the connections of Byzantine art with the imagery are very close. The document is the Turin Shroud, an object which by its nature subverts the boundaries between relic and work of art (illus. 41).[45] This extraordinary and rightly celebrated artefact demonstrates how images of Christ form a category which operates far beyond the range of the image of the Virgin Mary and Christ Child.

We have seen how the iconophile quest to prove the divine endorsement of figural icons was extravagantly fulfilled with the idea of St Luke as an active artist in the lifetime of Mary and Christ (illus. 6, 10). The most eloquent witness in Constantinople to the portrait of Mary was the Hodigitria icon. The same strategy had identified icons of Christ painted by St Luke, and Rome, as we have seen, was deeply committed to their use in devotional and public ritual. The

41 *The Turin Shroud*, (?)14th century. Chapel of the Holy Shroud, Cathedral, Turin.

concept of icons of Christ produced by miraculous intervention was an additional refinement of the argument. The Mandylion of Edessa was one of these images 'not made by human hands', most of which first appeared in the sixth century. The Mandylion was extremely well known in Byzantium both through continual copies over the rest of the Middle Ages and because of its presence in the Great Palace following its transfer to Constantinople in the tenth century (see illus. 40, 54).[46] But to represent Christ is always a more serious matter than to portray the Virgin. It always impinges on the theology of the nature of God.

The Medieval experience of the Turin Shroud opens up these issues, and the power of the object has even disturbed recent opinion. In London over the summer months of 1988, when speculation on the nature of the Shroud reached a high point, an announcement from the Vatican made front-page headlines in the London *Evening Standard* (illus. 42). After years of claims that the Shroud was the actual surviving shroud of Jesus from his Sepulchre, journalists may have thought that the story had come to an end: the famous burial cloth of Christ, once claimed as scientifically established as 'genuine', was nothing more than a 'fake'. The guessing game – 'original' or 'fraud' – was over.

The Turin Shroud is better treated as an icon. In this case,

42 London *Evening Standard*, front page, 26 August 1988.

what does it mean to say that this portrait icon of Christ is a fake? The speculation over that summer had been to second-guess the results of a carbon-14 test of three tiny samples taken in controlled conditions from the Shroud. The aim of the test was to decide the age of the cloth, and concomitantly the age and nature of the portrait. For some, the scientific announcement was enough to decide the case. The test had been carried out with proper care and control, and it was 'official'. Three laboratories were in agreement that the manufacture of the cloth of the Turin Shroud was to be dated *between* 1260 and 1390 (with a probability factor of 95 per cent). The cloth could not have come from the tomb of Christ or ever have been the burial shroud of Jesus.

The positive dating of the Turin Shroud to the Middle Ages is an extremely important piece of imformation. For some disappointed observers, it is true, the combined agreement over the date represents a conspiracy, the mysterious work-ings of God or some other explanation.[47] The next stage must surely be to work on the firm information we have. After all, the Turin Shroud is the *one* object of interest to historians and art historians which has been massively investigated by scientists. Art historians were in fact little involved in all this study, but there is much to explore now. We now need to separate out three elements of the Shroud. What do we know from historical evidence? What does the scientific work contribute? What are the implications for the study of popular and high religion from the historical context of the object?

The historical documentation on the Turin Shroud since its first mention in the fourteenth century is relatively detailed.[48] The cloth today is about one metre wide and four metres long (illus. 41). It is folded over, and the image on it is a full-length figure of a bearded man, seen from both the front and the back, as if the cloth had once been folded over him in the grave. Although the history of the Shroud in the cathedral at Turin cannot be documented fully from year to year back to France, where it was in the fourteenth century, the object as we see it with all its damage and repairs fits so well with the recorded episodes (including a fire and a subsequent repair) that it would take an excessive dose of scepticism to doubt its identity, although some are on record with doubts, such as those who attribute it to the hand of Leonardo da Vinci. This attribution, though far-fetched, does point to one real

43 Poster for the ostension of 4 May 1674.

difficulty about the Shroud. How was it actually made? How could the signs that this is an image of a crucified corpse have been so realistically produced in the Middle Ages?

The Shroud is kept at Turin locked away in a special container; for the last hundred years, it has been one of the most famous images of Christ in the Catholic church. It has been displayed on only rare occasions (illus. 43), and its notoriety depends more on photography than on the image on the cloth presented to the viewer. It was first photographed in 1898 and again in 1931. These photographs revealed the image: a striking bearded face seen in the negative (illus. 44).

From the fourteenth century, we have letters about the Shroud written in anger by a certain bishop of Troyes, Pierre d'Arcis, and sent to Pope Clement VII, who was in residence at Avignon. The key document is a memorandum of 1389 in which the bishop carefully sets out his version of events.[49] He refers to a *sudarium* (the Turin Shroud) at the centre of a local scandal. According to the bishop, the greedy clergy of the collegiate church at Lirey were making money from a cunning trick: pretending to the public that a painted cloth which it

owned was the actual shroud in which Christ had been enfolded in the tomb. They were saying this despite the investigation made while bishop of Troyes by Henry of Poitiers, who thirty-four years previously had come to the conclusion that this shroud was a fraud (as were the claims made by some men hired to say that they had been miraculously cured at the moment of its display). Henry said he had tracked down the artist who had manufactured the shroud and who had admitted that it was a work made by human hands.

The complaint of Pierre d'Arcis was that the whole thing had resurfaced in his time and that the present clergy (equally greedy) had surreptitiously got permission from the Papal Nuncio, Cardinal de Thury, to put the Shroud back on display. Their request, made on behalf of the church by the knight Lord Geoffrey de Charny, apparently the owner of the Shroud, had suppressed any reference to the previous investigation and had only referred to it as a 'picture or figure' of the shroud of Christ. As soon as they got permission to exhibit the Shroud, they cunningly called it the *sanctuarium* (instead of the *sudarium*), and since the public did not notice the subtlety of this, they continued to believe it was the actual shroud of Christ. Its sanctity was enhanced by the device of displaying it between two priests in liturgical vestments and on a platform with candles – so that it looked more holy than the display of the host in the eucharist. The bishop decided to put an end to this deceit in his diocese and prohibited the Shroud's display. At this point, the episode turned nasty – the clergy refused, went on with displays of the Shroud, and said that the bishop through jealousy and cupidity was attempting to confiscate it for his own use. The bishop went to the civil courts and had the Shroud taken into custody. At the time of his memorandum, he was desperately trying to get the pope's support to save face and solve a personal disaster. Clearly, public sentiment did not support the bishop's scepticism, offering us a case of popular belief in clash with élite religion. The pope was being asked to mediate between the interests of the bishop and the local lord, and his replies were highly circumspect.

By the next century, the French clergy had itself become more circumspect, too, and the description of the Shroud as a likeness or representation of Christ's shroud had come into currency. In 1453, the Shroud passed into the possession of the

duke of Savoy, and this family's ownership lasted until 1983, when the Shroud was given to the Vatican. During the Savoys' ownership, the status and prestige of the object was considerably enhanced. In 1464, Pope Sixtus IV spoke of the Shroud as coloured with the blood of Christ, and Pope Julius II named a feast day of the Holy Shroud. Some time before 1516, the Shroud had been scorched; a serious fire in 1532 nearly destroyed it. It was then still in France, in the Sainte-Chapelle at Chambery, inside a casket and folded into forty-eight layers. The outcome of this near-disaster was two long lines of holes and scorches from the fire; further damage was caused by the water which dowsed the flames. In 1534, Poor Clare nuns sewed patches over the damage, and a backing sheet of Holland cloth was sewn on. In 1578, the Shroud was moved to Turin, and in 1694 it was transferred to a specially built reliquary chapel in the cathedral of S Giovanni.[50] The Shroud was shown ceremonially on a number of special occasions, some in the cathedral, some on a vast outdoor stage constructed in the Piazza Castello in front of the palace (illus. 43, 45).

The turning point in the modern history of the Turin Shroud was its first exposure to modern technology when in the course of public display in 1898 the first photographs were taken. The publication of the negative images 'revealed' the

44 Front and back of the *Turin Shroud*, (?)14th century. Chapel of the Holy Shroud, Cathedral, Turin.

face on it (illus. 44). Further photographs taken at the displays of 1931, 1969, 1973, and 1978 led to increasing attention, particularly from those sindonologists who as a group set out to demonstrate the 'authenticity' of the shroud of Jesus.

From the side of the Catholic church, the position was from the fourteenth century onwards, as we have seen, that it was a manufactured object. It was an *imago* of the shroud of Christ, and in any case even it were the shroud of Jesus, this would not be of great spiritual value in the proof of the existence of God. Art historians took little part in the study of the Shroud, leaving the research to be done by the sindonologists, including journalists, Protestant Christians, and a group of twenty-four scientists from the USA. The group of scientists, known as STURP (Shroud of Turin Research Project), were to investigate the miraculous production of the Shroud. They opened a debate with a definition of the issue in empirical terms. Was the Turin Shroud a product of the Middle Ages, or was it the true cloth which was wrapped around the body of Christ after the Crucifixion and in which he entered the tomb on Good Friday? If it was the true shroud of Christ, the imprint of the body must have been etched by a miracle; it would show the divinity of Christ. This would mean that the face on the Shroud was the true face of Christ in the tomb, when his body was not subject to the corruption of rotting flesh.

No other 'work of art' has been subjected to such well-reported examinations using the techniques of forensic science and computer image analysis (illus. 44). Considerable ingenuity was applied to the task in hand. The assumption was that 'objective' science could demonstrate the miracle of the production of the face of Christ on a cloth now two thousand years old.

Since all the research done has been in the aim of a producing a simple answer to a simple question – Is this the shroud of Christ? – and since the answer that was desired was 'Yes', it is not surprising that in the eyes of the sindonologists a number of heroes and villains have emerged. Dr Walter McCrone (microanalyst at the McCrone Research Institute, Chicago) gained notoriety as gradual sceptic and critic of the authenticity of the Shroud. In 1978, he was given sticky tape samples lifted from the Shroud of what appeared to be blood. He identified them as Fe_2O_3 (= iron oxide = rust). His analysis led him to say that it had been applied to the Shroud as

powder mixed with a dilute solution of gelatin as a binder. He also detected in his samples stray particles of mercuric sulfide (vermilion), ultramarine, and the yellow pigment orpiment. The conclusion was that the Shroud had not only been in an artist's studio, but that it was painted with thin watercolour paint by an artist. All the members of STURP rejected this conclusion, although it was this research which generated the compromise suggested by one member that the Savoy family had made a new shroud which reproduced the original, probably hiring Leonardo da Vinci. Oddly, this would hardly help the problem, since it would mean that the original was lost, and no information acquired from the copy would tell us much about the face of Christ.

Other STURP members persisted in their belief that the Shroud was the original cloth from around the body of Christ. Two of then (Heller and Adler) declared twelve tests to have shown their sticky tape samples to be blood (from a victim concussed and jaundiced). Further evidence was adduced to indicate that the Shroud was originally in the Middle East; it contained pollen grains which must have come from the Dead Sea, Syria, or Turkey. STURP as a group accepted that the cloth had been made in the first century and that it recorded the body of Christ. Considerable attempts were made to find out everything about the body. The figure was described as a man aged between thirty and forty-five who had a beard and moustache and long hair falling to his shoulders. One ethnologist was prepared to say that the figure was semitic. In height, the man was estimated to be about five foot seven inches. His injuries indicated whipping, nails through his wrists and feet, and a chest wound. The medical diagnosis of the cause of death was crucifixion. The imprint was too realistic in all its details to be considered as 'a work of art'.

The carbon-14 tests in 1988 and the announcement that the cloth was Medieval did of course devastatingly contradict all the years of work by STURP. The scientific tests were in fact totally in harmony with the position of the two fourteenth-century bishops of Troyes who had firmly stated the Shroud to be a manufactured object. In other words, the importance of the Turin Shroud is its witness to the nature and veneration of icons in the Middle Ages, and the need is to put the Shroud into a historical context. This means going back again to the pilgrimage account of Arculf, who mentioned a large shroud

in Jerusalem, but without any mention of an image on it. We have no evidence to go further back (for example, to the world of the mummy portraits). We do have some evidence that by the twelfth century, there was a shroud in Constantinople; it was kept within the palace, out of the public arena. The suggestion has been made that this was indeed the Turin Shroud, and that the cult of the shroud of Christ was developed in Byzantium. Indeed, the argument has been pursued that this shroud in the Great Palace was none other than the Mandylion of Edessa brought to the capital by Constantine Porphyrogenitos in the tenth century.[51] The size of the Mandylion makes this an impossible guess (illus. 53).

There are some additional clues to the existence in the Great Palace of Constantinople of 'relics' of this kind. Robert de Clari described among the relics of the Pharos church in the Great Palace in 1204 a cloth and tile with the image of Christ, used in the healing of the sick. This has been speculatively identified as the *sanctam toellam* in the charter of Baldwin II, which was transferred to Louis IX and burned in the fire at the Sainte-Chapelle in 1792. Robert de Clari also described a *sydoine* at the Vlacherna monastery and probably referred either to the *sudarium* (the napkin of Veronica) or the *sindon* (shroud), both of which were also in the Pharos church in the Great Palace.[52] The contrast between the nature of the display of these images 'not made by human hand' in Byzantium and the later public showings of the Turin Shroud is a striking one. It is not that there was necessarily a difference in belief between east and west about such icons, but that the aspects of control differed. Here, control was kept by the ruling classes; it was the loss of control by the bishop of Troyes into the hands of the lower clergy and local lord that enraged Bishop Pierre d'Arcis.

All this evidence adds up to one particularly significant fact: the Middle Ages sought authentic images of Christ. One of the greatest issues for the Byzantine church was simply to know how Christ appeared and how he could be recognised. In this respect, there is little difference between the preoccupations of STURP and the Middle Ages. Indeed, some of the scientific study seemed obsessed by a desire to look on the face of Christ and worked more by faith than deliberation. One method, 'the polarised image overlay technique', claimed to bridge art history and science.[53] This involved the superimposition on a

screen of two images (photographed so that the two screen images were of identical size, whatever the scale of the originals). Polaroid filters were added to each projector so that the intensity of each image could be manipulated individually (and one could dominate the other). Bizarrely, the composite single image could be 99 per cent of one photograph and 1 per cent of the other, although it was treated as a neutral picture. The startling conclusion was that this *proved* that a number of Byzantine works were *copies* of the Turin Shroud. Among these were the Pantocrator icon in the Sinai monastery (illus. 54) and late seventh-century coins of Justinian II (685–95). The method was also claimed as a tool to demonstrate that a first-century Roman coin (with readable and datable inscriptions) had been put in one eye of the corpse. The point of this technique was to count the similarities between the Turin Shroud and the comparative materials (looking at the shape of the lips, eyebrows, and all other details) (these similarities are called points of congruence [PCS]). One hundred and eighty-five PCS were identified between the Turin Shroud and the Pantocrator icon, and one hundred and twenty-five PCS between the Turin Shroud and the coins of Justinian II. It is claimed that in an American court of law, an identity can be established if somewhere between forty-six and sixty PCS are established. It was thus thought to follow that the Turin Shroud portrait of Christ must have been the original from which these Byzantine images were derived (as a matter of fact, the research was equally prepared to see the Shroud as the original of images of Aphlad, a semitic storm god of eastern Syria, and of second-century Buddhas in Pakistan). The method of PCS showed that the Turin Shroud had acted as the Medieval source of knowledge of the appearance of Christ when on earth.

Art history must always assess carefully any technique which objectifies the visual comparison of art and aids attributional studies. This method does not seem even remotely to offer an answer, however. It does not explain how to recognise chronological sequence. Which object came first? Was the Sinai icon the source of the Turin Shroud? Were they indeed ever in close proximity?

The end result of all this activity, leading to the carbon-14 analysis, is that we have a date for the Turin Shroud which conforms with the Medieval investigation of the bishop of

Troyes, Henry of Poitiers, who dated it to his own time in the middle of the fourteenth century. Instantly, one notices that it is an object from the period of the Black Death. We have an object and linked documents which inform us about art and piety in the Late Middle Ages. The reaction of the upper hierarchy of the church in observing the object and its cult was to treat the Shroud as a fake; the lower clergy was ready to parade it to credulous pilgrims and to intensify the emotional impact. A dichotomy of the 'credulous' people and the 'sceptical' bishops might be invoked by this case. A work of art was transformed into a relic which offered healing miracles to the faithful. This relic was billed as one which actually had touched the body of Christ. The popularity of the displays of the Shroud could be interpreted as evidence of 'popular' religion. It offered literal and direct proof of the Incarnation and Crucifixion of Christ for the ordinary viewer. The higher clergy regarded the object in a symbolic way – as the *representation* of the Shroud of Christ. The documentation makes the interpretation more complex than this. The public was interested in the miraculous qualities of the Shroud. The clergy were also involved in the cynical manipulation of the object – making it look more sacred than the host itself and suggesting the presence of Christ in it. One is struck by the range and variety of attitudes that were elicited in the communal display of this icon.

The displays of the Turin Shroud from the fourteenth century onwards were perhaps the most dramatic of all public exhibitions of relics or icons in east or west (illus. 43, 45).[54] They point to the importance of icons of Christ and the question of his relics. In the west, the papal position on relics of Christ seems to have been consistently that the doctrine of the Resurrection was incompatible with the existence on earth of any bodily relics of Christ. Only pieces of the True Cross offered no difficulties. Guibert of Nogent therefore denounced the tooth of Christ at Soissons as a fabrication (though it was only claimed to be a milk tooth), and Thomas Aquinas expressed doubts about the blood of Christ venerated at Bruges.[55] Pope Innocent III spoke on the relics of Christ at Rome: 'What shall we say of the foreskin or umbilical cord which were severed from his body at birth? Were they too resurrected?' These two relics were in the Lateran from the eleventh century, and St Bridget in the fourteenth century had

45 *Ostension of the Sudarium*, woodcut from *Mirabilis Urbis Romae*, 1511.

a vision of the Virgin who assured her of the authenticity of both. However, from the eleventh to the sixteenth century, there was a rival foreskin at the monastery of Charroux in Poitou and another in the Benedictine abbey of Coulombs, not to mention those at Boulogne and Antwerp. In 1239, St Louis of France had acquired the Crown of Thorns from the Latin emperor of Constantinople and built the Sainte-Chapelle to house it – an example of an object of 'popular' devotion housed in great splendour and in a royal setting, in this case when it was both in the Great Palace of Constantinople and in Paris. The Byzantine relic of a piece of the stone of the Sepulchre of Christ, which was mounted in a Byzantine gold case in the twelfth century, was probably kept more securely in the private domain of the Imperial Palace in Constantinople, probably in the Pharos church. This too was acquired by St Louis, and brought to Paris in 1241 and kept in the Sainte-Chapelle (illus. 55).[56] Both Trier cathedral and the parish church of Argenteuil claimed to have the seamless robe which Christ had worn at the Crucifixion. Phials of the blood of Christ simply multiplied in numbers from the thirteenth century; they were usually said to derive from the host or

from an image wounded by a blow from an unbeliever. Aquinas declared such stories to be theologically acceptable except in those cases where the blood was said to come from the wounds of Christ on the cross (though Robert Grosseteste in 1247 accepted one of these claims to be genuine). The Franciscans in the fourteenth and fifteenth centuries were strong supporters of the idea that Christ's blood remained on earth after the Crucifixion. From the twelfth century onwards, there was a pilgrimage to the Holy Blood at Fécamp.

There is a mass of factual evidence of this kind. It adds up to a clear context for the activities of the clergy who promoted the Turin Shroud. When the local bishops spoke up against their duplicity, they were taking a serious risk. A similar type of situation was described by Guibert of Nogent when he found himself in a crowd at Laon. A relic monger held up a box which he claimed actually contained a piece of the bread of the Last Supper which had been chewed by Christ. When the man recognised Guibert in the crowd as a possible sceptic, he took steps to neutralise him by openly challenging him as a man of learning to confirm this was a genuine relic. Guibert recorded his intimidation and admitted that in the presence of mass popular belief, he was unable to express doubts. His silence was interpreted as assent.

The Turin Shroud highlights the powers of art when it was used to represent Christ. It is one of several such objects known in the Byzantine and western world, and one is tempted to accept the church findings in the fourteenth century that it was made in France (although this tells us nothing about the origins of the artist involved). In his letter of 1389, the bishop of Troyes speaks of the dean and his accomplices at the church of Lirey having hidden the Shroud away for approximately thirty-four years after the previous complaint. This takes us back to around 1355 for the previous display, and to a time of manufacture shortly before that, i.e. to the period of the first serious outbreak of the Black Death in 1348 (followed by further epidemics in 1363 and 1374). The relevance is not that this would literally offer a source for a corpse (there is no reason to assume a real body was involved in the manufacture), but that it reminds us of the climate of the period. Is it only coincidence that it was in the sixth century in Byzantium that icons 'not made by human hands' first appeared? This too was a time of sweeping plague.

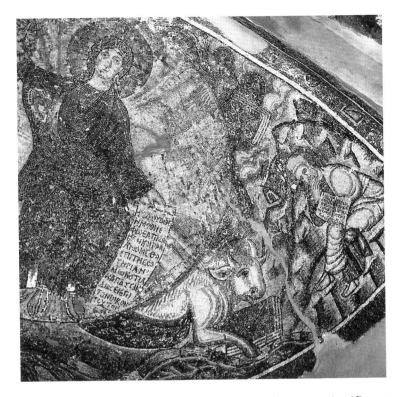

46 *Christ*, 6th century, mosaic of apse, Church of Hosios David (Church of the Latomos), Thessaloniki.

Icons of Christ 'not made by human hands' are a significant group. They do not simply take the forms of the Mandylion and Shroud, but also those of portable icons and even an apse mosaic. The apse mosaic of Hosios David in Thessaloniki (illus. 46), which we date to the sixth century and which was still being copied as a miraculous icon in the fourteenth century (illus. 56), was the subject of one of the most famous legends of the city.[57] According to the story written down in the eleventh century, the mosaic had appeared miraculously overnight in the fourth century and replaced an unfinished image of the Virgin. The original mosaic had decorated the apse over the altar; its fourteenth-century copy was a double-sided panel, meant probably for processional use. Both images were therefore adjuncts to the words and rites of the liturgy.[58] Icons of Christ, like the Gospel book, the cross, and the bread and wine, joined in liturgical processions in the church and were venerated with incense. But they had a symbolic role of their own. The historical failure of iconoclasm meant that after the ninth century, icons of Christ were produced in greater

numbers and had functions beyond their use in the liturgy and private devotions. Once the image of Christ was fully sanctioned, icons had one particular role. This was, as we have already seen, that they could not avoid confronting the central question of whether we can know the face of Christ.

Any image that goes back to Christ's lifetime must be a capital document. Equally, an 'icon not made by human hands' must have a special role in the quest for the face of Christ. These images constitute major weaponry in the argument about the truth of Christianity.[59] They are superior to any textual *ekphrasis*. All the art-historical evidence, in the case of both the Turin Shroud and of the other supposedly early icons, is that they are human productions from the sixth century onwards. We would therefore expect some collusion between the writers and artists who addressed the issue of the exact appearance of Christ. The clearest intersection comes (unsurprisingly) from the period when iconoclasm came to an end. In the *Letter of the Oriental Patriarchs* from this period, we read that Christ was 'three cubits tall'.[60] Much more is said in another text of the period. Written by someone we call Elpios the Roman, it sets down descriptions of Christ and a few saints:[61]

On the lordly appearance of Our Lord Jesus Christ in so far as the ancient writers have written concerning him.

Of good stature, with meeting eyebrows, beautiful eyes, long nose, curling hair, stooping posture, good complexion, and with a black beard; corn-coloured in the face in accordance with the appearance of his mother; large hands, sweet-voiced, sweetly-spoken, very gentle, long-suffering, patient and showing excellences as appropriate to his virtue; in all of which qualities his nature as the divine-human Logos is shown, so that no obscuring of this character nor any alteration or change shall be detected in the divine incarnation of the Logos as the ravings of the Manichaeans suggest, in such a way that things which are true and immutable could be considered to be the manifestation of an illusion, for 'the truth is shown by the likeness, the archetype in the image, each in the other, besides the difference of substance' and 'from physical signs we are led to the mystical contemplation of spiritual things'.[62]

These texts are at first sight very precise. But they are of course not as transparent as an icon. To put these words into images means going beyond such questions as the height of Christ, whether he looked young or old and whether he was bearded or not. Any visual statement has to show more than this and be consistent. All art had to agree in its portrayal of Christ – he was an unchanging concept. All copies of icons had to take on the details of the model. The consistency which can be observed from the sixth century to the Turin Shroud is no accident and represents the extraordinary technical accomplishment of the Medieval artist. It is not a matter of direct copying in the way that was proposed in studies in the Shroud. But there is another side to the necessary and crucial agreement between artists on the portrayal of Christ. His face had to be generalised; the portraiture could not be too exact, for there was in fact no model for it to conform to. The face of Christ had to be a mask. Each artist had to offer both an answer and a continuing element of mystery. It was anxieties about the nature and appearance of Christ which most likely lay behind the two bishops' opposition to the fraudulent claims of the promoters of the Turin Shroud (and they were undoubtedly incensed when their critics accused them of trying to get in on the act). The paradox is that here we find the Middle Ages to be a time of scepticism, and the STURP scientists to live in a time of credulity.

Icons of Christ take us to the emotive centre of the Byzantine experience of the power of art. The iconoclasts were sure that the eucharist was the 'one true image of God'; the iconophiles pointed instead to the image of Christ on his icons.[63] Both sides had to relate words and symbols.[64] Many statements were made: 'Images are guides to truth' or 'Icons are equivalent to writing.'[65] But it is difficult to find a coherent theory in the Byzantine texts on the functions of icons. We too can fall back on the Orthodox statement: 'If anyone does not reverence our Lord Jesus Christ and his pure Mother depicted on an icon, let them be anathema' (illus. 1).

This chapter has looked at the centrality of icons of Christ in everyday experience without drawing any analogies between the dominance of Christ in the symbolic universe and the dominance of the emperor in the temporal sphere. For the majority of Byzantines, the emperor, who was treated as Christ's representative on earth, was almost as powerful and

as remote as Christ.[66] The imageries of Christ and the emperor were constructed in dialogue with each other. Christ on his throne in heaven was portrayed in a range of modes, sometimes benign, sometimes threatening. He was addressed through a petition, a *deisis*, in which people asked above all for the remission of their sins. Their attitude of mind can be gauged when we see how a Byzantine subject might seek to address not the emperor himself but a mere imperial official in the provinces. The following is a petition to the governor of the Thebaid in Egypt in 576:

> Petition and supplication from your most pitiable slaves, the wretched small owners and inhabitants of the all-miserable village of Aphrodite … We humbly recall your all-wise, most famous and good-loving intelligence, but it reaches such a height of wisdom and comprehension (beyond the limited range of words to express) as to grasp the whole with complete knowledge and amendment: whence without fear we are coming to grovel in the track of your immaculate footsteps and inform you of the state of our affairs … All justice and just dealing illuminate the proceedings of your excellent and magnificent authority … we set all our hopes of salvation upon your Highness … to help us in all our emergencies, to deliver us from the assault of unjust men, to snatch us out of the unspeakable sufferings.[67]

This abject language is just one document of the nature of the ordinary acceptance of inferiority in the Byzantine empire. In court circles in Constantinople, this discourse was elevated to a fine art. When two luxurious manuscripts were produced for Basil ii (975–1025), one an illustrated book of psalms (now Venice, Marciana Library, Cod. gr. 17), the other an illustrated calendar of saints (the so-called *Menologion of Basil ii*, now Vatican Library, Gr. 1613), each was prefaced with a laudatory poem and an accompanying picture (illus. 47).[68] The picture shows the emperor towering over his grovelling enemies and in the company of icons of saints. From above him descends a crown, carried from Christ's hand by angels. The image and accompanying text are equally dominating:

> A strange marvel is to be seen here: from Heaven, Christ, in his life-giving right, extends the crown, the symbol of power, to Basil, the pious and mighty Ruler. Below are the foremost two of the incorporeal Beings: one of them has

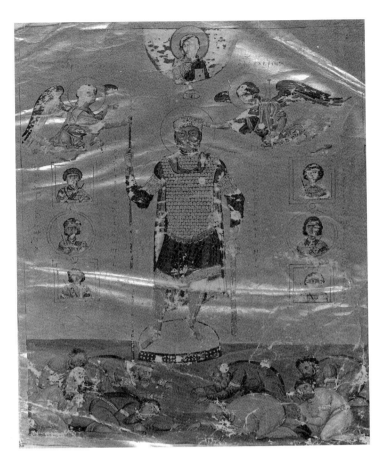

taken the crown and brought it down, and is joyfully
crowning the Emperor; the other adding victories to the
symbol of power, is placing the lance, a weapon that
frightens the enemies away, in the ruler's hand. The martyrs
are his allies, for he is their friend. They smite his enemies
who are lying at his feet.

In the other manuscript, we have only the text without the
image (which seems to have represented Christ the Panto-
crator above and Basil below, reigning in their respective
spheres):

Viewer, see here the most exquisite of works, containing the
best deeds, a most beautiful work of God, astonishing to the
mind, a work which, with reason, fills the whole of creation
with joy.

Above there is he who as God and Lord has painted the heavens with a circling motion of stars – the Heavens which, by his word, he stretched out like a curtain of leather – and illumines the world through his all-wise forethought.

Below, Basil, who mirrors him in his character, ruler of the whole earth, sun of the purple, reared in purple robes, excelling both in victories and in learning, gladdens the minds of all the Orthodox and cheers all contemplation with delight, having produced a book genuinely like another heaven, stretched out from sheets of leather provided by nature.

This book contains beautiful images like stars: first of the Word, both God and Man; then of the Mother who gave immaculate birth; of wise prophets, martyrs and apostles, of all the righteous, of angels and archangels.

In all those whom he has portrayed in colours, may he find active helpers, supports of the state, allies in battles, deliverers from sufferings, healers in sickness, and above all, eager mediators before the Lord at the time of Judgement, and providers of ineffable glory and the Kingdom of God.

This set of texts is quoted as a way of indicating both the special messages contained in icons of Christ and their connections with the ruling ideology of Byzantium. While the Byzantine Pantocrator is one of the most remote images of the Middle Ages for a post-Reformation concept of Christ, it illumines the character of imperial society which developed in Constantinople. While the images of the Virgin may seem easily approachable, the icon of Christ stands as a stark witness to Byzantine society.

4 Maturity and Identity

Who would find it easy, after a visit to Ravenna and its solemn mosaics, to think of noisy children in Byzantium?

E. H. Gombrich, *Art and Scholarship*

At the end of the last chapter, the representation of the Byzantine emperor emerged. We have seen how the reaction to iconoclasm promoted the imagery of the Hodigitria and the portraiture of Christ, and this imagery can be seen primarily through the medium of the painted panel. We need to bring in other types of art in the investigation of the range of imagery after iconoclasm. The period after iconoclasm has many prominent representations of the emperors. The most conspicuous of these is a mosaic panel set up in the narthex of the main church of the empire, St Sophia. It decorated the lunette over the main door into the centre of the nave of the church. This mosaic icon represented four figures within a semicircular frame (illus. 49).[1] The grand doorway below was used exclusively, it seems, by the emperor and the patriarch together as they made the transition from the everyday world outside to the heavenly interior of the church.

From around the year 900, when the image was set in place, every visitor to the church must have looked up at the panel and contemplated the four figures. In the centre was Christ enthroned. To the left was a crowned emperor prostrate on the floor before Christ, the King of Kings. Above the emperor, the viewer saw within a circular frame an icon of the Panagia. To the right was an icon of an archangel, also within a circular frame. None of the figures is accompanied by a name; they were – and are – to be recognised and identified visually. A century or so after the mosaic was set up, the panel was renovated, and the sigla for Christ (JESUS CHRISTOS) were inserted on each side of his halo, but neither the emperor nor the figures in medallions were ever identified with clear written inscriptions. The viewer always had to read the message from the pictorial clues, except for one verbal hint:

Christ does hold a text, which must have been meant to aid viewing. This text is a combination of two phrases from the New Testament: 'PEACE BE WITH YOU. I AM THE LIGHT OF THE WORLD.'

This mosaic has been much studied since its restoration in 1932. The debate has centred on the identification of the emperor. Is this a portrait of Basil I (867–86) or his son Leo VI (886–912)? The question of identity was narrowed down to these two candidates on the basis of style. The debate also raised a question about whether the mosaic's meaning depends on the identity of the emperor or whether it might be a more general image of 'emperor'. The omission of any identifying text for the emperor might be a positive and significant decision. In either case, the work contains many ambiguities. Is it a derogatory portrayal of the emperor – the sinful emperor shown in remorse, awaiting the Judgement of Christ? Or is it a celebration of the emperor graced with the favour of Christ, the King on earth before the King of Kings? Both interpretations have been set out, opening a debate over the relative political and ecclesiastical significance of the image.[2]

One thing above all is clear from this image: it declares to all visitors who enter the showpiece monument of the Byzantine world that the Christian message can and must be proclaimed symbolically through icons. Although the viewer will speak of seeing the emperor in *proskynesis* in front of Christ, it is of course only an icon, not an emperor, that we see. The emperor and Christ are icons set in a spaceless world of gold and light, and they are accompanied by framed icons of the Panagia and the archangel. We know from accounts of the ceremonial of the church that emperors did indeed kneel down in front of this door. From the time of the production of this mosaic, this moment was reflected in the icon above; the peace and light of Christ at the doorway of the church were promised, and emperor and Christ were symbolically present together. The temporal act and eternal promise are united in the space of the church. But the problem set by the image in this location remains one about meanings and levels of evocation. How far beyond the explicit text held by Christ should the interpretation go?[3]

The decoration of St Sophia was developed piecemeal in the years after iconoclasm, but from the viewer's perspectives, the

48 View of the central doorway of St Sophia, Constantinople, showing the mosaic (illus 49) in the lunette.

49 *The Emperor before Christ*, 9th or 10th century, mosaic in the central lunette of the narthex, St Sophia, Constantinople.

various images would still be read as a unity. The viewer of this lunette who looked through the open door into the nave would have seen the distant apse mosaic, the first image set up in St Sophia after iconoclasm and inaugurated in 867. Here was a decoration of the Panagia enthroned holding Jesus and attended by the archangels Michael and Gabriel. The link between the two mosaics is seen in the representation of the Panagia and an archangel in both. The celebratory sermon delivered when the apse mosaic was inaugurated by the patriarch Photios dwells on the imagery representing through the figures of the Mother and Child the mystery of the incarnate logos. Photios points out that the logos is Wisdom, Sophia; the church was dedicated to Holy Wisdom and celebrated the annual commemoration of its dedication on Christmas Day. This opens up the possibility that a Byzantine viewer in the narthex might have seen this lunette too as a reference to Holy Wisdom, the gift of Christ to the reigning emperor.[4]

The triumph of Orthodoxy not only legitimated the use of icons; it surely meant that there was an obligation to set up icons in a church like St Sophia. Icons were to be the essential complement to other expressions of belief and values. The failure of iconoclasm gave the impetus to develop a role for icons in Byzantine society. Not only were Christ and the saints to be represented; icons would give a further dimension to all ways of thinking. A case in point is the language in which the life of a tenth-century holy woman called Irene, the abbess of the monastery of Chrysobalanton, is portrayed.[5] This text offers some of the terms in which the end of iconoclasm was portrayed. It shows the triumphal nature of the celebration (and some of the phrases are borrowed from the office for vespers on the Sunday of Orthodoxy): 'God's Church regained her ornament, the God-pleasing representations on icons, which were made and venerated on walls and panels, in all kinds of material, bronze, silver and gold' (ch. 1, pp. 2–5, ll. 17ff). Later in the *Life,* there is a description of the holy woman, as she prays, with her arms raised. She sees St Basil standing before her, and in her sight he looks exactly as she has seen him in his icons (ch. 13, pp. 56–7).

The *Life* of Irene (however apocryphal) shows how deeply the awareness of icons penetrated the Byzantine conscious-ness. The text goes beyond mere mention of icons and reflects

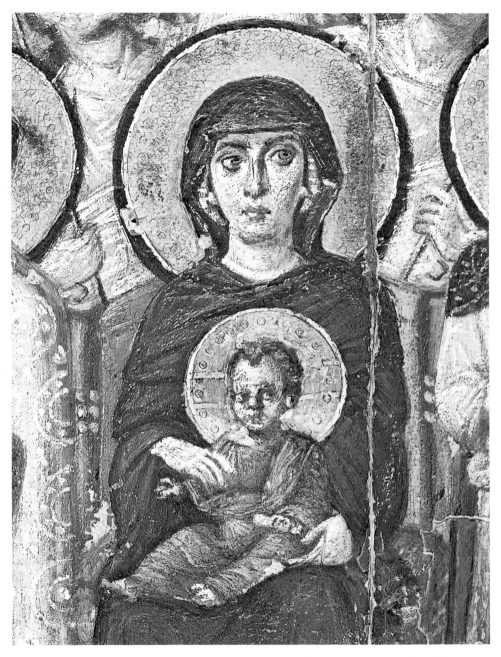

50 *Panagia and Child with Angels and Saints*, 6th century, detail from an icon. St Catherine's Monastery, Sinai.

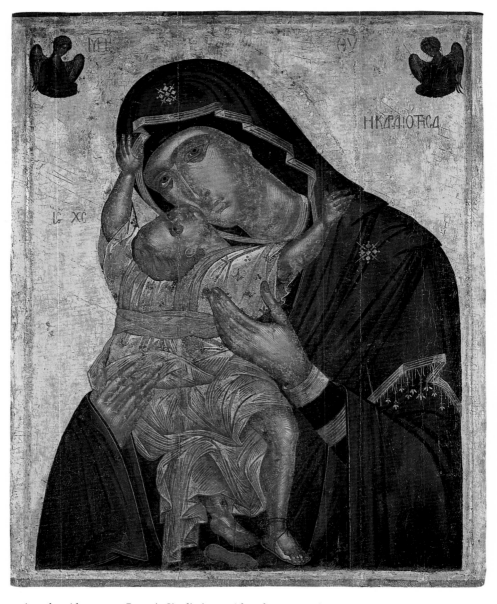

51 Angelos Akotantos, *Panagia Kardiotissa*, mid-15th century, icon.

52 *Annunciation*, late 12th century, icon. St Catherine's Monastery, Sinai.

138

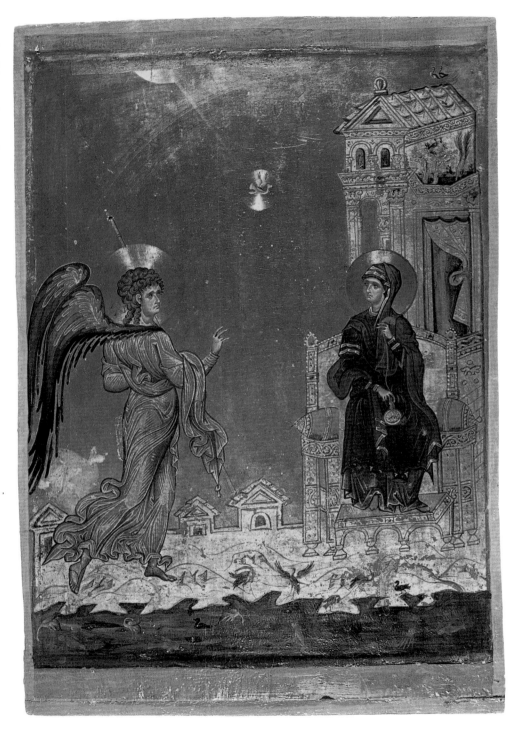

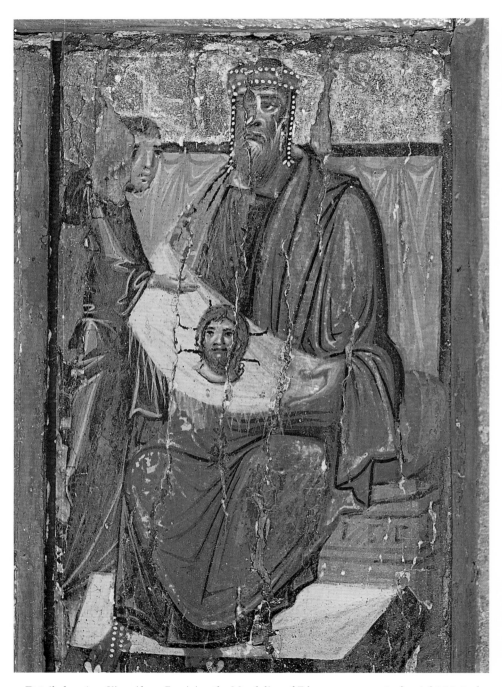

53 Detail showing *King Abgar Receiving the Mandylion of Edessa*, upper part of a right triptych wing, 10th century. St Catherine's Monastery, Sinai.

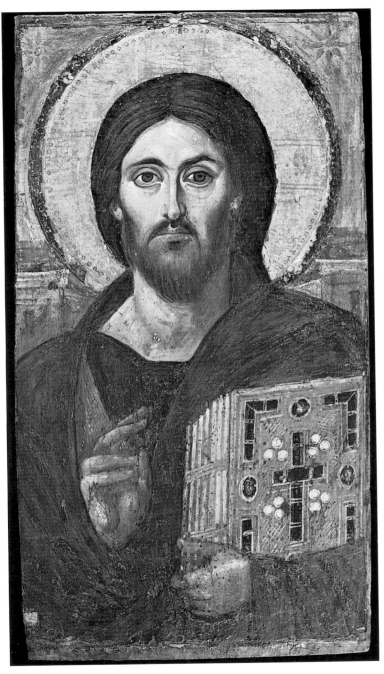

54 *Christ*, 6th century, icon. St Catherine's Monastery, Sinai.

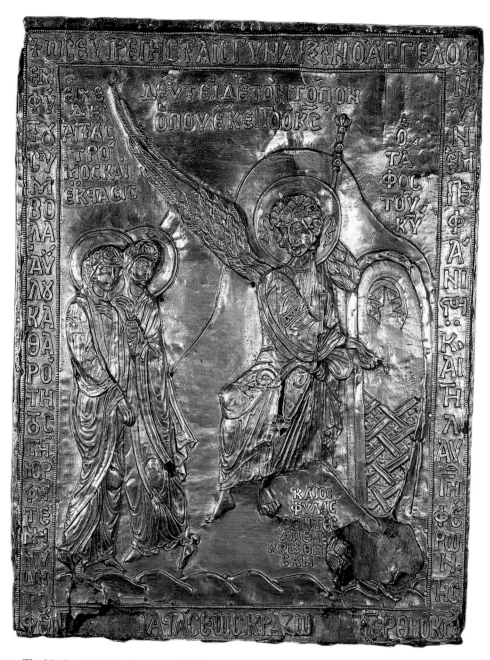

55 *The Maries at the Tomb* on a gold reliquary, 12th century.

56 *Christ*, 14th century, icon. Crypt of the Church of Alexander Nevsky, Sofia, Bulgaria.

57 *Heavenly Ladder of John Climacos*, 12th century, icon. St Catherine's
Monastery, Sinai.

ways in which Byzantine thinking now depended on visual portraiture to verify the existence of saints. It belongs to the period when one justification for icons was felt to be their guidance on the appearance of saints (useful when the Orthodox Christian met them in the next world).[6] This text shows how icons had a function in helping people to recognise the saints in dreams and visions.[7] It was strongly influenced by visual imagery. In a passage which describes a dream vision of the Panagia, we read that Irene's companions shone as brightly as the sun, but the face of Mary was too radiant to be seen (ch. 13, pp. 58–9). Another story tells how the emperor had a dream vision of a woman who might have been Irene. He sent a group of courtiers to the monastery to visit her together with a painter charged to paint her portrait icon. The emperor wanted to try to identify the woman in his dream. The painter produced the portrait, working from the life in the monastery. This icon was brought to the emperor, and he saw the face of the woman in his dream (ch. 21; pp. 92–3, 96–7).

The freedom to work with icons which came after iconoclasm changed Byzantine ways of expression. It initiated a period of experiment and celebration, which might best be indicated through a manuscript production of the ninth century. One of the most famous iconophiles during iconoclasm was the monk St John of Damascus (675–c.750). He was a prolific writer and defender of icons. Soon after iconoclasm, a manuscript which contained the vast text of one of his books (Paris, Bibliothèque Nationale, Gr. 923) was produced. It also contains a striking number of pictures (more than six hundred).[8] One of its miniatures is the representation of an icon painter at work which records from the perspective of the ninth century the importance of the icon already in the early Byzantine period (illus. 22). The manuscript equally offers a perspective on its own period of production. The fundamental publication of the manuscript aimed to solve one particular question: it was a (controversial) attempt to reproduce lost manuscripts of the early Byzantine period by identifying the models of all the pictures. The argument was that the book was created by artists who painstakingly consulted earlier Byzantine manuscripts each time they were set to illustrate the text with one of the four hundred scenes and twelve hundred portraits that we now have. The

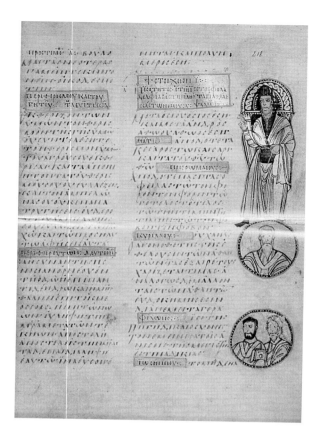

manuscript was treated as a pictorial dictionary of lost sources; its importance was seen as the preservation of art from the period before iconoclasm (illus. 58).

A work produced in the ninth century is better handled as an object which answered the needs of its ninth-century audience. The extraordinary number of icons in the Paris manuscript is one of its immediate features. These include a portrait of Methodios, the first patriarch of Constantinople after iconoclasm (843–7) in whose period of office the triumph of Orthodoxy was celebrated; this earned him a conspicuous place on the upper register of the British Museum icon of the Triumph of Orthodoxy (illus. 12). His inclusion dates the Paris manuscript after iconoclasm, and very likely it was produced in Constantinople in the second half of the ninth century.[9] It is a massive production, both in the number of pages (requiring many animal skins for its parchment) and in their size (36.6 by 26.5 centimetres), and gold leaf was used lavishly throughout.

It is the only illustrated edition of this text of St John of Damascus, and so a very special and very expensive 'promotion'. The text is a partial version of an enormous *florilegium* compiled under his name, just the kind of book that the Byzantines loved – a digest of snippets and quotations. This particular *florilegium* is often called the *Sacra Parallela* (after the contents of the third and last section) and is a vast selection of scriptural and patristic texts on the Christian moral and ascetic life. The first section contains texts on the nature of Divinity; the second and longest part consists of texts on the nature of Man; and the third is a parallel treatment of virtues and vices – hence the popular title. The Paris manuscript contains part II of this compilation, the selected quotations on the nature of humankind. A complete text of the *florilegium*, of which the Greek title is *Hiera*, was published by Migne in the *Patrologia Graeca*, although none of the various manuscripts in which it has survived coincide exactly in their contents. No doubt, it went through several versions of differing lengths and contents.

Although the *florilegium* is conventionally attributed to John of Damascus, and a portrait of him as the author appears in this manuscript, we do not know if John himself carried out the whole vast project personally or if it was part of a corporate exercise in his Palestinian monastery of Mar Saba, a complex developed in the sixth century overlooking the Dead Sea.[10] Nor do we know exactly when an edition of the *Sacra Parallela* was first put together, whether it was soon after c. 716, when John seems to have entered Mar Saba, or sometime later in his life after the outbreak of iconoclasm and before he died in the middle of the eighth century. The writings which established John as the major theologian of the iconophile cause were the *Three Discourses against Iconoclasts*, dating between 726 and 736, and *The Fount of Wisdom*. But these attributional questions are not so important for the art history of our manuscript as the fact that by the ninth century, John was seen as one of the great saints who contributed to the victory over iconoclasm; everything he wrote must have reflected his heroic image in the history of the Orthodox church.

The importance of St John as an iconophile must have been a factor in the production of this manuscript. The contents do not seem directly relevant to the iconophile debate, although

one might argue that the choice of part II of the complete *Sacra Parallela* might be significant (in view of the topicality of human beings as made in the image of God within iconophile theology). This should be said with the qualification that the Paris manuscript might be only one volume of a set which also contained the other parts in separate books. What is obvious from its production is that it was planned to make a great visual impact. The book has a narrow text column with wide margins, thereby offering scope for the artists to provide a visual commentary on the excerpts. Sometimes, a short cycle of narrative images brings the text to life as a story with a moral; sometimes we see no more than a sequence of iconic portraits of the authors of each excerpt. In illustration 55, we see a page which is the beginning of a chapter, one of twenty-four which each represent a letter of the alphabet. This folio shows the start of the chapter dedicated to the letter 'iota', which consists of a number of sections containing key words which begin with the letter 'I'. The quotations attached to each key word are arranged systematically in the following order: Old Testament, New Testament, early Church Fathers. The chapter headings, section headings, books, and authors are highlighted against a gold ground. Here, we see section 1 (*peri isotetos*, 'on equality') with appropriate quotations from Psalms, Matthew, Romans, Cyril, Philo, and Josephus. The pictures, set in the margin, are of a selection of the authors of the passages on the page, including John of Damascus (the author of the whole book), Cyril of Alexandria, Philo (portrayed as a Christian bishop), and Josephus. This page consists entirely of portrait icons, painted rapidly and fluently over a gold ground. These miniature icons work as signs with the utmost brevity. In just the same way, the text is telegraphic – it gives a moral code and a set of values through brief relevant quotations which state Christian ethic. The assumption is that the quoted texts state truth without the need for further argument. They record Orthodox authority and wisdom.

This is one of the major pictorial enterprises of the years immediately after iconoclasm. Its theological importance lies in its texts, yet it is full of pictures and the only *Sacra Parallela* to follow this pattern. Only a few books in the history of Byzantine art ever embarked on such a full cycle. The text beside the icon painter (illus. 22) suggests that the function of

all these texts and images might be described as 'didactic' or utilitarian: they were intended to encourage the viewer to imitate Christ or the holy fathers and to follow their ethical precepts. The pictures were meant to call attention to the authors of edifying thoughts and instructions. Such an explanation is only satisfactory up to a point, however. It is too neutral a viewing of the images. Were *all* these hundreds of pictures really necessary to mark the text or make it more accessible?

For such 'excessive illustration', we have, of course, a ready fall-back explanation, often brought into the discussion of Medieval art, that the illustration was done 'for the glory of God'. In other words, Byzantine authors and copyists, and the artists who decorated their books, expended vast effort on decoration and illustration, beyond all considerations of economy, because they were directed towards the honour of God. This is no doubt true in part, but it fails to explain why it was *this* activity (rather than plant cultivation, visiting the sick, or something else) that was directed so lavishly at the Lord. It was not a random activity – 'art' was produced in preference to many other activities. This suggests that the utilitarian explanation for these pictures is an incomplete one. The visual component of the manuscript is only one element in the whole, and integrates text and image. The images are not just a pictorial index. For the ninth-century viewer who had succeeded to a century of debate about the legitimacy of images, the manuscript had a special message. Its author had fought to be recognised as Orthodox and had succeeded. He had fought for the freedom to have icons. This book parades the orthodoxy of St John of Damascus, and it parades the iconophile victory. How more appropriately could a champion of orthodoxy be celebrated in the ninth century? The name of John of Damascus instantly evoked icons. The prestige and power of the manuscript depends on the presence of icons. Another manuscript of the same period uses the same paradox. The Khludov Psalter illustrates an iconoclast patriarch in the act of destroying icons (illus. 59). But the act of painting confutes the action it portrays. Another way in which the pictures in the Paris manuscript convey more than literal meanings is by their lavish use of gold. Many of the figures included are ascetics and monks. In life, the monk wore black, but in death he took on the white 'angelic'

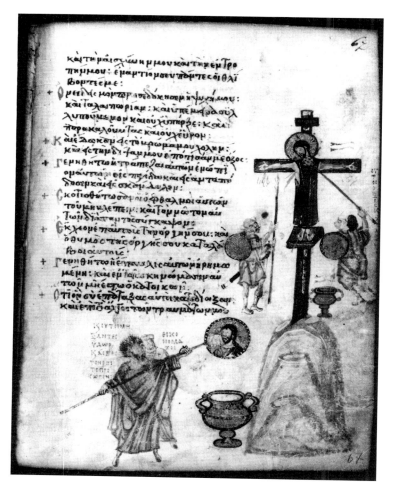

59 *The Crucifixion with the Iconoclast Patriarch John the Grammarian whitewashing an Icon*, from a 9th-century manuscript (the Khludov Psalter). Moscow State Historical Museum.

habit. In this book, their portrayal with gold suggests that the monks are invested with the light of Heaven.

The meaning of these icons is as much in their manner of portrayal as in their subjects. The relation of images to text here is not an equal one; the authority of the icons is to validate the text and its orthodoxy. Page after page of icons of monks and theologians progressively celebrate the faith of the monk and church leaders who as a group were attacked during Iconoclasm. This suggests a further dimension in the imagery. The text promotes many of the values of the monk, who in his life imitates the model of Christ. An alignment of the monastic life and the use of icons is suggested. The holy monk needs the holy icon. Another implication of the imagery

is that the Church Fathers, because they are represented in icons, are to be numbered among the iconophile champions. St John of Damascus himself, although acting more as editor than author, is given greater authorial prestige through the inclusion of a grand portrait.

This analysis of the manuscript depends on an appreciation of its precise historical date and context. Its form and contents depend on topicality as a witness to a great champion of Orthodoxy. It suggests that in the ninth century, Byzantium was developing an identity expressed through and with icons. If this is true, there should be some corrobation by the perceptions of Byzantium shown by other groups. A comment on the response of outside viewers to European group identities is given by the Russian conversion to Orthodoxy in 988, when Prince Vladimir of Kiev reportedly assessed the relative attractions of Byzantine Orthodoxy, Latin Catholicism, and Islam.[11] As the story goes, missionaries of each group went to Kiev to advertise the superiority of their faiths. It was decided next to send a delegation of ten men of the great and the good of Kiev to make an inspection in each country. They went at last to Constantinople, where they were received at a ceremonial audience by the Byzantine emperor (at this time Basil 11; see illus. 47), whom they told that they would inspect the Orthodox faith the next day. The emperor sent a message to the patriarch which directed him to prepare the church of St Sophia and to array himself and the clergy in their priestly robes to give the best impression of the glory of the God of the Greeks. The next morning, the patriarch and the clergy celebrated the rites and burned incense and the choirs sang hymns. The emperor took the Russians into the central space of the church, pointed out the beauty of the building, the chanting and the service, and explained how God was worshipped in Byzantium. They in turn praised the ceremonial and were dispatched back to Kiev with honour and gifts. Their report back at Kiev was ecstatic about the churches of Byzantium: 'We knew not whether we were in heaven or on earth. For on earth there is no such splendour or such beauty and we are at a loss how to describe it. We know only that God dwells there among men, and their service is fairer than the ceremonies of other nations.' This report was decisive, and Prince Vladimir commanded all the people of the Kievan state to be baptised in the Dnieper River.

This account of what impressed the Russian visitors in Constantinople reveals how the impact of the church was carefully orchestrated. One of the elements they saw was the figurative decoration of the interior of St Sophia, including no doubt the lunette over the central doorway. Russian accounts of Constantinople in the fourteenth and fifteenth centuries indicate that by then it was the icons of St Sophia and other churches that they admired as much as the relics; western visitors, it appears, showed less interest in the devotional icons of Byzantium.[12] The aspect of state ceremonial that was common to east and west was the public display of the ruler in processions. The classic description of the protocol comes from Late Antiquity, when the historian Ammianus described the visit to Rome on 28 April 357 of one of the sons of Constantine the Great, the emperor Constantius II (337–61).[13] We are told that the emperor appeared to the public enthroned in his golden carriage, immovable as a statue, amid the glitter of precious stones. The emperor was acclaimed by the crowds; 'he never flinched but showed himself immobile as he was normally seen in his provinces.' He kept his gaze straight ahead, turning his face neither right nor left, as if his neck was held in a clamp. Like a graven image of a man, he neither allowed his head to shake when the wheel of the carriage jolted nor was he at any time seen to spit or to wipe or rub his face or nose or to move his hands. The demeanour of the emperor is compared in this (Latin) text to an image, although the notion of the immobility of the ruler goes back to Greek and Persian tradition.[14] It is clear that all emperors were advised and trained in strategies of public presentation. A later example in Byzantium was the conduct of the emperor Constantine IX Monomachos (1042–55), whose public appearances in later life became extremely stressful as the result of a debilitating (and terminal) disease. The historian Michael Psellos gives an account in his *Chronographia* (ch. 129) along the following lines.[15] Constantine accepted that for the sake of the city populace he had the duty to attend imperial processions, despite his appalling and painful illness. His attendants managed to mount him on his horse and keep him propped up by riding beside him. Despite his problems, Constantine managed to act normally. He would assume an expression of great benevolence and even managed to move and change his position, which concealed the fact of his illness

and paralysis from the spectators. Special arrangements were made for him in such processions; for example, the roads were covered with carpets to prevent his horse slipping on the smooth stones.

Psellos did not emphasise the immobility of the emperor, as Ammianus had done in the case of Constantius, nor did he compare Constantine's bearing with an icon. Psellos wanted to make the opposite point – that the paralysed emperor needed to show his humanity, and so he had to move and smile. In both cases, the aim of the public display was to impress the people, but for once the analogy with an icon was an inappropriate one for Psellos to use. The convention of comparing the emperor with an icon is also subverted by the account of a Byzantine imperial procession given in his satirical description of his tenth-century official visit to Constantinople by the sophisticated Italian cleric Bishop Liudprand of Cremona (c. 920–72). The revealing part of his 'diary' refers to his second visit to the Byzantine capital as an ambassador. His first visit (949–50) had been a diplomatic triumph; the second (968) was a humiliating disaster. He correspondingly produced an adverse comparison of the (usurper) emperor Nicephoros Phocas (963–69) with the rosy picture he had previously constructed of Constantine VII Porphyrogenitos (913-59). In chapters 9 and 10 of the *Embassy to Constantinople (Relation de Legatione Constantinopolitana)*, Liudprand describes a procession from the palace to St Sophia in which he found as much ammunition as possible with which to pillory the emperor he now loathed.[16] The procession was on the early morning of 7 June, the day of Pentecost, and Liudprand was given a good position on a platform near the singers, away from the ragged crowd of people whom he snobbishly disdained. Nicephoros wore the imperial regalia with jewels and golden ornaments, but Liudprand saw him as only a 'dwarf' in appearance. While the singers chanted the set praises of a Byzantine emperor – 'Behold the morning star approaches: the day star rises: in his eyes the sun's rays are reflected' and 'Long life, long life to our prince Nicephoros. Adore him, ye nations, worship him, bow down before his greatness' – Liudprand produced his parody. In his view, they should have sung: 'Come, you miserable burnt-out coal: old woman in your walk: wood-devil in your look: clodhopper, haunter of byres: goat-footed, horned,

double-limbed: bristly, wild, rough, barbarian, harsh, hairy, a rebel, a Cappadocian.' Liudprand went on to complain that Nicephoros entered St Sophia, puffed up with 'lying ditties', while the co-emperors Basil II and his brother Constantine III were forced to pay homage to him. This is, of course, the same imperial pair who were later to prompt the patriarch to magnify the ceremonial of the church in order to astound the delegation from Prince Vladimir of Kiev.

The intense experiences of Liudprand and others bear witness to the mystique which overlay and supported the structures of power in the empire. Official power lay within the imperial system, which was an institution subtly inter-woven with religion. The emperor was regarded and pictured, as we have seen, as Christ's representative on earth. One task of a courtier was to support the institution and express these ideas in new ways. When Bishop John Mauropous wrote a letter to Constantine IX Monomachos around the year 1047, he filled it with the obligatory rhetoric of flattery, directly calling the emperor 'image and likeness and type of Christ'.[17] The public must have seen the Great Palace where the emperor resided as a sacred palace, partly due to his status and partly due to the growing collection of sacred relics displayed in its churches. These imperial possessions, although inaccessible to the general public, played an essential role in the development of the Byzantine icon.

The display of sacred relics and icons was of course a feature of the whole city of Constantinople. Certain churches possessed particularly famous and precious objects, including the major churches dedicated to the Panagia, such as the Chalcoprateia, Vlacherna, and Hodigitria, which contained the key relics connected with Mary (her girdle, mantle, and portrait by St Luke). With the transfer to the city of so many relics or connected objects, such as the Mandylion of Edessa, Constantinople could be regarded as almost literally a new Jerusalem. The Russian travellers avidly recorded the legends and stories connected with the tour of the icons and relics of Constantinople. All these relics were enhanced by the rich church settings in which they were displayed for devotion and by their presentation in precious encasements. But the concentration of the most precious images and relics was either in St Sophia or, increasingly, in the private domain of the Great Palace. As temporal power was concentrated in the

palace, so the symbolic realm increasingly became the preserve of the emperor.

One relic in particular exemplifies these processes. A piece of stone from Christ's tomb in Jerusalem came into the possession of the emperor and was housed in the private church of the Pharos inside the walls of the Great Palace. As we have seen, it was one of the major relics which westerners removed during the Latin occupation after 1204 (illus. 55). Hardly a promising item aesthetically, it was nonetheless beautifully mounted, probably in the second half of the twelfth century, within a gold repoussé cover. The imagery chosen was appropriate – the Maries at the Tomb – and the scene was enhanced with texts evoking the moment of the Resurrection. The stone itself was sanctified by its contact with Christ, and like the Turin Shroud it was physical evidence of the mystery of the Resurrection. But as an object of reverence in the palace, the artistic enhancement was crucial to its effect.

In 1241, this precious relic was taken to France along with other relics of the Passion of Christ, entered the royal collection of King Louis, and was displayed in the Sainte-Chapelle in Paris.[18] The main plaque over the stone represents the figure 'dressed in white' sitting on the 'actual' rock-cut tomb from which the relic came; the sweeping wings are formally dramatic and show iconographically that this is an angel – Matthew (28:1–8) tells of an angel which appeared like a flash of lightning. The angel points to the empty tomb and shroud of Christ; the two Maries cling to each other in alarm and amazement. What is emphasised is their intense emotion at the miracle rather than the narrative of their early morning visit with spices and aromatic oils to anoint the body. Below the empty tomb are the soldiers on guard. At this moment, so we are told by Matthew, they were either asleep or at the sight of the angel 'shook with fear and lay like the dead'. The artist chose therefore to put the emphasis on the reactions of the participants to the event. The icon works through texts as well. The words around the picture tell of the brightness and purity of the angel who revealed the splendour of the Resurrection by his beauty and by his words, 'The Lord has awakened'. Other texts from the Gospels say, over the two Maries, 'Fear and trembling came upon them' (Mark 16:8); over the angel, 'Come and see the place where he lay' (Matthew 28:6); over the rock, 'The Tomb of the Lord'; and

over the soldiers, 'The guards as if dead'. Any viewer would be emotionally and intellectually satisfied by the combination of expressive style and precise textual reference. Picture and writing work together. Text is more than a device to reduce the inherent ambiguity of the pictorial image; it helps to underline that Christianity is a religion of the book, that every image of the faith has a corresponding support in the genuine word of God. This offers a great contrast in the use of art to the Méronas icon (illus. 8), which works as an image almost entirely without descriptive text. The other extreme in Byzantium is contained in the *ekphrasis*, which can conjure up an 'invisible' icon for a literate audience of viewers. It may exist, however, only in the mind.[19]

The period after iconoclasm established the role of the icon in Byzantium, and in the course of the eleventh and twelfth centuries the implications of the use of the icon were worked out. This is rightly seen as the pivotal period in the major study by Hans Belting, who has attempted to document the development of a 'new style'.[20] The question is how far the Byzantine themselves were aware of the character of this period. Since we may want to define it through stylistic changes, this raises the question of how far a Medieval society which went through changes in its art could recognise the situation. Belting sees the style of icons being transformed in the eleventh century; the marker is the appearance of narrative elements and the depiction of states of emotion (for example, of motherly love or of mourning). This characterisation can be supported from the icons of the period. One text is adduced as evidence of a contemporary appreciation of artistic change. In the inventory of icons listed at the end of the Rule (*typikon*) of a rich monastery of the Panagia Kecharitomene (Our Lady of Grace) in Constantinople, there is the possibility that the writer mentions an icon in a 'new style': 'An icon painted on wood *in the new style* with Christ Enthroned and below him the Mother of God also enthroned, and Peter and Paul on each side'.[21] The Greek word translated 'in the new style' is *kainourgos*. Is this what it means? Elsewhere, the inventory describes other icons as 'old' (*palaia*). This supports a more neutral translation – that *kainourgos* means 'newly made'. This translation has the advantage of providing an 'objective' description rather than a critical one, and this sounds more reasonable for a legal

document. It has the disadvantage of removing a possible witness to the sensitivity of Byzantine viewers to style.

The most sophisticated writing on art in eleventh-century Constantinople is found in the work of Michael Psellos. Belting treats one of his treatises with an *ekphrasis* of an icon of the Crucifixion as evidence of the delicate tension between visual representation and literary rhetoric.[22] This subject invites the painter to show the religious paradox of Christ both 'alive' and 'lifeless'. This also mirrors the (old) iconoclast debate about whether the dead materials of paintings were appropriate for use in the artistic representation of holy figures, about more obvious theological metaphysics of the senses (in which Christ was God *and* man and 'died' on the cross), and about whether Christ's body was imperishable. Psellos tried to resolve the theology by seeing the artist (like an evangelist) as inspired by God and so enabled through pictorial evidence to offer a solution to the puzzle of how the figure of Christ could be both alive and lifeless. In the course of his argument, Belting suggests that Psellos had constructed the notion of 'living painting' and that in his exposition the icon had become the parallel medium with text for expressing theological doctrine, which had at the same time to work vividly on the viewer. Art in this conception can help one through the maze of theology; unlike abstract argument, it is seen to represent the truth directly. If the representation can be read correctly, it must solve the theology!

Psellos wrote at a time when we see change in the forms of Byzantine icons; that the impulse was the contemporary intellectual and philosophical climate is an attractive explanation. But the picture remains unclear, for the functions of icons were changing, too. In this period, the cult of the Hodigitria was on the increase, and there is evidence of changes in monastic spirituality.[23] We may see hints of sentimentality in the representation of the Panagia in this period, as in the icon of Vladimir that was sent from Constantinople to Kiev in the early twelfth century (illus. 60). But an increase in the 'emotional' power of the icon in this period does not presuppose some kind of psychological change on the part of viewers. That would be like saying that the music of Beethoven is more emotional than that of Bach. The state of research is such that we must look further to describe changes in art. One of these involves the development of the altar

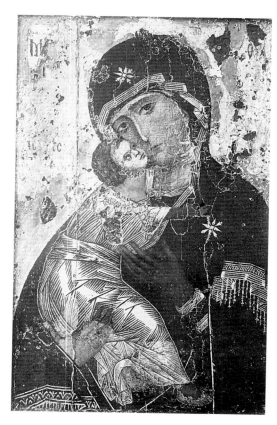

60 *Panagia and Child*, 12th century, icon of Vladimir.

screen and the increasing introduction of stands (*proskynetaria*) for icons around the church (illus. 34–36). The precise chronology of change in the character of the *templon* is uncertain; very likely, the pace of development varied in different regions and different types of churches. The *templon*, as we have seen, gave the opportunity for the insertion of intercolumnar icons and for icons running along the beam (illus. 36). This is, then, one practical and empirical factor which stimulated the manufacture of an increasing number of icons. The development of an opaque screen had a further effect on laity in the church; their viewing of the altar could henceforth be controlled. The axis of viewing in the church also changed. There were more icons and they were accessible; once they began to be regularly and communally kissed and used as objects of devotion, they gained a special personal relationship with each of the participants in the church rites.[24]

Another feature of the period was an increase in the regular celebration of the liturgy, a fact known most strikingly from the church of St Sophia, which was given funding by the emperor Constantine IX Monomachos to ensure a daily liturgy – previously, the mass in St Sophia had only been celebrated on great festivals and Saturdays and Sundays. With the development of the liturgy in monasteries and all the other services which patrons of monasteries systematically specified when they drew up the Rule of their new foundations, one begins to appreciate the investment of both spiritual and financial capital in the monasteries.[25] The clergy were aware of this flow of patronage into the monasteries from the secular churches, which acted to the detriment of the cathedral churches of the empire.[26] Such developments changed patterns of worship and attitudes, and both in the cities and in the countryside the visible construction and development of the property-owning monasteries declared the dominance of these nodes of power. In the case of central Greece, there was the cult already noted of a special icon of the Panagia, belonging to a monastery of St Michael at Naupactos, which was regularly paraded in processions as it was taken from its shrine (*stasis*) to the private house of one of the members of a confraternity of merchants in the region (normally for a month); the whole cycle was regulated by a formal contract.[27] This cult was initiated in 1048 and was still going strong in the twelfth century.

This increase in the prominence of church rites and practices has led to the description of cultural change in this period as the 'liturgification' of daily life. One might equally well speak of the 'iconification' of the environment! As we look at the subjects of the icons from this period, it is clear that the increase in production was matched with new functions and new subjects. We see more large processional icons, probably to fit new display opportunities. The large double-sided icon from Kastoria, which shows the 'sad' Mother and Child on one face and the Man of Sorrows meeting his destiny on the other, has convincingly been seen as a twelfth-century case of the early development of a theatrical Good Friday processional carrying of the (representation of) Christ's body (illus. 61, 62).[28] The side of the icon with the body of Christ after the Crucifixion could be turned to face the congregation on Good Friday. As the experience of icons became continually more

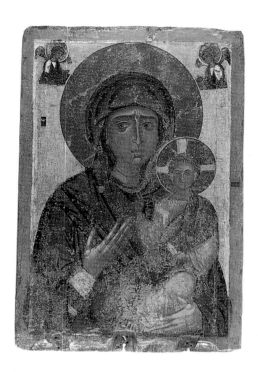
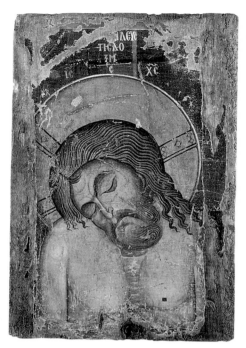

familiar, so the responses of viewers might have become jaded and have needed to be progressively refined with 'innovations' with further iconographical nuances. Later in Crete, the Man of Sorrows icons were further developed under the influence of Western versions of the Pietá.

It was not simply the expansion in the production and types of icon which made it a dominant and complex medium of expression in Byzantium; there were other factors of social change that supported icons' powers.[29] Church walls continued, of course, to be decorated (although fresco painting gradually superseded mosaic). These decorations displayed an orderly and didactic record of church history and a roster of the great holy figures and events of the past. Within this frame, icons were chosen for more piecemeal reasons, and they could selectively stimulate personal emotions in private and public prayer and worship. People could choose their own personal champions of the faith and relate directly to an intimate portrait icon.

One new image of this period may pinpoint the concerns of Byzantine society in this time (illus. 57). This is the icon of 'the Heavenly Ladder of John Climacos', now in the collection of

61 *Panagia, c.* 1200, bilateral icon. Byzantine Museum, Kastoria, Greece.

62 Other side of illus 61, the *Akra Tapeinosis* ('Man of Sorrows').

St Catherine's monastery on Sinai and dating from the twelfth century. This was a new subject for a portable icon that carried with it a load of ambivalent meanings. In a sense, the icon illustrates a text. This text, the *Heavenly Ladder (Scala Paradisi)*, had been written in the seventh century by St John Climacos in the Sinai monastery (where he became the abbot) as a guide for ascetics and monks on the proper life style for aspirants to Paradise after death.[30] To judge by the production of illustrated manuscripts, this text greatly increased in popularity in the eleventh century.[31] The icon is one further index of the popularity of its instructions.[32] But neither the icon nor the illustrated manuscripts of John Climacos can comfortably be described as literal depictions of the text.[33]

The icon shows a ladder with thirty rungs, which reflects the divisions of the text – the thirty monastic virtues leading to Paradise. The text explains that Christ was baptised in his thirtieth year, having attained the thirtieth step on the spiritual ladder. At the top, being received into Heaven, we can see the author, John Climacos, in person, followed by (it says) Archbishop Antonios – probably the man who commissioned this icon and probably the (living) abbot of Sinai, a position which carried an archbishopric. One instant problem in reading the icon is how to relate to Antonios. He might be the only intended viewer, if this was a devotional icon for his private cell, which offered him both a space for prayer and a promise of salvation. But it might also be a statement to the community of the superiority of the abbot over the ordinary monk. While others plummet into the jaws of Hell, Antonios goes steadily upwards. One must accept that there might be a private reading of the icon. But there is also another, more public one, if we draw the icon into a wider orbit. One illustrated manuscript of the Climacos text (now Paris, Bibliothèque Nationale, Coislin 263), produced in 1059, has a simple illustration of the ladder and ascending monks. While perhaps not a product of great art, this illustration conforms well with the text's spirit of optimism: the monk who follows all its prescriptions to the letter is guaranteed the ultimate ascent to Heaven. John Climacos had succeeded, one feels, in promoting the idea that the rewards of the monastic life are superior to all other ways of living. But another eleventh-century manuscript, produced in 1081 and now in Princeton (Garret 16), introduces the pessimism found in the

icon, admitting that even the monks who follow behind John Climacos may not make it to Heaven.[34] Some of the ambivalence of the simile of the ladder is implicit in the obvious Biblical parallel, the ladder in the Dream of Jacob, which makes it clear that one can use any ladder to ascend or descend.

The Climacos icon must be viewed with the pessimism of failure in mind. It shows the temptations of devils and the realities of the mouth of Hades. This pessimism matches the development at this period of Last Judgement iconography, more prominently displayed now on church walls. The icon documents these fears and suggests concern with individual salvation, and probably knowledge of the growing criticism of monastic corruption and luxurious living. In the east, these criticisms may have represented social tensions rather than any interest in spiritual reform as in the west. The development of monasteries in the eleventh and twelfth centuries was a significant factor in Byzantine history. They continued to attract the extremes of strict asceticism first seen when St Antony went into the Egyptian desert or St Symeon the Elder climbed up his column in Syria. The rock-cut cells of Byzantine Cappadocia or the Enkleistra of St Neophytos near Paphos (illus. 1) show us the uncomfortable rooms in which ascetics lived; a prayer room, or at least a prayer niche, was an essential element of an anchorite's dwelling, and some monks and hermits focused their prayers on icons.[35] Jerome spoke of 'weeping', and the text of John Climacos enthusiastically reports the 'gift of tears'. The most influential source of spiritual change in the eleventh century was St Symeon the New (949–1022), particularly in encouraging mystical practices.[36] In this respect, eastern monasticism agreed with expressions of the pious life in the west in the fourteenth century: 'a vale of tears that called for patience, penitence, assimilation to the suffering Christ, and fervent yearning for escape'.[37] All these indications lead one to suppose that it was for a monastic environment that the Kastoria double-sided icon was made (illus. 61, 62). It would have supplied a major processional icon for Easter which could also have assisted devotions to the Panagia and meditation on the meaning of the Crucifixion during the rest of the year.

This chapter has led from the 'official' centres of power in the palace and St Sophia into the 'unofficial' world of the

monastery. The church had developed into two different worlds. In the 'official' imperial structure of the Byzantine state, the patriarch of Constantinople was head of the church; his clergy and bishops formed the 'secular' church (although the patriarch could be, and sometimes was, a monk). The monasteries operated differently, with some measure of alternative 'power' within the state. They owed this to the spiritual authority of the 'Holy Man', who might be a solitary hermit or a monk and who might be male or female. Indeed, perhaps one element of iconoclasm was an attempt to limit the challenge of the monks to central authority.[38] Michael Psellos has more to offer here. In his account of the reign of Constantine IX Monomachos, we find a revealing autobiographical passage on his motive for deciding to become a monk – escapism from political trouble (*Chronographia*, bk 6, sect. 200). He defends his decision to enter the holy church and be tonsured as a monk by claiming that this was his only refuge from the emperor's inconstancy: 'We were afraid of his whims, and therefore preferred a monk's life to the inferior existence of the courtier, the untroubled calm of the church to the confusion and disorder of the Palace.' The existence and attractions of this alternative society are well indicated by Psellos, even if his motives for the retreat from secular life were highly tactical, for he re-emerged as a major power at court after the death of Constantine, and when he returned to monasticism at the end of his life, it may have been more out of necessity than choice.

Our attempt to understand the extraordinary and continuing success of the icon in Byzantium has led us to see its promotion and expansion in the eleventh and twelfth centuries in the particular circumstances of the monastery in Byzantium, away from the political centre consisting of the Imperial Palace and the patriarchal network. But it was, of course, at the centre that art worked most tirelessly to promote the idea of an Orthodox empire. The mosaic of the emperor and Christ in St Sophia shows some of the functional powers of the Byzantine image (illus. 49). If any icon was 'official' art, then a representation of the emperor over the main door of St Sophia must constitute it. But even official art can have many readings, and the promotion of state power through art is an ambivalent and collusive process which depends on the desires of viewers as well as of planners. Some may support

the emperor and look positively on his representation; others may have a hostile viewpoint. The same imagery is subject to varying interpretations. This is equally true of icons of Mary with Jesus. For some, they might evoke the family, for others, the theology of the Incarnation. An icon of Christ might appear awesome to some, supportive to others. The monks are one group with perhaps more predictable attitudes. In rejecting marriage and procreation, they stood outside the central unit in society, the family. They proclaimed the virtues of asceticism and the service of God. Yet the 'monastic' icon of the Ladder of Climacos gives us no clear message (illus. 57). The elusive element in the study of the icon is deciding where meaning lies.

This chapter is headed with a comment of Gombrich, responding to the 'official' art of Ravenna. The mosaics of Justinian and Theodora in the church of San Vitale from the middle of the sixth century are as ambivalent in their messages as the imperial lunette in the narthex of the church of St Sophia (illus 49, 63).[39] They have the apparent 'seriousness' of 'official' art made for adults. One sees that the values of an imperial society are embedded in them, and this may encourage us to think that we can decide their meanings. Gombrich warns us against this by saying that to visualise a society through its art may be to commit a 'physiognomic fallacy' – the fallacy of supposing, for example, that Byzantium was devoid of noise – or even of jokes and laughter. The limitations of the Byzantine material come clearer in this light. It is predominantly church art, and the Byzantine church had to be presented as a place apart – it was one task of the artist to create sacred space, a paradise on earth. The church was full of incense and noise, but that atmosphere was controlled and universal. There certainly was humour (and eroticism) in Byzantium, if only recently noticed.[40] The hermit Neophytos in 1183 knew about this. When he set about constructing an atmosphere of holiness in the sanctuary of his cave monastery on Cyprus, he chose among other images a painting of St Ephrem the Syrian holding a scroll which read: 'The beginning of a monk's ruin are laughter and license of tongue.'[41]

Detecting noise, children, and laughter in Byzantium is only the empirical answer to Gombrich's point; it does not solve the questions of how you see Byzantium *through* the icon. Our

63 The Emperor Justinian and his Court, c. 548, mosaic, Church of S Vitale, Ravenna, Italy.

best answer is that this is itself a mistaken strategy, if taken literally. To perceive the icon as a mask, as we have done, is not to say that you must lift it up to find the true face underneath. You must discover why the mask itself takes the particular form which we see. How is it constructed? In this light, it matters less that Byzantine art is almost entirely a 'religious art'; this is only to recognise that Byzantine art is complex, because it has to carry so much conceptual weight and because it is essentially a 'functional' art. Understanding its 'category' helps us to see how art contains the values and priorities of the society which developed it. The institutional nature of the Byzantine state might however suggest that this art only promoted the aims of the leaders of the culture to use the decorative environment to proclaim the inner moral and aesthetic standards which they believed in. The seriousness and solemnity of Byzantine art would then be predictable. Except that the perception of a culture that had no jokes (and no eroticism), but just perpetual solemnity, must be recognised as *our* perception, not the Byzantine one. If we look and read without humour and sensitivity, we will find no humour and no sensitivity. In the same way, the debate about how

much classicism there was in Byzantine art (and when) is to be resolved not by defining the essence of 'classicism', as if it were an objective reality, but by recognising that classicism is an attitude of mind, both of producers and viewers.

The history of the Byzantine icon is difficult to write because it is a history of how a whole society became implicated in its particular forms and meanings. Maybe much in the Byzantine state was promoted from 'on top' – including the rise of the cult of relics and iconoclasm. But the case of the Turin Shroud suggests much more complicated dynamics of give and take in society. We have seen the story that the Byzantine emperor and church won over the Russian delegation to Orthodoxy. It assumes that there was a choice to be made.

The prevalence of the icon seems to identify Byzantium as a specific Medieval Orthodox culture and empire, separate from the Islamic east and Catholic west. The outcome of iconoclasm was a new cultural certainty. Henceforth, church, home, and street were all the domain of the icon. On this basis, the distinction of Byzantium from the west seems indicated. But we have seen similar cult uses of art in the west, and even the use of the word *icon* to describe used objects. Byzantine perceptions of identity may have been strong, but they are not enough to separate the history of Byzantine art from that of the west.[42]

5 Rebirth

The estrangement of Eastern and Western peoples has become proverbial. In Western stereotypes, the Orient is a land of unfathomable calmness, danger, and mystery, whereas the West is one of urgency, hope, and pragmatism. Oriental ostentation, cruelty, and despotism is opposed to Occidental nobility, sacrifice, and freedom. Although actual experience repeatedly demonstrates the inadequacy of these stereotypes, yet, in its signifying triteness, the refrain persists,

East is East and West is West, and never
the twain shall meet
Till Earth and Sky stand presently at
God's great Judgement Seat ...

Rudyard Kipling, *The Ballad of East and West*, quoted in K. F. Morrison, *History as a Visual Art*[1]

PLEASE SEND 500 ICONS SOON AS POSSIBLE. SUBJECT MOTHER OF GOD. STYLE PERIOD 19TH CENTURY. DIMENSIONS 30 × 40 CMS. PRICE RANGE US$2,000–10,000. TELEX CONFIRMATION OF ORDER. KIND REGARDS ISSEI FUJIWARA VICE PRESIDENT GEKKOSO.

My first reaction was one of indignation. Didn't the Japanese realise that icons were works of art, not factory products churned out on a belt like Toyota cars? Did they think I could call some painter in a remote monastery in Russia or Macedonia, living some two or three hundred years ago, and place an order as casually as they might ask for hamburgers at the local McDonalds?

Michel van Rijn, *Hot Art, Cold Cash*

A vast number of icons were commissioned in 1497 by a Venetian dealer from a Cretan painter. The paintings were to be put up for sale in Europe, notably in Flanders. Half of them had already been disposed of, with great success, in the Western markets by May 1498. The constant demand for these icons is demonstrated by the dealer's insistence that the other half of the order be completed as quickly as possible.

An order for hundreds of icons of the Virgin was placed in 1499 by two dealers, one from Venice and the other from the

Peloponnese, with three painters living in Candia, each of them being dealt with separately. The restrictions set by the merchants as to the iconography and style of the paintings (*in forma alla greca* or *in forma alla latina*), the explicit instructions regarding the colours of the Virgin's garments, and the obligatory use of predetermined models, all reflect the demand of the foreign market, which influenced art production in Crete. The large number of the pieces commissioned (seven hundred) and the short delivery period (forty five days) attest to the efficiency of Cretan workshops, which can in fact be regarded as production units with a considerable output. Five hundred of the icons commissioned were to be in the style of Late Gothic painting, and the remaining two hundred in the Byzantine tradition.

Maria Constantoudaki-Kitromilides, *From Byzantium to El Greco*

In the year 1499, two merchants, an Italian and a Peloponnesian, commissioned three painters from Candia to make 700 icons of the Virgin in 45 days. The commission specified the style of the icons, stating that 500 should be *in forma alla latina* and 200 *in forma alla greca*. The subject and frequently also the style of the icon were, in fact, often prescribed by the customer, who might prefer a traditional or an Italianising style, and in the same contract even the colours on the maphorion of the Virgin are specified: 'turchin broca d'oro' and 'pavonaco broca d'oro'.

N. Chatzidakis, *Venetiae quasi alterum Byzantium: From Candia to Venice. Greek Icons in Italy 15th–16th Centuries*[2]

The emperor and his court, the church, and the monastery emerge as the key agencies of change in the development of the icon, but the Byzantine viewer with an ever-accumulating experience of icons acted as the audience which supported the medium. From outside the culture, the prevalence of icons is its identifying sign as an Orthodox community, but the 'difference' or 'otherness' of the Byzantine east as a constructed polarity with western Europe must remain open to further interpretation. In the final centuries of the empire, change in the Byzantine icon was conspicuously accelerated, and the circumstances of production and viewing are clearer. Although the rise of the icon goes back to Late Antiquity, the final centuries of Byzantium show nothing less than a rebirth of the medium. The relative importance of emperor and

64 The *Panagia Hodigitria* icon (illus. 8) *in situ*, Méronas, Crete.

Constantinople in its production changes, as the regions become centres of patronage and production; the artists and viewers become more visible, and the encounter between east and west is real and dynamic.

The sophistication of viewing in late Byzantium may be glimpsed in the situation of many churches like that at Méronas, where the main icon was made around 1400 and reproduced the oldest icon in existence, but it was just one among a number of icons (illus. 64) collected piecemeal in the church. The streets of Byzantine cities – both Constantinople

and others – provided an environment which had grown organically over the centuries and blended the old and the new. But in the period after 1204, viewers confronted in their churches icons made in both traditional and contemporary styles; they could not miss noticing the changing forms of expression, particularly if the texts written beside the figures were in Latin as well as Greek (illus. 2).

In 1204, east and west did finally clash. This is one of few well-known dates in Byzantine history, the moment when Christian fought Christian under the flag of the Crusades. For the Byzantines, the Frankish siege, capture, and occupation of Constantinople meant loss of territory and the sight of their churches and monasteries altered and disfigured to fit the Catholic rite. The experience was repeated all over the empire. The Frankish occupation of Constantinople was, in the event, a temporary, if ruinous, phase in the history of the city. In 1261, Michael VIII Paleologos (1259–82) regained control of the capital and brought back the court and patriarch of St Sophia from exile at Nicaea. It was this impoverished and reconstructed Byzantine empire which survived up to the Ottoman Turkish capture of Constantinople in 1453; some parts of the previous Byzantine empire, particularly among the lands and islands of Greece, were never recovered from western control. By the fourteenth century, much of Asia Minor was under Turkish control, and parts of Greece and several Aegean islands were in the hands of westerners.[3]

One region above all offers revealing evidence of the transformation of the icon in this final period of Byzantine history. This is the island of Crete, which passed permanently out of the political control of Byzantium in the events of 1204 and was under Venetian jurisdiction from 1210 up to 1669, when it was captured by the Turks. It represents an entirely new social and political community within the Byzantine orbit. It is here in the encounter between Orthodox traditions and the west that the clearest evidence of change in the production and nature of the icon can be followed.

While Crete provides a distinctive political and cultural profile and great amounts of visual material, it was not in a unique situation in the period. Other islands, among them Cyprus, Rhodes, Chios, Naxos, Corfou, and Zakynthos, had a similar kind of colonial history, and their experience of the immigration of colonists from the west is likewise reflected in

the art produced.[4] But Crete can be treated as a special case;
there is the greatest evidence of artistic achievement on the
island and also the documented export of Cretan art and
movement of Cretan-born artists to other parts of Greece and
to the west (either to pursue permanent careers there or on
temporary visits). In the present state of knowledge, more can
be said about icons from Crete than from Constantinople.
Constantinople no doubt remained a creative centre and
continued to influence Byzantine production in the east, yet
the local production of Crete became more and more self-
contained.[5] It was the precise combination of east and west on
the island that was the decisive factor in the development of
its artistic production, but the commitment to Byzantium
remained strong, and more nostalgically so after 1453, when
Crete was perceived to have survived as a 'fortress' of
Orthodox Christianity in an Ottoman sea (illus. 65).[6]

The nature of the late Byzantine icon and the Cretan
position in its history can only be sketchily understood in the

171

present state of research. The problem is not art-historical inability to recognise 'Paleologan' style or to sense the rough chronology of the period after 1261. The production of art in the regions is a fact, although attribution is hardly still possible in the once-popular division of the art of this period into tight regional 'schools' (such as 'Macedonian', 'Cretan', or 'Constantinopolitan' schools), for the clues suggested for the recognition of these groups now appear much too general.[7] The art of the regions of Byzantium and the neighbouring countries is simply not self-contained in this way. The problem of research at the moment is simply the quantity of materials being recognised, both in museums and monasteries in Greece and internationally. Suddenly, in the study of the icon, we come face to face with named artists, known patrons, new subjects and styles, and a mass of historical and archival information. This is no longer the anonymous Middle Ages.

One icon, that in the British Museum of the Triumph of Orthodoxy, has been seen as the product of an artist from Constantinople around 1400 (illus. 11). This attribution is based more on intuition and optimism than on knowledge – this is an icon of quality that has none of the features of Cretan icons! It is clear enough, however, that future study is likely to relate it to other works of the period, perhaps to an artist, for the dossier of known artists and their careers is continually growing.[8] For Constantinople, we happen to know more about the artists who left the city (in search of work elsewhere) than about those who remained. The most famous of the former is Theophanes the Greek (aka Theofan Grek), who was in Russia in the second half of the fourteenth century and who worked in a distinctive, apparently 'original' style in Novgorod and Moscow (illus. 66). Yet he continued firmly in the 'Byzantine' tradition, encouraging the belief that he remains a source of information about the art of Constantinople, where he started his career.

Theofan Grek is only one of the prominent names in the history of late Byzantine art.[9] Some artists evidently wanted to be conspicuous.[10] They not only signed icons, but even wrote their names quite ostentatiously on the walls of the churches they decorated.[11] Such records take us still further from the notion of Medieval art as a production only 'for the glory of God'. We may not understand all the implications of the poetic inscription on the wall of the 'Church of Christ' in the

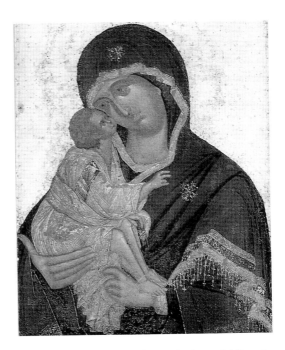

66 Theofan Grek, *Virgin of the Don, c.* 1400, front of a bilateral icon.

town of Veria in northern Greece, but the artist's ambition to make himself known is clear enough:

Xenos Psalidas builds a church of God
Seeking redemption from his many sins
Giving it the name of the Anastasis of Christ.
His wife Euphrosyne completes this.
The artist's name is Kalliergis
– in respect to my noble and modest brothers –
Of all Thessaly the best painter.
A Patriarchal hand dedicates the church
In the reign of the great emperor Andronikos
Komnenos the Palaiologos in the year 6823 (= 1314/15).[12]

The text is on the west wall of the church above the main door, and it is easy to suggest that it advertises the confidence and self-consciousness of a late Byzantine artist in North Greece.[13] What is more difficult to determine is how far the existence of an unprecedented inscription of this kind might identify a change in the social status of the artist in this period. The order of the statements which are made put the artist in a subordinate position to the donor who paid for the church and its decoration.[14] In any case, Kalliergis, whatever he says

173

himself, was just one of several highly competent artists who found work in this region at this period of flourishing production in North Greece; he has been put forward as one of the (anonymous) artists who painted the frescoes of the church of St Nicholas Orphanou in Thessaloniki and who worked in the church of Holy Apostles in the same city.[15] All members of this group had a closely similar style, but we find other artists at the same time and place working in different manners, even though all might have been based at Thessaloniki, which may have acted as an 'artistic centre'. Two artists who worked together further north in the Balkans were named Michael Astrapas and Eutychios; they recorded their names in inscriptions (and more elusively in some of the figures painted on the walls), but bizarrely (or perhaps not) we cannot separate two individual personalities in their paintings.[16] Another artist of this time is even more shadowy. Manuel Panselinos of Thessaloniki is celebrated in the *Painter's Guide* of Dionysius of Fourna in the eighteenth century as the supreme artist whose work could lead later artists back to the ideals of Byzantine art. He is the legendary painter of the wall-paintings of the large church of the Protaton on Mount Athos, the central church of the all-male monastic community on the Holy Mountain, dating around 1300 (illus. 35).[17] But we have no signature or clear documentation of his career.

This new exposure of the artist marks a change with Byzantine art before the twelfth century. Up until then, the Byzantine icon was not normally signed and dated. In other words, Byzantine viewers did not ask for such information and did not look out for signatures or dates on the icons in front of which they prayed and worshipped. Such information had no special interest or meaning for them. One might say that if the Panagia Hodigitria icon in the church at Méronas (illus. 8) was known by everyone to be a copy of the original painted by St Luke, why should the name of the artist or the date of the copy matter?

Only in the last centuries of Byzantine icon production did signing and dating the object appear as a regular practice; it marked a transition from the 'anonymous' artistic production of the Middle Ages to the emergence of more transparent statements about the production of icons – an interest often associated with the notion of *art*. This is a clear example of

visible cultural change, but it does not mean that one can jump to conclusions about the extent of change in Byzantine society or be sure in terms of the icon how far it meshes with a change in *religious* art. The icon may seem more personalised; does that signify a change in the relationship between individual and communal spirituality?[18]

Crete offers the best chance of measuring any changing equilibrium between self and community, between interior and exterior statements of intent. The evidence of artists and their conditions of work is fuller than for any other period.[19] Nevertheless, when we are told that 'more than 120 painters lived and worked in Candia in the second half of the fifteenth century', we are far from knowing how to process this empirical information.[20] In a similar predicament when facing hundreds of unstudied icons in the storerooms and chapels of the monastery of St Catherine's on Sinai, Kurt Weitzmann decided that the first step was to 'identify the leading ateliers'.[21] On Venetian Crete, this procedure has its temptations, too; in this case, there is the evidence of the notarial archives (now in Venice), which can be combined with that of signed and dated icons. Work along these lines is indeed advancing all the time. Since the painters are known, the surviving icons might be grouped under artists' names (although the term *artist* is perhaps sometimes pretentious, for, as in the west, numerous painters were registered whose work consisted of ephemeral decoration, processional banners, or devotional panels sold in the streets).[22] This optimistic endeavour does need to be carried out with some caution, however. This field of study has the benefit that it can learn from the experience of others. Names of painters are of the greatest value when accompanied by illuminating biographical information (like their religious affiliations) or some additional knowledge of how patronage worked. The documentary evidence quoted at the head of this chapter about large numbers of icons produced to order in Crete is rare in icon studies. Its interpretation requires more than artists' or patrons' names; we need to know how 'art' itself was understood in the society at the time.

The art-historical search for the artist has moved in recent years from traditional connoisseurship of the attribution of masters to the conceptual death of the author.[23] Both are to be seen as extreme positions, but with this historiography and its

warnings in front of us, Crete offers a considerable methodological challenge. In the considerable documentation of art on Crete from the thirteenth century onwards, there are records of large numbers of icons and many named artists. A structure of 'major' and 'minor' figures can quickly be detected. We can see figures emerging from generation to generation, including dynastic artistic families: Nicholas Philanthropenos (active 1375–1440); Angelos Akatantos (active 1436–c. 1457); John Akatantos (active 1435–77); Andreas Ritzos (1422–c. 1492); his son Nikolaos Ritzos (1460–c. 1507); his son Maneas Ritzos (1528–71); Andreas Pavias (died after 1504); Nikolaos Tzafouris (died before 1509); Angelos Pitzamanos (1467–after 1518); Theophanes Strelitzas Vathas (often known as Theophanes the Cretan; died 1559); Michael Damaskinos (1530/5–92); Georgios Klontzas (c. 1540–1608); and El Greco (Domenikos Theotoko-poulos; 1541–1614). There are many more, both during this period and in the seventeenth century. One common feature is their distinctive handling of the icon in a way which combined Byzantine traditions with a greater or lesser input of western ideas, sometimes up to the moment, sometimes of a traditional kind. These artists knew western ideas from material on the island, from western paintings or engravings, or from direct knowledge of Italy, in particular the art of Venice. Their works offer the best opportunity to observe the final stage of the history of the Byzantine icon and to appreciate that it was not a twilight period, but one of rebirth.[24]

The artistic position on Crete during the Venetian period is best seen through the evidence of the painted panel, although wall-paintings on the island are as a matter of fact numerous, as a pilot survey of surviving wall-painting in Greece carried out a few years by Manolis Chatzidakis showed. Out of a total of 1,852 wall-paintings counted in Greece, 916 were on the island of Crete. Like the icons, the wall-paintings show a mixture of interests; Cretan artists shared in the artistic developments and ideas of Constantinople and Greece during the Byzantine centuries, and Crete was in this sense a 'province' of Byzantium. But after 1204, an increasing number of western elements appear, and after the fall of Constantinople in 1453 a Cretan identity is established: the Byzantine tradition invigorated by western ideas.[25]

The cultural transition from Medieval to Renaissance Crete occurred within a political set of circumstances; we are looking at a development in Byzantine art which was in part the result of internal factors, in part of external ones. Since the art of Constantinople reacted also to western ideas, Crete remains special in this period, but not isolated. Historically, the event which decisively changed the history of Medieval Crete happened outside the island: it was the capture of Constantinople in April 1204 by the Crusaders and its political and economic effects. This turning point in the history of Byzantium was remembered at the time through a dramatic story about an icon, one of those panels which had long acted as a supernatural defender of Constantinople. The story features the capture of the icon of the Panagia, which the emperors of Byzantium carried into battle, 'fully believing that no one who carries it into battle can be defeated'.[26] The icon was taken into battle by the Byzantine emperor Alexios V Murtzuphlos (1204), and it was lost to the French troops under Henry, brother of the count of Flanders. Both sides interpreted the capture of the icon as a turning point in the siege. Although not the famous Hodigitria icon itself, the account shows the trauma which the capture of a talisman of this kind inflicted on the morale of the Byzantines inside the city.[27] The exultant French displayed the icon on a galley which sailed up and down the sea walls of Constantinople to prove they now owned it, and soon the Crusaders owned the city itself. God was on their side.

Although the events of 1204 marked the loss of Crete and other Byzantine possessions, the Crusaders had first moved eastwards in 1095, occupying Jerusalem and other parts of the Holy Land and Levant. It was only during the Fourth Crusade that they deflected their armies to Byzantium itself and ensured a continuing presence of Catholic western Europeans in the east, not only up to the end of the Byzantine empire in 1453, but beyond in some of the islands. Any understanding of Crete depends on an interpretation of the Crusader impact on the Byzantine and Islamic orbits, and historians' views of the period have altered in the face of differing modern understandings of imperialism and colonialism. Divergent (and partisan) views have been expressed regarding the character of relations between westerners and the indigenous populations of the east with whom they co-existed. Who

learnt from whom? Which side had the 'superior' traditions of law, politics, or art? Which group was the teacher and which the student? The answers to these questions will be heavily determined by the outlook of the modern commentator. In the case of the meeting of east and west in the art of Crete, one possible view is that the Byzantine icon on Crete lost its 'purity' and that through a process of 'westernisation' the icon lost its powers of expression. That the Cretan icon is 'neither one thing or the other' is one possible perception of the period. The view taken here is that the pictorial changes in the late Byzantine icon occurred throughout the Orthodox world and that they mark a transformation into a new, powerful form of art that not only satisfied the Orthodox viewers' spiritual needs, but extended the appetite for the icon to a wider Christian audience. The changing character of contacts between Byzantium and the west after 1204 was productive in cultural terms. For the art historian, they involve a new question in looking at the individual icon: Was it produced by an immigrant western master for a western patron or by a resident Byzantine artist working for an eastern or western client?

If the late Byzantine icon is to be seen in the light of the meeting of cultures, its art history must be multidisciplinary, and certain other questions must be faced.[28] There is the problem of the levels of cultural and everyday contact with the outsider society. Can we reconcile the evidence of the 'élite' literature and culture of the writing classes with more mundane evidence from other writings and customs? If change was not equal across the whole community, which sphere of materials could 'measure' change more accurately? Within a 'multicultural' community, the experience of each individual may be different, and from our perspective complicated if we do not know how much real opposition there was on the ground. The history of Venetian Crete could crudely be seen as a period of foreign occupation, or the changing circumstances over four and half centuries could be much more carefully subdivided. But the assessment of acculturation in a society may differ according to the methods applied. In this chapter, it will be reductionist and considered more in terms of the individuals whose actions and patronage exemplify Cretan society. This risks, as in all art history, limiting the scope to the élites who could afford the expense of

patronage of the arts and the artists who carried out the commissions. However, since the finished product of these transactions was the icon displayed in the church or set up in the home, the acceptance of change in the production of the icon can be witnessed through the responses of the viewing public. This may again raise issues of popular practices which might cut across official Orthodox and Catholic divisions.

The most tempting historical concept of Venetian Crete has been as a *crossroads*. The island of Cyprus shares this fate, although in its case the description may be qualified by admitting this as one of 'the clichés that invariably appear in the popular books and tourist brochures'.[29] Crete and Cyprus are both seen, then, as 'a crossroads, a melting pot, a meeting place of east and west'. This is of course bland, and maps of Crete that show trade routes and shipping lines suggest it is more a junction than a 'crossroads' or even 'the crossroads of three continents'.[30] Equally bland is the 'melting pot' image, presumably implying the meeting of peoples to resemble the mixing of liquids, some merging and coalescing, others separating. Both models describe the meeting of different people, but both are vague on the processes of integration. The precise pictorial evidence of the icon on Crete does offer a transparent record of the outcome of the encounter of east and west in the transformation of style, and the architectural record of the Venetian presence can equally help to see the visual character of Cretan society. Both the built environment and the interiors of church and home in Crete were radically and permanently altered during the period of the Venetian presence (illus. 34, 65). This evidence is a record of the effects of the confrontation of Byzantine and Westerner, of Greek and Italian and of Orthodox and Catholic. But it prompts the question of how far there was a polarity of cultures on the island and how far a deeper level of integration and interaction.

There was a massive production of icons on Crete, and this can only mean that its society had the means and the appetite to support the 'industry' of religious art. Under the Venetians, Crete was conceived as a trading base and stopping point as well as a major agricultural resource. The island exported notably wine, oil, and cheese, but also wool, cotton, honey, wax, and raisins and other fruit. The conventional view of Venetian interest in Crete is for shipping and commerce,

making the island a staging post on the spice (and slave) route and implying an empire not unlike that of the ancient Carthaginians, who set out to control strategic shipping ports and Mediterranean trade. But Crete was more substantial a centre than that, as it had an agricultural infrastructure which could be exploited for good living at home and for export. The Venetians initiated the planting of sugar (regarded as an oriental spice) on Crete and developed the island as part of a new kind of merchant empire.[31]

Venetian Crete was controlled locally by a governor, the duke, based in the capital city of Candia (which we now call Iraklion); he would stay in office for two or three years and then go back to Venice. While Byzantium lost control of Crete in political terms, in cultural and religious terms a high percentage of its population remained attached to its Orthodox past and traditions. Although the Venetians sought to remove the Orthodox church's power structure on the island by the strategy of permanently expelling its bishops, the Orthodox parish churches and monasteries remained the focus of Byzantine loyalties. The head of the Christian church on Crete was the Latin archbishop, and the Cretan Orthodox church was stripped of its properties. Orthodox priests could only be ordained outside the island, and the movement of monks and priests was controlled – so much so that a priest and an artist were imprisoned for illegally going to Constantinople in 1419.[32] Venice after 1439 tried to impose on Crete the Union of the Orthodox and Catholic churches that had been achieved (on paper at least) at the Council of Florence. Since both delegations signed the acts agreeing to the union of the churches, Venice could hope that the future ecclesiastical structure on the island could be Uniate. But on Crete on the Orthodox side, this agreement remained more theory than fact, and when the Venetian regime saw the strength of the local Orthodox opposition, what actually developed from the 1450s both ecclesiastically and politically was a more liberal strategy, no doubt influenced after 1453 by the fall of Constantinople and subsequent change in the importance of Crete in the Orthodox world – it now occupied a central rather than a peripheral position in the eastern Mediterranean Christian universe. This continued for another two centuries.

When the Venetians took over at the beginning of the

thirteenth century, the island was covered by large estates owned either by the Greek aristocracy (*archontes*) or by the Orthodox monasteries. By 1300, the countryside had been organised into four administrative districts which consisted of properties now in large part owned by Venetian colonists; they were allotted land in return for military duties. Society remained hierarchical, as under the Byzantines, and the initial Venetian period was marked by uprisings by the native Byzantine population, led predominantly by the old families (who could gain privileges in return for a settlement) or supported by the Byzantine establishment in Constantinople. By the fourteenth century, Cretan society can be seen as having fallen into four categories: *nobili veneti*, the Venetian colonists; *nobili cretensi*, the new assimilated group of intermarried Venetian and Greek aristocracy; a bourgeoisie; and the peasants. In the main, the villagers were Greek and the Latins preferred to live in the towns, but this is a very rough generalisation. It does mean, however, that village churches were more likely to be Orthodox and their architecture to conform to Byzantine architectural traditions, even if there were Venetian details in the carvings. In the towns, new churches in Gothic or Renaissance styles were built and must have contained paintings and furnishings of a Catholic kind – either brought by ship from the west, or manufactured by artists who travelled to work here from the west, or produced by Cretan artists ready to create Italianate works.[33]

If the monastery was a major catalyst in the ways the icon developed in Byzantium in the eleventh and twelfth centuries and continued to influence currents in the late Byzantine period, on Crete itself this is less evident. Monasteries on the island continued to prosper, and contact was close with monastic centres outside the island (in particular, Athos, Meteora, Patmos, and Sinai); some artists were also monks. Crete knew of the mystical movement of Hesychasm, popular in some monasteries, which emphasised contemplative prayers and meditation and may have encouraged pictorial subjects which included divine light (the Transfiguration, for example). But the changes we see in the Cretan icon appear to depend less on such monastic influences than on the west.

The production of the icon on Crete needs to be interpreted in the light of the artists, the patrons, and the circumstances of

making such works in a Venetian state which was clearly flourishing in the sixteenth and seventeenth centuries. A detailed picture is in the course of elaboration with the help of the notarial archives of Candia, many of which were shipped back to Venice in 1669 after a negotiated settlement with the Turks over the surrender of the city and stored in the state archival collection. These allow us to ask in more detail what it means to speak of the artist on Crete. If we take one particular case, the artist Angelos, we shall need to cover the archival indications and the surviving pictorial evidence signed by or attributed to him, and to explore the related conceptual issues.

Angelos Akotantos was seen until recently as an artist of the sixteenth or seventeenth century, known from a few signatures on icons (illus. 51 is signed 'HAND OF ANGELOS'). He was regarded as a painter of considerable technical virtuosity, but stereotyped and traditional interests, since his icons have many features of the period a hundred years or more before he was thought to have worked. In other words, he was a total contrast to El Greco, who showed up the mentality of artists locked into the past working beside innovators. This characterisation has now collapsed through careful study of archival documentation linked with the evidence of the signed icons.[34] The artistic career of Angelos actually belongs to the first half of the fifteenth century (before his death around 1457). He was no retrogressive painter looking back to the fifteenth century, but rather one of the innovators of the final years of the Byzantine empire. His work is an early example of the profound integration of western ideas and elements into the Byzantine tradition. If you like, he is the 'El Greco' of his time![35] At first sight, the work of Angelos is not so obviously 'western' as a number of other Cretan fifteenth-century icons. An icon of Christ meeting the Samaritan Woman (illus. 67) more obviously puts Byzantine iconography in a western setting – the townscapes and landscapes of Tuscany – or rather the pictorial version of these, which the Cretan artist knew from Italian paintings. A feature of fifteenth-century Cretan icons is their diverse ability to merge east and west in their art. Their knowledge of Italian art was close, derived through what they could see on the island, learnt from visiting artists or seen on visits to Venice.[36]

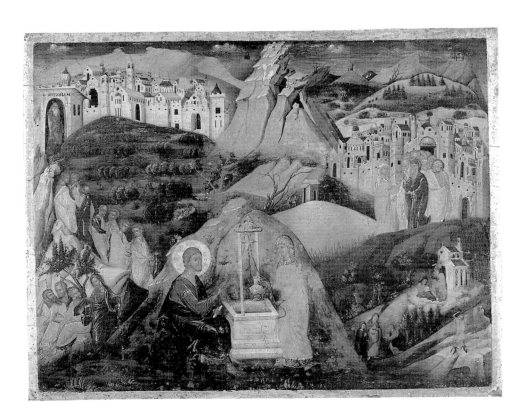

67 *Christ and the Samaritan Woman*, second half of the 15th century, icon.

The dating of the icons of Angelos depends on the document which records the testament of Angelos Akotantos of 1436. This will was provoked by his family circumstances when he was about to make a voyage to Constantinople (for an unspecified purpose). On the eve of his journey, his thoughts went to the future of his family and his workshop, and his scribe wrote:

> ... I Angelos Akotantos, the painter, being a mortal man and subject to death, and being about to sail to Constantinople, do make my testament about my possessions as follows: ...

> My child who is about to be born, if a boy, I wish him first to learn to read and write and then the art of painting. And if he learns the latter, I bequeath to him my drawings (*teseniasmata*) and all the articles of the craft; but if he does not learn the craft, I bequeath my drawings (*skiasmata*) and all the articles of the craft to my brother John. And my

books I bequeath to my child, if male, so that he may learn to read. I also wish that the head of St Catherine, the round icon, should be given after my death to the monks of Sinai, who will display it every year on the festival day of the saint in my memory. I wish also that the two icons that are in my room, the Anastasis of Christ and Nativity of Christ, be taken to the church of Christ Kephalas at Candia and set up in the middle of the church together with the veil which I have for this purpose, namely the Anastasis on Easter Day and the Nativity on Christmas Day...

We learn that Angelos was leaving a pregnant wife in Candia and was keen to ensure that if he never returned, his baby, if a boy, would learn to read and write, be trained as a painter, and inherit all his drawings and tools. He further arranged that three of his icons (of St Catherine, the Anastasis, and the Nativity) would be given to particular churches as donations. This is obviously a rich document of the circumstances and social position of a painter in Candia in 1436 and of his professional expectations. The case has been made that the artist who signed his icons as Angelos was Angelos Akotantos, transforming him into one of the most significant artists of late Byzantium, working on Crete at the time when in the west the International Gothic Style was giving place to Tuscan experimentation in perspective and narrative. Angelos marks the Byzantine awareness of this moment.

The signed icon of the Virgin and Child in the Byzantine Museum in Athens is inscribed as the Panagia Kardiotissa (illus. 51).[37] This large panel (introduced in chapter 2) shows Mary as the tender mother (the so-called Glykophilousa type), and as an icon it is one of those monumental panels which portray an intimate devotional subject on a massive scale, a combination of 'opposites' at which Byzantine art was so successful. A reasonable assumption is that this was the 'patronal' icon of a church, probably destined to fit the altar screen. If so, the dedication of the church may have been to Mary as the Kardiotissa. Such labels for Christ and Mary were, as we have seen, neologisms which late Byzantine art popularized; whatever the precise motivation for the label, the rendering of the image fits with the emotional evocations of the 'heart'. But the commission carried out by Angelos, with its dramatic pose of the child throwing his arms around the

68 Angelos Akotantos, *Christ Enthroned*, mid-15th century, icon.

neck of the Virgin Mary and its great attention to detail, nevertheless represents a traditional iconographical subject in Byzantine art; Theofan Grek working in Russia at the end of the fourteenth century likewise produced a version of this type of icon (illus. 66). The emotional subject matter has no obviously Italian impetus.

Other icons by Angelos show his possible range of influences. Another signed work ('HAND OF ANGELOS') is a panel of Christ Enthroned, now in Zakynthos (illus. 68). The figure type of Christ and the rendering of the gold highlights of the drapery are traditional in Byzantine art, but the solid green marble throne and its form and detail reflect a knowledge of and interest in Italian Renaissance pictorial furniture and its representation. The combination of east and west increases the pictorial illusion of the presence of Christ in

the icon and so adds new power to the Byzantine tradition. Other artists on Crete in the fifteenth century also showed an interest in developing the pictorial effects of space in this way. Examination of other works by Angelos build up a picture of an artist experimenting with new effects learnt from Italian art: a signed icon of St Theodore slaying a dragon in Athens has western details in the armour, while a panel of St Anne, the Virgin, and Christ on Zakynthos (an attribution to Angelos) sets the figures on an Italianate marble throne and is a Catholic, not a Byzantine, traditional subject (the three generations of the Holy Family).[38]

The stylistic range of Angelos distinguishes his work from what we know of earlier Byzantine painters – with, of course, the qualification that we do not have such a clear set of documented works in the earlier period. The question posed by an artist who worked on Crete is how far this 'eclectic' range represents his 'personality' or occurred in response to the conditions of patronage. Did he work, it may be asked, for both Orthodox and western patrons and adapt his style to suit the patron? Does his 'composite' style represent a response to a pluralist society and environment? In stylistic terms, the development of Cretan icons can be defined as the overlay of western ideas onto the Byzantine tradition, but this description underplays the extent of the revolutionary effects of these icons. The changes of expression amount to a profoundly different viewing experience and new category of icon. If you think of the attempts to characterise the Byzantine icon as a medium which represents the 'unseen' world beyond, you see the extent of the changes. The fifteenth-century Cretan icon represents the holy figures as in the 'real' world of experience. This is the result of the experimentation with Renaissance modes in the work of Angelos and his successors. The complication is the continuation of traditional subjects and treatments (as in the Méronas icon; illus. 8) with varying degrees of Italianate styles and subjects.

The full *oeuvre* and artistic character of Angelos is under intense study in present scholarship, but there is a further, more difficult conceptual problem: Does he exist as a personality? How far could an attempt to portray him in favour of church union between east and west be derived from an analysis of his style and subject matter? A short digression may help to answer this question, for in the generation before

Angelos we have another artist, Theofan Grek, who is documented through a text and a body of surviving work, but who offers an equally enigmatic face.[39] In these two names, we appear to have solid information about the working methods and social situation of Byzantine icon painters.

A letter about Theofan Grek in Moscow preserved in a single copy of the seventeenth century was written about 1415 by the Russian monk Epifanij the Wise.[40] It tells of a meeting of Epifanij and Theofan in Moscow in the Kremlin Annunciation church (where other sources say Theofan worked in 1405 with the artist-monks Prokhor and Rublev). The letter reads as a thumbnail sketch of the artist and among the salient points made are his Byzantine origins, his prolific output 'with his own hands', his speed of execution, and his freedom from reliance on models, unlike the copyist practices of the Russian artist. We read: 'He seemed to be painting with his hands, while his feet moved without rest, his tongue conversed with strangers.' It is tempting to think this was all true observation and to look at the virtuosity of his surviving works in this light. But more careful consideration of the text suggests this is too optimistic a reading. Some of the phrases repeat all too familiar literary conventions. Pliny too found ways of evoking individuality among painters, as in describing the speed and quality of an artist, Iaia of Cyzicos: 'No artist worked more rapidly than she did, and her pictures had such merit that they sold for higher prices than those of well-known contemporary painters.'[41]

How real or how literary is the description of Theofan Grek? How far is it a description of the artist and how far a representation of an artist? Consideration of the context of this letter within the writing of Epifanij will clarify these questions. Epifanij was a major writer and great stylist of the period, most famous for his *Panegyric of St Stephen of Perm* and *Life of St Sergios of Radonezh*. His style in these works is highly rhetorical and known for its mastery of 'word-weaving', characterised by sentences empty of verbs and full of adjectives and nouns, often combined to form neologisms. As biography, these works are full of topoi, and without alternative sources they make unreliable guides to the character of their subjects. Against this background, we may expect the letter to reveal more about Epifanij than Theofan. Epifanij writes about Theofan Grek as follows:

I ask your Wisdom to paint for me with colours a representation of that great church of St Sophia at Constantinople erected by Justinian who rivalled the wise Solomon in his achievement. Some say that in quality and size it is like the Moscow Kremlin when you walk round it. If a stranger enters and wishes to go about without a guide, he will not be able to find a way out again, however clever he may be, because of the multitude of colonnades and peristyles, descents and ascents, passages and corridors, and various halls, chapels, stairs, treasuries and sepulchres as well as chancels and side altars of various names, and windows, ways, doors, entrances and exits and stone pillars. Portray for me Justinian, as he is called, sitting on horseback and holding in his right hand an apple which they say is so big and capacious that it would hold two and a half buckets of water. Please represent this on a folio of a manuscript so that I can put it at the beginning of a book and imagine myself in Constantinople.

Compared with Epifanij, Theofan is positively laconic: 'Yes, but I cannot draw all this. Since you insist, I shall draw a part of it, not one part but a hundredth part – something small out of something great. Through my minimal representation, you will be able to imagine and understand all the rest.' He soon did a quick sketch of St Sophia, we are told, to act as a model for painters in Moscow, and it was copied four times by Epifanij himself, who now claimed to be a manuscript painter as well as everything else.

The letter is dominated by the words of Epifanij, who cleverly introduced a complex *ekphrasis* of St Sophia that is consummate 'word-weaving'. Theofan is the listener, and when *he* speaks about St Sophia, it is in the rhetorical metonymies of Epifanij. The letter does more to put Epifanij on the same international footing as Theofan than to describe the artist.[42] Perhaps, however, the information given that Theofan came from Constantinople and the itinerary given of his progress to Moscow are factually correct. But only a few revealing assumptions which might help to build up his individual character show through. One is the implicit notion of artist and writer as individuals with personal reputations. Another is the indication of the superiority of Theofan over

his contemporary artists in Russia. It is also clear that Theofan was regarded as an 'artist' and one of great quality. Other stated aspects of the artist's personality lack conviction; it would be difficult to rely on the 'speed' of Theofan as a clue for the attribution of paintings to him (however tempted we are to use this in favour of the attribution of the famous icon of the Transfiguration in the State Tretiakov Gallery in Moscow with all its *pentimenti* to him rather than to a Russian contemporary).[43] The letter offers nothing to support the attribution of the Virgin of the Don to Theofan – such an attribution still depends on stylistic analysis (illus. 66). Even the Deisis tier of the iconostasis of the cathedral of the Annunciation in the Kremlin, the church where Epiphanij met him, is a much challenged attribution.[44] The Russian artist Rublev was working with Theofan, but the letter gives no indication of their artistic relationship.

Angelos was working on Crete in the generation after Theofan, and our verbal contact with him comes from a different sort of document. The testament of Angelos Akotantos of 1436 was filed with the Venetian authorities by his painter brother in 1457. It emerges that the pregnant wife of 1436, left behind in Candia while Angelos went to Constantinople, produced not a son, but a daughter, and so the alternative provisions of the estate came into effect. The 'sketches' (*teseniasmata* or *skiasmata*) and all the articles of his trade (which one can speculate would have included old and valuable pigments and tools, etc.) were now claimed by his brother. So was the large icon of Christ. The icon of St Catherine was to go to the *metochion* of Sinai at Candia (it was a dependent monastic house), and the Anastasis and Nativity to the church of Christ Kephalas. The picture given by the testament is of a small family business rather than any larger industrial workshop organisation; this business was professional and lay, but Angelos was not isolated in his work, having a brother in the same business.

What else can this legal text suggest? One thing is that the artist had some status in the city of Candia, as well as disposable goods.[45] He was in a position to gain permission from the Venetian authorities to travel to Constantinople and to produce a legal testament. Another less fortunate painter from Candia who a few years earlier had gone to Constantinople and met the patriarch had been imprisoned by the

Venetians immediately on his return.[46] The testament of Angelos therefore reveals more than the factual evidence of his family and possessions.

The documents about Theofan and Angelos both mention the existence of workshop sketches, which were a prized commodity in both Crete and Moscow among painters, but not yet among collectors.[47] The designs (*anthivola*) of Angelos subsequently passed from the possession of his brother Ioannis and were bought in 1477 by the painter Andreas Ritzos (1422–92). Conceptually, the texts show the status of the Orthodox artist by the fifteenth century: a figure with self-awareness and an accepted identity in society. Both paintings and painters had a value. Icons may be symbolic vessels for religious piety, but were clearly understood as 'art'.

Since the texts document artistic self-identity, they suggest the feasibility of attribution in the study of icons – treated not as anonymous products for the glory of God, but as distinctive commissions among informed members of society. This digression on the artist in the early fifteenth century reopens the conceptual question by documenting a world which is very different from earlier situations in Antiquity, where art history has confronted *invented* Cycladic master artists or Attic vase painters. This difference is between the existence of named artists or deduced personalities.[48] The Cretan evidence reopens these questions, and Angelos can remain at the centre of the discussion, firstly because we have seen how attribution has changed him from a later 'retrogressive' artist into an earlier 'progressive' artist, and secondly because his new-found position is likely to stimulate further discussion and definition of his production. This is instantly clear from two recently discovered unsigned panels (perhaps the two wings of a triptych) which are 'in the style of Angelos'. They are small and delicate, one showing David and Solomon and the 'souls of the righteous in the hand of God', the other showing St George and St Mercurios (illus. 70, 71).[49] Do we from our knowledge of Angelos have a *method* which can decide between these as works of Angelos or in the 'style' of Angelos? There are a number of possible variations in an attribution argument. Are the works from the hand of the 'master', by a 'pupil', or could they belong to the 'master' of Angelos? A solution would be far from purely academic. If an effective attributional technique could be developed for the

icons of Crete, then a framework of 'artists' as the tool of future study would be ensured.

The realistic view must be that there are no controllable methods of attribution in the distant historical period in which Cretan icons were produced. If attributions to well-documented artists like Rembrandt and Michelangelo cause a spectrum of disagreement among specialists, can we seriously entertain the notion that there is a definitive answer in the case of Angelos (or Theofan Grek)? The range of methods goes from that of Morelli, Berenson, and Beazley (and Sherlock Holmes), who relied on 'the small insignificant, unconscious detail to betray the individual hand' and, at the other extreme, the 'holistic' method, which is to seek the totality of technique, expression, and 'quality'.[50] Theoretically, we need a method which could distinguish 'objectively' between *idiom* or *general style* (the conventions of a period) and *style* or *individual style* (manner of expression and technique of a particular artist).[51] And we would need to be persuaded that the identification of icon painters would add a dimension to the study of icons which could not be derived from the works themselves. This second desideratum is the easier to argue. We have seen that the documentation supports some exploration of the relationships between artists and patrons and should enable the establishment of figures at particular times and so illuminate the character of craft specialisation, trade, and circulation.[52] Precise knowledge of an artist's production would allow insights into their versatility and ability to work in different manners. It would help to see how ideas and subjects were transmitted; it would enlarge our knowledge of artists' networks and of which artists went to Venice or stayed on the island. Attribution kept in cautious perspective can therefore be justified as an aspect of the study of Cretan icons, but it cannot solve all the questions of changes in style and the response of viewers.

Attribution has been a central factor in the investigation of the early work of El Greco (1541–1614). It has enabled the visual materials to be linked to new archival information about the nature and length of his training in Crete and to illuminate from his perspective the stage of Cretan icon painting in the sixteenth century. The nature of El Greco's relation to Byzantine art is beginning to emerge in a new and precise light.[53] It is no longer reasonable to make such

statements as 'El Greco had a natural disregard for optical truth in favour of unseen, inner values – a legacy from Byzantium' when we can see a profile of work produced over his whole career. We can ask how far the mature artist in Toledo was formed by his past and whether his distinctiveness lay in that past or in his later western experience. Already in Candia the young El Greco was familiar with western art and western responses to Byzantium.

As in the case of Angelos, our understanding of El Greco – Domenikos Theotokopoulos as he started life – has been transformed by the discovery of new information and more dates in the Venetian archives.[54] His birth date in Candia of 1541 derives from his own statement in 1606 when he was sixty-five, but the documents allow much greater precision. A document of 6 June 1566 from Candia includes as a witness a certain Master (*maistro*) Menegos (Venetian dialect for *Domenikos)* Theotokopoulos, painter (*sgouraphos* = *zographos*). On 26 December 1566, Domenikos obtained written permission to put one of his paintings up for auction. It was most probably an icon of the Man of Sorrows (Ecce Homo) painted on a gold ground (possibly now in the collection of the monastery of St John on Patmos).[55] The valuation was provided on 27 December by two other painters (one was George Klontzas), who gave independent figures of 80 and 70 ducats – both relatively high figures, it seems. On 18 August 1568, El Greco is first recorded in Venice in a Greek document showing that he was still in touch with people in Candia, but established in Venice. Other sources tell us that in 1570, after working in Titian's studio, he moved to Rome and soon to Madrid, settling in 1577 in Toledo, where he died in 1614. One might suppose that this curriculum vitae represents the problem of the foreign painter in Italy in the Renaissance – the failure to get work from Italian patrons.

These documents establish that El Greco was working as a painter in Candia until at least December 1566 – up to the age of twenty-four or twenty-five, though we do not know if he had already spent time in Venice or had gained his experience of Italian art through Italian artists on the island and through imported works. The influence of Titian and Tintoretto is seen early in his production. There have always been several attributions made to the hand of El Greco, as well as considerable (acrimonious) dispute about the acceptability of

69 Andreas Ritzos, *I.H.S.*, 15th century, icon.

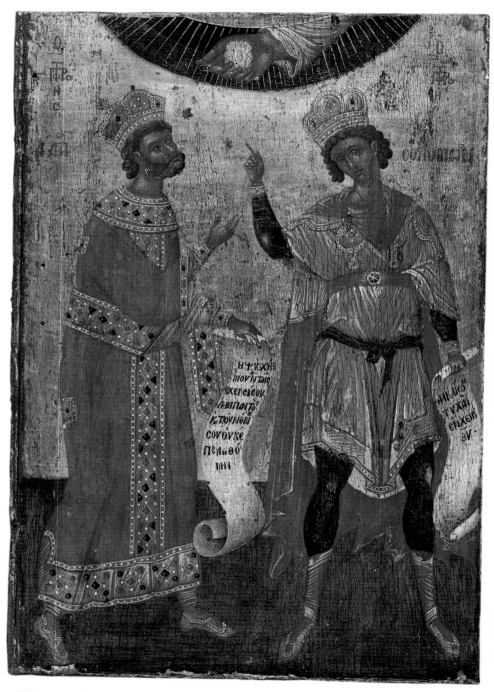

70 (?)Angelos Akotantos, *David and Solomon*, mid-15th century, icon.

71 (?)Angelos Akotantos, *St George and St Mercurios*, mid-15th century, icon.

72 El Greco, *Koimisis of the Virgin*, 16th century, icon. Church of the
Koimisis, Syros, Greece.

73 El Greco, *The Adoration of the Magi*, 16th century, icon.

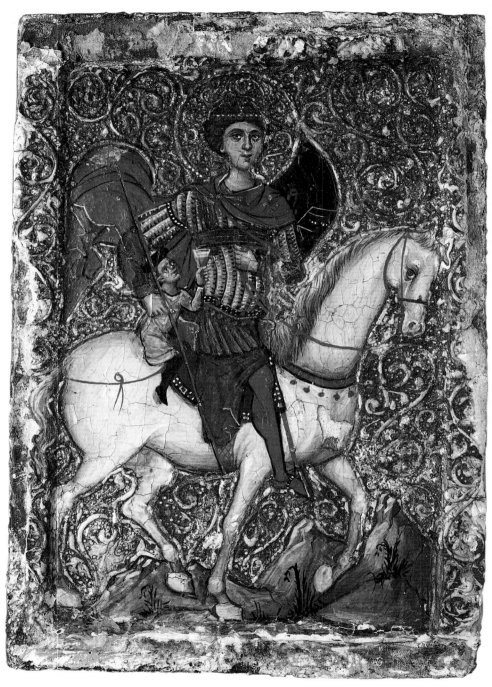

74 *St George and the Young Man from Mytilene*, mid-13th century, icon.

any of them. The turning point in our knowledge of his early work came in two stages: the establishment of the length of his career on Crete and the surprise discovery in 1983 of an early work (illus. 72). This was an icon of the Koimisis of the Virgin Mary in a nineteenth-century church dedicated to the Koimisis on the island of Syros.[56] When restored and its later silver revetment removed, an inscription in capital letters was discovered: *DOMENIKOS THEOTOKOPOULOS O DEIXAS* ('Domenikos Theotokopoulos the creator'). Exactly the same (unusual) literary usage of this verb is found in El Greco's first Spanish work at Toledo, which also treats the subject of the Assumption of the Virgin. Technical examination made it quite clear that the inscription under the silver cover was not a modern forgery, but integral with the original paint.

The festival of the Koimisis is celebrated in every Orthodox church on 15 August. It shows the 'death' of the Virgin in the presence of the apostles, Church Fathers, and holy women and the moment of Christ receiving the soul of his mother. The imagery at the top of the icon hints at her bodily assumption, though this doctrine was never officially declared by either the eastern or western church in this period. The idea can be pictured, but not declared. Mary is crowned as in Catholic pictures, but not in traditional Byzantine art. Another western feature, though increasingly frequent in the art of Crete, is the presence of St Thomas, to whom the Virgin hands her girdle. The portrayal of the dove in the centre is a western element, too. The main composition of the scene does conform with the Byzantine pattern, and by this period Cretan art regularly treated perspective and space in this way. The handling of the compositional devices is perhaps not very successful – or was not a major concern; to us the figures look uncomfortably cramped. It is normal to have candles in front of the bier, but the ornate candelabra decorated with the Three Graces is distinctive and eye-catching. The icon has the precision of modelling of the face that one expects in the Byzantine tradition, but the composition is as fluid as a Venetian painting in the style of Titian.

This icon of the Koimisis is a clear integration of traditional Orthodox iconography with a number of Catholic ideas and details, and a setting which conforms more with western forms of expression than Byzantine ones. The strategies found

in the work of Angelos and his successors had led to a radical transformation of the Orthodox icon. In one sense, El Greco can be related to Byzantium, but this now seems as vague as relating any major subject of Christian art to the 'Middle Ages'. The Cretan world in which El Greco was trained was distinctively different from Byzantium: the subjects, styles, and viewers had changed. If this panel was painted by the young El Greco, his patron may have been Orthodox, Catholic, or someone whose spiritual outlooks partook of both spheres. Its first destination cannot have been a nineteenth-century church on Syros.

This is a signed panel by El Greco, but should we call it an icon? It has a traditional icon subject, a traditional icon format, and a traditional basic composition. Yet it does not represent strict Orthodox belief, and its original destination is unknown. It has the atmospheric quality of a Venetian painting. But the same problem – are Cretan panels 'icons'? – is raised by the painting production of the island for decades before the appearance of El Greco. In his case, the question can be enlarged by looking at other works attributed to him. The debate has now passed in the scholarly literature from the question of authorship to that of date. Were these early panels painted before El Greco left Crete permanently or in Italy immediately after his departure?

Two 'El Greco' panels have been for many years in the collection of the Benaki Museum in Athens: one showing the Adoration of the Magi and the icon we have already seen, St Luke painting the portrait of the Virgin (illus. 10, 73). The Adoration is painted in tempera and signed 'HAND OF DOMENIKOS' (in Greek). The composition has a firm architectural structure, but fluid figural composition. This lack of clarity in the handling of the figural group links the panel to the similar 'criticism' which can be made of the Syros painting. Light and colour are clearly major pictorial interests, features which are easy for us to connect with Venice and Titian's late style. The painting of St Luke is likewise signed 'HAND OF DOMENIKOS' in Greek, and, as we have seen, it contains a paradoxical pictorial scheme which counterposes a Titian-style St Luke and angel with an amazingly conventional 'portrayal' of a Byzantine icon of the Virgin; the two worlds of Christian art are juxtaposed almost as an exercise in virtuosity. The new art of Italy is in counterpoint with the old

traditional art of the icon. This paraded contrast was seen in chapter 2 as a case of an artist attempting to bring attention to himself.

These two panels in the Benaki Museum, unlike the Syros painting, do not represent major festival days in the Orthodox church. They do problematise the concept of 'icon'. One cannot be sure that their intended location was an Orthodox rather than a Catholic environment or patron. Rather than decide between two such *alternatives,* we might prefer to regard them as representing the complex viewing habits of the society which had developed in Venetian Crete. In art-historical terms, these questions are equally applicable to other works from the early career of El Greco. The two other most striking pieces are the signed Modena triptych (Estense Gallery and Museum) and the (unsigned) view of Mount Sinai, now in the Historical Museum of Crete in Iraklion (illus. 14).[57] The Modena painting is a triptych in tempera, a typically Cretan format in the period. It is signed 'HAND OF DOMENIKOS' in Greek on the back of the main panel and includes a number of traditional and less traditional subjects, whose details show El Greco's knowledge and imaginative use of engravings of the work of sixteenth-century Venetian painters. This triptych and the Iraklion painting include a composition of 'The Holy and God-trodden mount Sinai'. Both these panels seem to derive their composition from a copper engraving by the Veronese artist Giovanni Battista Fontana printed in Venice in 1569. It therefore must be concluded from the chronology that the Modena triptych and Iraklion view of Sinai (which was recorded in Rome in 1600 in the collection of Fulvio Orsini) were painted by El Greco when newly arrived in Venice. But it is equally clear from the other paintings that El Greco – in common with his predecessors and contemporaries on Crete – habitually incorporated and assimilated reworked western ideas in his paintings and that one highly influential source was western engravings.[58] In this procedure, the artists of Crete were of course in line with other Orthodox artists, both in other Greek Orthodox communities and in Russia.

For once, we find that the study of sources does genuinely help to explain the adaptations and developments of a category of art. But finding the sources which helped El Greco construct his 'icons' does not explain the nature of their

patronage. To illustrate the landscape of Sinai in a western form does not alter the fact that this is a traditional pilgrimage site both for Orthodox and Catholic believers, and a monastery which had connections (and property) on Crete. The imagery of the sacred site of Sinai would therefore have had a broad appeal and have stimulated strong responses among many viewers, whether or not they had gone there as pilgrims.

All the early icons of El Greco show an artist working for a clientèle who wished to have their religious visual experience mediated through a contemporary Venetian vocabulary. But they are all profoundly religious paintings, not art for the connoisseur. The reformulation of Byzantine visual traditions that had started well before the time of El Greco, but that was deepened by him and his contemporaries, was not a negative development, but a way of offering the Cretan and Venetian viewer in the period of the Renaissance a new form of spiritual and emotional involvement that was related to, but different from, mainstream Italian experience. El Greco offered just one form of religious painting among several on late sixteenth-century Crete. Georgios Klontzas produced more dramatic colour. Michael Damaskinos (a key figure with documented works from 1555 to 1591 who is recorded as working in Venice between 1574 and 1582) offered art which is more akin to the style of Veronese. Emmanuel Lambardos was the producer of a mixture of old-fashioned Siennese and Flemish painting. Others too can be characterised in terms of their sources. The internationalism of Michael Damaskinos was helped by his first-hand experience in Venice; other artists based their work on models brought from the west to Crete, often engravings. Unless El Greco slipped away to Venice by boat before the age of twenty-five, he gained his western knowledge on Crete.

Byzantium can hardly be described as the 'source' of El Greco's art. Of course, he was working in the Byzantine tradition. His choice of colours, the lacquer effect, the pale grounds might be seen as Byzantine elements, but to argue that El Greco was going back to Byzantine models seems pointless. He was trained in the methods and interests of Venetian Crete, and Titian was the dominant 'influence'. These are the works of a self-conscious painter who knew many permutations of the traditional types, forms, and values

of Byzantine church art, but who worked to produce new interpretations of narrative and portraiture. He strengthened the power of the icon by challenging its past.

These discussions of Angelos, Theofan, and El Greco have focused on the role of the artist in changing the icon. The method should be recognised as problematic and as a response to the documentation of the period. But the other side of the icon is the effect that new styles and subjects had on the viewer. When the viewer in the church was confronted with a mixture of hallowed Byzantine icons side by side with new forms and subjects, a new and complex situation arose. The archives show the range of the different types of patronage for Cretan painters, both on the island and outside: Catholic bishops in Greek mainland cities under Venetian control; Orthodox monasteries such as St John on Patmos and St Catherine's at Sinai; foreign merchants, mostly Venetians; and rich Greek and Venetian individuals. At the same time, the Cretan audience were experiencing a change of culture in the forms and contents of literature, music, and other arts.

If we are to move from the production to the viewing of the icon on Crete, we need to look further at the churches on the island. The ecclesiastical organisation under the Venetians has already been mentioned: although at community level, there was a coexistence of Orthodox and Catholic worship, the higher clergy consisted of a network of Catholic bishops. The importance of Angelos is that his work shows that even before the fall of Constantinople in 1453, the Renaissance way of imaging the saints had appealed to some Byzantines, both on Crete and in the other Byzantine regions.[59] After 1453, the westernisation of Orthodox art continued, particularly in Crete with its Venetian contacts. This trend can be examined from the perspectives of everyday life as well as from the circumstance of production of the icon. What happened on Crete was that Orthodox and Catholic converged as *viewers* of religious art; a middle ground developed, even if some works produced were more directly intended to serve the traditional forms of one side or the other. El Greco in his early work occupied this middle ground, and his Syros painting would have fulfilled the religious needs of either the Cretan Orthodox viewer who preferred Renaissance modes or the Catholic who felt at home in Crete with an exotic 'Orientalised' art. From this point of view, El Greco is less an

individual 'genius' on Crete than one talented artist among many; only in Spain did he become an exception when he developed the identity of an extravagant humanist 'Renaissance' artist, surrounded like Titian by music and books.[60]

We can investigate the society which produced this 'middle ground'. Perhaps the Crusaders and the Venetians among them who went to the east had as their first response to icons feelings of awe, just as they were impressed by the authenticity of the Christian relics of the Byzantine empire. St Sophia at Constantinople was the best museum of relics and icons in the world. As an initial strategy after 1204, the Venetians did their best to remove the relics to Italy, and many objects went west. The Treasury of San Marco shows that they wanted more than relics, including other precious works of art as well. The situation was transformed when the meeting of east and west changed to co-existence. Venetians who stayed in the east were changed culturally, and the Byzantine reaction was to absorb many western features in their art. The clearest sign of the situation was the expressive changes in icons, which can be seen in the works of exceptional power and originality produced on Crete. By looking more closely at the practical mechanisms of syncretism on the island, perhaps we can begin to recreate the character of the viewers. Some (interconnected) facts of intermarriage and bilingualism should help to define the community of viewers more closely.

Initially on Crete after 1210, the Venetian authorities decided to forbid the marriage of the colonists with Greek women. Things were conceived this way round. Documents from the late thirteenth century onwards show that the facts of life had changed at all levels of society.[61] If we turn to the reports of Venetian officials and other sources of the late sixteenth century, we find, as did the *Provveditor General* Giacomo Foscarini, that 'Among the noble Venetians, many are those who ... have completely forgotten the Italian language and who cannot hear the Latin rite in any of the island's villages and who have to baptise their children, marry and die in the orthodox rite.'[62] This is clear enough evidence of the gradual emergence on the island of Catholic Cretans with no knowledge of Latin. In the towns, we hear that Greeks might go to mass in Latin churches and that Latins might go to Orthodox churches; also that Greeks had a particular devotion to St Francis and his church.

One of these Venetian families mentioned in the sixteenth century as 'in all respects Greek' was the Bon family. The story of their Hellenisation can be evocatively tracked back in the fourteenth century thanks to the notarial archives. These offer evidence of the appearance of Venetians who were ambivalent in their identity and who felt themselves to be both Frankish and Cretan. A direct piece of published evidence from the archives is the Testament of Stefano Bon (27 September 1331).[63] This is another of those revealing documents which hide much human life in the dry legal terminology of a last will and testament. Stefano was a Catholic and a Latin notary in Candia, a member of a Venetian urban family who had a sideline in the business of livestock and its by-products. He also knew Greek. He was, it is clear from the references to his relations, the child of a mixed marriage; his mother's brother was John Saclichi, a member of a prosperous Greek family who were active in the livestock trade and probably also in the slave trade. He himself married a Greek woman, Helena Paterimi. His bequests correspondingly take on a significant ecumenical character, and the key legacies show up his position. He gave 25 *hyperpera* for a memorial mass to the *fratribus predicatoribus* and 25 for a mass to the *fratribus minoribus*, sums which therefore went to the Catholic order. He gave 20 *hyperpera* to the church of St Michael the Archangel, 'where I wish to be buried' and where he had learned Greek. This was an Orthodox church in Candia. As philanthropy, he allocated food and clothing for five years to the sick and infirm of St Lazarus. He gave 5 *hyperpera* to the convent of San Giorgio in Borgo (converted by now from a Byzantine into a Benedictine house). Similarly, he gave 5 *hyperpera* to the Dominican convent of St Catherine. In addition to other bequests, including provision for his family, he gave 5 *hyperpera* to the congregation of St Titus, a Latin church, and 10 *hyperpera* to the presbyter Nicolaos, *capellano* of St Titus.

At the least, one can say that Stefano Bon was integrated socially into the city's society. We find also that he had four children, Pothiti (a Greek name), Franceschina (an Italian name), and two sons, Domenicus and Petrus. In Franceschina's testament of 28 March 1348 (we have this, too), it emerges that she married a Matteo Gradenigo. Yet she had a Greek

nursemaid and left bequests to several Orthodox churches and Greek friends and relatives.[64]

These documents counter any simple notion that Greek and Frank were in total conflict at this period in Crete.[65] Of course, there were severe tensions and property disputes, and these led to a number of hostile uprisings on the island. But the documents of this particular family show how everyday life was lived. They suggest, for example, a *model* of how integration is to be tracked on Crete. The pattern to see is of a larger indigenous population and smaller immigrant group. Because of the relative sizes of the two sides, the outsiders were absorbed, and this may have happened within only three generations; the 'Venetian' colonists soon spoke the local language, retaining Latin as the official language for legal documents such as testaments and contracts.[66]

This model suggests that Byzantine culture remained in some respects the dominant tradition on Crete.[67] But the icons show that things were more complex than this – they change too radically to explain their production and viewing as a continuation of the old Byzantine values. Technically, one might point to their maintenance of traditional standards of virtuosity, but although the history of the late icon is certainly in part the history of (superb) craftsmanship, it is much more than just that. It is about the incorporation of western religious art into Byzantine expression. The archival documents such as those of the Bon family do indeed have visual reflections in the choices made in the subjects – and surely the styles – of many icons. When we look at a fifteenth-century triptych (in the State Pushkin Museum in Moscow) which represents both St Francis and St Dominic, names them with Latin inscriptions, and then represents the Koimisis of the Virgin Mary with its inscription in Greek (illus. 75), it is hard not to think of these socially interwoven families.[68] Was this triptych made for a Franciscan church in Candia or for an Orthodox patron with a love of St Francis?

One extraordinary icon sums up the profound character of the meeting of east and west on Crete. This is an icon with a unique composition, now in the Byzantine Museum in Athens, painted in the second half of the fifteenth century (illus. 69).[69] It has an artist's signature which though in part repainted is most likely that of Andreas Ritzos, a younger contemporary of Angelos, documented between c. 1422 and c.

1492. We have already met Ritzos as the artist who in 1477 bought the 'designs' mentioned in the 1436 testament of Angelos. The subject of this icon is remarkable – the monogram *IHS*. This monogram was the emblem of the preacher and reformer of the Franciscans, St Bernardino of Siena (1380–1444), a figure notable for his prominent role in the attempt to unite the churches at the Council of Florence. The initials of this distinctive badge stand for *Jesus Hominum Salvator* ('Jesus Saviour of Men'). The icon represents the emblem in Gothic capitals exactly as St Bernard wore them. But within the letters, the painter included Christian scenes: a Crucifixion on the left and on the right two representations of the Resurrection – one the Catholic version, the other the Orthodox version of the Anastasis. In addition to the imagery, the icon includes a text, chosen from the Orthodox liturgical book (the *Paraklitiki*) and consisting of one of the *troparia* for the *Orthros* (matins) of Sunday: 'You were crucified and died willingly. But resurrected as God, you will join the forefather. Remember me crying out when you enter your kingdom.'

This is a pointedly spiritual icon.[70] But it also works on the level of the intellectual mission to join and unify the churches. Few icons offer such a complex viewing agenda and appeal to heart and mind. It also has a later history which reflects a different viewing climate. In a document of 1611, the same icon is described in terms of a treasured possession rather

than as the repository of deep religious emotions. In the testament of a Venetian-Cretan noble, Andrea Cornaro, it is characterised as a precious object of Greek art, *cosa pretiosa per pittura greca*.[71] It was kept in the owner's house, in his room (*camera*). The testament records that he bequeathed it to his patron Alvise Zorzi and that it was to be sent to Venice for him. The language of the testament (and the fact that it was bequeathed with another small picture and a marble head) show that by the seventeenth century, the icon had entered the domain of the connoisseur and could be treated as a 'work of art' more than as a work of religious function. Of course, since we do not know who originally commissioned this special painting, its full intended function cannot be deduced. It has been suggested that the destination of the icon was a monastery or church of the Franciscans on Crete or a person who had some connection with the order. This hardly accounts for the inclusion of the Orthodox liturgical text inscribed so prominently on it. Its subject matter, matched by its style, must surely indicate that one function was to argue the Uniate case and to promote the joining of the eastern and western churches. Other icons – such as the representations of the embrace of Peter and Paul by Angelos – have been interpreted as visual statements of the advantages of the union of the churches, but their imagery is less direct and open to other interpretations.[72]

The *IHS* icon demonstrates the depth of the Cretan visual integration of both the eastern and the western traditions; it undermines the notion of a polarity at this time, while at the same time conceding it by its subject matter. It demonstrates the special form of art that the conditions on Crete encouraged and stimulated, but points to the social and intellectual divisions which remained. It is a warning that while the differences of east and west should not be exaggerated, they cannot be denied. The Byzantine tradition was never superseded, and icons like the fifteenth-century Méronas icon continued to act as a focus of worship and devotion (illus. 8). The Orthodox viewer on Crete could no longer believe that the traditional Byzantine icon was the only form of Christian expression, but the development of new forms of expression did not diminish the powers of the old. Similarly, the Catholic viewer knew that icons came in many forms. On Venetian Crete, the audience of the Méronas icon probably consisted of

both Orthodox and Catholic viewers, and today it continues to serve an Orthodox community. Apparently in the Ottoman period, as we have seen, the icon was attacked and the eyes of the Virgin Mary scratched out by a Muslim. Its history is of the acceptance in common of its powers by all these groups, but beneath this surface conformity their personal religious beliefs were in the last resort incompatible.

This examination of the development of the Cretan icon has moved from the artist and patrons to its viewing public; the stylistic changes of the icon and the emergence of new composite forms have been emphasised. This development has been expressed in terms of the nature of the Medieval viewing experience. By the fifteenth century, the Cretan viewer would have encountered many icons in radically different styles. How sophisticated were these viewers? When this question is put, it becomes apparent that this discussion has glossed over a deeper problem which exists throughout the history of the Byzantine icon when it is treated in formal terms. Byzantine art never in fact produced one type of formal expression, and the diversities have always been recognised by art historians. The whole history of the icon might be expressed as a dialogue between different styles, ranging from the most abstract to the most naturalistic. We have seen examples of this, and in some icons the extremes are combined, even in the early Byzantine period (illus. 50). While this final chapter has put emphasis on the viewer, the question of the relative input of artists, patrons, and viewers over broader factors like tradition, region, or pictorial experience ought to be considered at all stages of the history of the icon.

Early Byzantine icons have been analysed in terms of the choice of different 'modes' and their pictorial values.[73] The 'hellenistic mode' worked to portray remote sacred figures, and the 'abstract mode' worked better to portray saints as vessels ready to receive prayers. The equivalent dichotomy on Crete would lie in the choice between 'Byzantine' and 'Renaissance' modes. In the Crusader period, the dichotomy has been identified in sharp terms of east and west. The panel of St George in the British Museum is a case in point (illus. 74).[74] This can be dated to the middle of the thirteenth century, since it shares several stylistic features with the mid-thirteenth-century Franciscan cycle in the Latin chapel of the

Kalenderhane Camii in Constantinople and with the miniatures of the mid-thirteenth-century Arsenal Bible (Paris, Arsenal, 5211). The explanation of its style has been seen as a mixture of elements of eastern and western forms. In this discussion, the figure style of St George (as well as his armour) is connected with the western orbit of representation; the clue here to the west is the saint's 'Gothic swing'. Yet the story – the rescue of a young man of Mitylene captured by Saracen pirates – and also the composition come from the Byzantine tradition. But even if the various stylistic elements are accepted as properly identified, the problem remains about the terms in which the dichotomies are to be expressed. The favoured frame has been in terms of the artist: this is a western artist influenced by the east, or a Byzantine artist influenced by western Gothic style. This analysis has led therefore from style to conclusions about the artists, and indeed has been taken further to assume that western patrons in the east used western artists and that Byzantine patrons used Byzantine artists.[75]

In one sense, the richness of the Cretan documentation may be seen to show up the flimsy nature of the analysis of 'Crusader art' in terms of production and with the simple polarities of east and west that assume that Byzantine and western styles existed in separate categories. Crete has offered us signed icons which show that individual artists, like Angelos, could indeed work seamlessly, incorporating various levels of Byzantine or Western forms and subjects. This material does not support the view that we can unravel artistic personality and careers from the style of one icon alone. Since the St George icon in the British Museum represents at present just one work of an otherwise unknown artist, it would be premature to assume that we can pinpoint the place of origin of its artist.

But even the richness of the Cretan documentation does not allow us to resolve the perennial question about the diversity of expression throughout the history of the icon. We may want to argue that the icon on Crete was transformed in late Byzantium, not because for the first time the Christian art of east and west were in creative contact, but because the co-existence of Orthodox and Catholic on Crete occurred at a time when western religious art was radically changing its forms of expression, and these influenced and changed the

forms of Byzantine art, too. There were always contacts between Italy and Byzantium, but only the situation after 1204 led to constructive interractions at many levels.[76] This book has argued that the Cretan icons should be considered as 'Byzantine' and as 'icons'. They can help us see into the earlier processes of the development of the icon.

There is another side of the icon in Crete that leads away from the retrospective insights into Byzantine art and opens up broader perspectives. The documentation of the icon on Crete has shown a historical pattern: the reception of outside ideas, their integration into the tradition, and then their production and the export of the new art form. The final section of this chapter can consider Crete as a staging post in cultural exchange. In this respect, we find that the island looked both east and west.

First, let us look east. We know that Angelos sailed to Constantinople, but we cannot document the impact of the art of Crete directly on the art of that city. Instead, our view can be enlarged through the art of a region on the far margins of Orthodox culture in Africa. Ethiopia was first the target of Christian missionary activity from the Orthodox orbit, and later the target of Jesuit missions.[77] It reflects a similar experience to that of Crete as a location of diverse influences. Ethiopian icons, like those of Crete, are found in forms which continue the Orthodox tradition in some cases, but in others exhibit composite styles. An example of the latter helps to give a perspective: an 'icon' of St George (illus. 76), a triptych now in the collection of the Institute of Ethiopian Studies at Addis Ababa.[78] The wings show eight scenes of torture from the martyrdom of St George, with (left) scourging the martyr, pinning his body beneath a stone, burning his body, nailing him to a wooden plank; and (right) beheading, cutting his body on a wheel, dismembering him, and sawing his body in half. The central panel shows St George killing the dragon and rescuing the young princess of Beirut. The saints below follow Ethiopian models: two local black saints and St Kiros, said to be the brother of Theodosios the Great.

This Ethiopian icon has many features of fifteenth- and sixteenth-century Ethiopian painting, but it also has some stylistic pointers to a more complex background. A glance at the modelling of the drapery worn by St George, with its texture and bulk given by means of carefully painted light and

shade, is a clue to the knowledge of techniques and methods practised outside Africa – indeed, the instant evocation is of Italian Quattrocento style. Yet the face of the saint, the drawing of the horse, and the plain background look much like provincial Byzantine work. As for the details of the iconography, the dragon looks familiar from Byzantine icons, particularly those known from Crete, whereas the leash held by the princess is a detail more familiar from western paintings – although the idea passed pictorially into Cretan icons. In fact, the style of the horse and the triptych format bring this icon into the orbit of Cretan icons. In all, we have an icon that is Orthodox in appearance, but that has elements which are unusual for the world of Ethiopian art and which must have instantly surprised the Ethiopian viewer. It is a work which prompts the same questions as the Crusader and late Byzantine icons. We can describe it in formal terms as a

76 Nicolò Brancaleon, *St George and Scenes of his Martyrdom*, c. 1500, triptych.

painting of composite style and in religious terms as a painting likely to startle the viewer out of ingrained patterns of response and veneration of images. In terms of the Cretan experience, it suggests changing patterns of spirituality. Maybe a triptych format and a composite style represented a new artistic fashion and taste in Ethiopia, but the subject matter is striking and violent. As art, this may be a product of composite influences; as icon, it offers the Christian message of hope for the faithful. The style is a means to an end.

This icon contains one important piece of historical evidence – an artist's signature. Beneath the figure of St George is written: 'I, Marqoryos, the Frank, painted this painting.' This information allows us to date and contextualise the icon. This signature marks the Ethiopian name of a painter known also in its Italian form, Nicolo Brancaleon. This artist, perhaps Venetian in origin, is known to have travelled to Ethiopia, where he worked for the court from c. 1480 to 1526. We do not know where he was trained – it might just as well have been Crete as Venice. In any case, here is a painter who declared his identity to be Frankish, but who was a popular and successful painter for the wealthiest patrons of Ethiopia. This named painter studied and adapted traditional Ethiopian forms, succeeding in producing icons which were distinctively different from the more linear work of his contemporaries in that part of Africa. He set out to produce an adaptation of Byzantine and Quattrocento ideas within an Ethiopian tradition. This is a similar scenario to that in the Cretan situation, except that we can here be sure that we are dealing with someone who declared himself a westerner, but who worked subtly in both the worlds of east and west. Despite the strength and clarity of the Ethiopian tradition, this icon produces an acceptable and different international style which appealed to court patrons, whose devotional experience must have been altered by their exposure to the visual manner of the art of the international Christian world. This case of Ethiopia enlarges the Cretan context by defining a similar multicultural situation and suggesting that the composite art of Crete itself might have played a role in other regions.

Crete's role in the west is even more striking. Cretan icons were a commodity which could be exported. They were sought in western Europe. This meant that some painters

were able to leave the island and work in Italy as itinerant professional icon painters; they were numerous enough to be named as *Madonnerei*. Otherwise, workshops on Crete served dealers who purchased from workshops hundreds of mass-produced icons of the Madonna or Panagia made either in the 'Italian' or 'Greek' *forma*, which they then sold in western and northern Europe. Three separate orders of seven hundred icons of the Virgin drawn up in 1499 by two dealers from three painters in Candia required completion in forty-five days![79] Two quotations at the head of this chapter record the character of the 'made in Crete' industry as we currently know it. They show that the type of art from Crete in greatest demand for the western market (including the Netherlands) around 1500, the time of the High Renaissance in Italy, was the icon of the Virgin. This puts a different complexion on the state of the arts in the west in the High Renaissance outside the strictly 'humanist' market. It illustrates the existence of an alternative demand for religious art. It would be too cynical to assume that Cretan icons were sought by dealers because they were 'cheap'; the taste for this 'timeless' form of religious art must have been a factor in western churches then as it is now.

For someone with the attitudes of a modern dealer like Michel van Rijn, the explanation for the export of icons which came to mind was that 'as soon as a people become rich, they set about buying up culture, and their methods are usually those of the marketplace, which they understand.' The late Medieval dealers, knowing their market, are in this framework seen to have made demands about the iconography and style of the paintings (*in forma alla greca* or *in forma alla latina*) and to have given explicit instructions for the colours of the Virgin's garments and the nature of the models to be copied. Of the order for seven hundred icons, five hundred were to be in Latin form and two hundred in Greek.

This documentation raises again, but from another perspective, the question whether eastern and western style can so easily be polarised in this period. Is it correct to assume that by 'form' here, the dealers were distinguishing styles – Byzantine or Renaissance? We have accepted that the Cretan viewers of icons were aware of different styles, but this does not mean that they could articulate them in such clear terms.

In the pioneering publications of the notarial documents of Crete, the interpretation of the term *forma* is carefully treated,

questioning whether it identified icons intended for Orthodox or Catholic rites and drawing attention to the remarkable details in the descriptions of icons to the required colours for some garments, particularly those of Mary in different iconographic types.[80] The question is how objective a term *forma* was; does it refer to Greek or Latin 'style' or to something more tangible? Recent studies have treated the categories as styles; Christ, the Virgin, and other subjects are taken to be in the Byzantine stylistic tradition if they are described as *alla greca* or *in greco*, and in western style or formats if they are listed as *alla italiana* or *in italiano*.[81] This is convenient, but implies a greater sensitivity to style than is perhaps justified. There may be a more neutral way to handle these terms in the documents, which are after all the products of the legal mind and more likely to aim at objective and agreed descriptive terms of reference than subjective decisions. If *forma* referred not to style, but to the language of the inscriptions written on the icons, whether Greek or Latin, the documents would have been easier for the lawyers to draft and to use.[82] A description based on the language of the inscriptions rather than the style of expression sounds more practical. Of course, sometimes the language of their inscriptions might have coincided with the style of the icons, but not necessarily so in the composite icons which we have seen. It might indicate the church surroundings in which the icon was destined to be displayed or the language of the patron. In the final reckoning, the function of the icon was to support the spirituality of the viewer, not to flatter their stylistic discrimination. This book opened with questions about our visual literacy in confronting icons; it does not need to conclude that visual literacy was more advanced in the Middle Ages and unproblematic. The encounter with the icon was and still is a demanding experience.

Crete shows the rebirth of the Byzantine icon and its continuation beyond the fall of Constantinople. The Medieval art of Byzantium no more withered away than did Medieval art in western Europe. Anyone who sees the towering gilded wooden sculpture of St George and the Dragon now in the north transept of the cathedral of St Nicholas in Stockholm, carved by Bernt Notke of Lübeck in 1489 (and set up in this church in 1741), can feel the vitality of art in the Late Middle Ages. The highly productive period of the Venetian

Renaissance on Crete was in its turn not the end of the history of the icon. Icons have without pause been produced in great numbers in the Orthodox world up to the present day. In this sense, we cannot ask about the end of the Byzantine icon.[83] But this book has suggested that the icon cannot be viewed narrowly as an instrument of Orthodox Christianity alone. The word may be Greek, but the imagery had far greater currency in Europe than in Byzantine alone, and in Byzantium the icon became closer and closer to western modes of expression in stages. This history should demonstrate that Byzantium was as much a part of Europe as the culture of Classical Greece – the culture of Medieval and modern Greece no more peripheral, marginal, or non-western than that of the ancients. Byzantium does not represent a thousand years of decline!

The icon was never an art form which set out to shock the viewer aesthetically, but it may often have provoked intense emotional responses. Icons supported and enriched the communal values of the Byzantine viewer and were an integral part of the personal Byzantine experience of life. We speak loosely of art as decorating churches, but no one in Byzantium acquired an icon for decoration alone. To be Orthodox was to belong to a church which prided itself on the maintenance of unchanging truth. The icon, with its achievement of timelessness, despite the changes which we have found in its history, supported and advertised this maintenance of tradition. Byzantines did not seek novelty and originality; as sources of heresy, they were dangerous for a society encouraged to believe it had already achieved the monopoly on truth and inherited the ideal state on earth. New icons continued the past; the technical expertise with which icons were made meant that hallowed ones would survive for centuries. If we accept icons as 'art', we can make sense of their treatment as well as their functions. In churches, artists lavished immense craftsmanship and patrons lavished immense wealth on materials (gold, silver, and lapis lazuli among others). This was the setting in which God was present in the eucharist, and it was a worthy Christian duty to beautify it. Patrons, and their commissioned artists, wished to be remembered for what they had contributed to the decoration of the church, and by the last centuries of Byzantium, it was increasingly the norm to record this in writing – the icon

by itself was not enough. The rise of signatures on the icon in this context is a record of a contribution to society as much as a directing of attention to the individual.[84]

It has been emphasised that the Byzantine church contained icons often made at several times and in different places. Yet just as the church could offer peace and tranquillity, so together the icons enhanced a single harmonious 'heaven on earth' – to quote again the description of a Byzantine church given in the eighth century by the patriarch of Constantinople, Germanos. All the icons represent cultural complexity, but viewing unity. We cannot choose to enter Byzantine culture exclusively through the eyes of the patrons or the artists. In the end, we have *our* eyes and *their* materials!

References

1 CONCEPTION

1 E. H. Gombrich, *The Story of Art* (London, 1950).
2 J. J. G. Alexander, *Medieval Illuminators and Their Methods of Work* (New Haven and London, 1992), for example, does not sift through the Byzantine material in building up a picture of the manuscript production of the Middle Ages. Byzantium did not even make it into M. Camille, *Image on the Edge: The Margins of Medieval Art* (London, 1992), despite the rich marginal imagery of such Byzantine manuscripts as the Khludov Psalter; see K. Corrigan, *Visual Polemics in the Ninth-Century Psalters* (Cambridge, 1992).
3 A notorious case of this appears, oddly, in the work of someone who was equally at ease in the study of Romanesque, Gothic, and Byzantine art; see Otto Demus, *Byzantine Art and the West* (London, 1970). A corrective collection of materials, O. Mazal, *Byzanz und das Abendland* (Vienna, 1981), has yet to be exploited.
4 C. Mango & E. J. W. Hawkins, 'The Hermitage of St Neophytos and Its Wall Paintings', *Dumbarton Oaks Papers*, 20 (1966), pp. 119–206, esp. p. 156.
5 The project is directed by P. Kuniholm (Cornell).
6 D. & T. Talbot Rice, *Icons and Their Dating: A Comprehensive Study of Their Chronology and Provenance* (London, 1974), esp. pp. 161, 164. Their chronology can hardly be described as reliable!
7 Hans Belting, *Likeness and Presence: A History of the Image before the Era of Art* (Chicago, 1994); German edn (1990).
8 The best treatment of the icon as a conceptual history is traced concisely by M. Barasch, in *Icon: Studies in the History of an Idea* (New York, 1992).
9 See A. Cameron, 'The Language of Images: The Rise of Icons and Christian Representation', in D. Wood, ed., *The Church and the Arts* (Oxford, 1992), pp. 1–42, esp. p. 9.
10 For the order of reverence in the Coptic church, see Nelly Van Dorn, 'The Importance of Greeting the Saints', in H. Hondelinke, ed., *Coptic Art and Sculpture* (Cairo, 1990), pp. 101–18; and in the Greek Orthodox Church, see J. Dubisch, 'Pilgrimage and Popular Religion at a Greek Holy Shrine', in E. Badone, ed., *Religious Orthodoxy and Popular Faith in European Society* (Princeton, 1990), pp. 113–39. J. Dubisch, *In a Different Place: Pilgrimage, Gender, and Politics of a Greek Island Shrine* (Princeton, 1995), has now further opened out the discussion about Tinos.
11 R. L. Gordon, 'The Real and the Imaginary: Production and Religion in the Graeco-Roman World', *Art History*, 2 (1979), pp. 5–34.
12 For a more universalist position, see David Freedberg, *The Power of Images* (Chicago, 1989).
13 A particularly helpful account of the developing ways in which the Byzantines interpreted the symbolism of the liturgy and the fittings of the church is given by H.-J. Schulz, in *The Byzantine Liturgy* (New York, 1986), translated from the German edition of 1980. See also J.-

M. Spieser, 'Les Programmes iconographiques des églises byzantines après l'iconoclasme', in F. Dunand, J.-M. Spieser, J. Wirth, *L'Image et la production du sacré* (Paris, 1991), pp. 121–38.

14 A. Cutler, *The Hand of the Master* (Princeton, 1994).

15 P. Brown, in 'A Dark Age Crisis: Aspects of the Iconoclastic Controversy' in his reprinted essays, *Society and the Holy in Late Antiquity* (London, 1982), pp. 251–301, esp. pp. 264ff., sympathetically but conclusively eliminates E. Kitzinger's (1954) explanations of the rise of icons in terms of the 'naive animistic ideas of the masses'.

16 J. Gouillard, 'Le Synodikon de l'orthodoxie: Edition et commentaire', *Travaux et mémoires*, 2 (1967), pp. 1–316.

17 For discussion and documentation of these statements, see Ambrosios Giakalis, *Images of the Divine: The Theology of Icons at the Seventh Ecumenical Council* (Leiden, 1994), esp. pp. 85, 119.

18 J. J. Yiannias, 'A Reexamination of the "Art Statute" in the *Acts* of Nicaea II', *Byzantinische Zeitschrift*, 80 (1987), pp. 348–59.

19 Against which see B. Cassidy, ed., *Iconography at the Crossroads* (Princeton, 1993).

20 For a French translation of the acts of the Council, see M. Duchesne, *Le Stoglav ou les cent chapitres* (Paris, 1920); on the interpretation of the canons and the distortions of art historians, see L. Ouspensky, *Theology of the Icon* (Crestwood, N.Y., 1992), esp. vol. II, pp. 287ff.

21 R. W. Scheller, *Model-Book Drawing and the Practice of Artistic Transmission in the Middle Ages (ca 900–ca 1450)* (Amsterdam, 1995).

22 A. Didron, *Manuel d'iconographie chrétienne grecque et latine, avec une introduction et des notes … traduit du manuscrit byzantin Le Guide de la Peinture par le Paul Durand* (Paris, 1845). A German translation was published in 1885 by G. Schäfer (*Das Handbuch der Malerei vom Berge Athos* [Trier]). A version was published in England as A. Didron, *Christian Iconography: or the History of Christian Art in the Middle Ages* (London, 1886). This had additions by Margaret Stokes and an English translation of some of the *Hermeneia*. The first critical edition of a Greek text was A. Papadopoulos-Kerameus, *Hermeneia tis Zographikes Technes (Manuel d'iconographie chrétienne)* (St Petersburg, 1909).

23 Compare the translation by C. Mango, in *The Art of the Byzantine Empire 312–1453* (Englewood Cliffs, N. J., 1972), pp. 172–3, and Yiannias, 'A Reexamination of the "Art Statute" …', pp. 349, 357.

24 See Freedberg, *The Power of Images*.

2 BIRTH

1 The best collection of writings is Mango, *The Art of the Byzantine Empire 312–1453*.

2 See A. Borg, *War Memorials from Antiquity to the Present* (London, 1991), p. 130, pl. 198, and R. S. Nelson, 'Living on the Byzantine Borders of Western Art', *Gesta*, 35 (1996), pp. 3–11.

3 See D. Summers, 'Real Metaphor: Towards a Redefinition of the "Conceptual Image"', in N. Bryson, M. A. Holly, & K. Moxy, eds, *Visual Theory* (Oxford, 1991), pp. 231–59.

4 C. R. Dodwell, *The Pictorial Arts of the West, 800–1200* (London and New Haven, 1993).

5 See E. W. Said, *Orientalism* (London, 1978), and *idem, Culture and Imperialism* (London, 1993).

6 See N. Kantor, *Inventing the Middle Ages* (Cambridge, 1991).

7 See also G. Kubler, *Esthetic Recognition of Ancient Amerindian Art* (New Haven, 1991).

8 Quoted by A. Cutler and R. Browning, in 'In the Margins of Byzantium? Some Icons in Michael Psellos', *Byzantine and Modern Greek Studies*, 16 (1992), pp. 21–32, from Psellos, *Scripta Minora*, vol. II, ed. E. Kurtz & F. Drexl (Milan, 1941), epistle 194, 11, 220, 19–27.

9 C. Mango, 'Antique Statuary and the Byzantine Beholder', *Dumbarton Oaks Papers*, 17 (1963), pp. 53–75, and K. F. Morrison, *History as a Visual Art* (Princeton, 1990), esp. pp. 102ff.

10 S. Goldhill, 'The Naive and Knowing Eye: Ecphrasis and the Culture of Viewing in the Hellenistic World', in S. Goldhill & R. Osborne, eds, *Art and Text in Ancient Greek Culture* (Cambridge, 1994); and S. Goldhill, *Foucault's Virginity: Ancient Erotic Fiction and the History of Sexuality* (Cambridge, 1995).

11 L. Brubacker, 'Perception and Conception: Art, Theory and Culture in Ninth-Century Byzantium', *Word and Image*, 5 (1989), pp. 19–32.

12 See M. Conkey & C. Hastorf, eds, *The Uses of Style in Archaeology* (Cambridge, 1990), for several studies of situations for which we have artefacts, but little, if any, writing about art.

13 R. Wollheim, *On Art and the Mind* (Cambridge, Mass., 1974), esp. pp. 155–76. 'Walter Pater as a Critic of the Arts' criticises the 'aesthete' conception of Pater.

14 *National Curriculum: Art Working Group: Interim Report* (Department of Education and Science and the Welsh Office, 1991).

15 R. L. Gordon, 'The Real and Imaginary: Production and Religion in the Graeco-Roman World', *Art History*, 2 (1979), pp. 5–34, and *idem*, 'Reality, Evocation and Boundary in the Mysteries of Mithras', *Journal of Mithraic Studies*, 3 (1980), pp. 19–99.

16 Dubisch, 'Pilgrimage and Popular Religion at a Greek Holy Shrine', pp. 113–39.

17 See I. Kalavrezou, 'Images of the Mother: When the Virgin Mary Became Meter Theou', *Dumbarton Oaks Papers*, 44 (1990), pp. 165–72.

18 T. F. Mathews, *The Clash of Gods: A Reinterpretation of Early Christian Art* (Princeton, 1993), criticises this viewing of Christian images through the perception of the emperor. For a more sophisticated viewing of the historians, see N. F. Cantor, *Inventing the Middle Ages: The Lives, Works, and Ideas of the Great Medievalists of the Twentieth Century* (Cambridge, 1991).

19 See the documentation by G. Clark, in *Women in Late Antiquity: Pagan and Christian Lifestyles* (Oxford, 1993), esp. pp. 111ff. For the passage from the treatise on virginity ascribed to Athanasius, see p. 116.

20 R. S. Lopez & I. W. Raymond, *Medieval Trade in the Mediterranean World* (New York, 1990), pp. 114–15, doc. 43.

21 *Icons of Cretan Art*, exhibition catalogue edited by M. Borboudakis (Iraklion, 1993), no. 137.

22 R. S. Nelson, 'The Discourse of Icons, Then and Now', *Art History*, 12 (1989), pp. 144–57.

23 M. Camille, 'The *Très Riches Heures*: An Illuminated Manuscript in the Age of Mechanical Reproduction', *Critical Inquiry*, 17 (Autumn 1990), pp. 72–107, quotes Walter Benjamin: 'That which withers in the age of mechanical reproduction is the aura of the work of art.'

24 For Rome, see the catalogue of the exhibition of the Holy Year of 1988, *De Vera Effigie Mariae: Antiche Icone Romane* (Rome, 1988); for Ethiopia, see R. Grierson, ed., *African Zion: The Sacred Art of Ethiopia* (New Haven, 1993); and for Russia, including an attribution of the Vladimir icon, see L. Ouspensky & V. Lossky, *The Meaning of Icons*,

2nd edn (Crestwood, N.Y., 1989). For a broad-reaching and fully documented treatment of the subject of St Luke as artist, the fundamental study is Belting, *Likeness and Presence*.

25 Discussed further in ch. v.

26 Brown, *Society and the Holy in Late Aniquity*, p. 262, n. 48.

27 Jerusalem, Monastery of the Holy Cross, Cod. 14, fol. 106r (*Homilies of Gregory of Nazianzus*); illustrated in Mango, *The Art of the Byzantine Empire 312–1453*, frontis.

28 R. Janin, *La Géographie ecclésiastique de l'empire byzantin: Les Eglises et les monastères* (Paris, 1969), esp. pp. 199–207, and G. P. Majeska, *Russian Travelers to Constantinople in the Fourteenth and Fifteenth Centuries* (Washington, D.C., 1984), esp. pp. 362ff.

29 Pero Tafur, *Andanças é Viajes*, ed. M. Jimenez de la Espada (Madrid, 1874), trans. by M. Letts as *Travels and Adventures 1435–1439* (London, 1926), p. 141.

30 R. L. Wolff, 'Footnote to an Incident of the Latin Occupation of Constantinople: The Church and the Icon of the Hodegetria', *Tradition*, 6 (1948), pp. 319–28. The church may have been substantially altered during this period.

31 See V. Nunn, 'The Encheirion as Adjunct to the Icon in the Middle Byzantine Period', *Byzantine and Modern Greek Studies*, 10 (1986), pp. 73–102.

32 Examples of this sort of small icon are found in the Sinai monastery; see D. Mouriki, 'Variants of the Hodegetria on Two Thirteenth Century Sinai Icons', *Cahiers archéologiques*, 39 (1991), pp. 153–82.

33 For this question from the perspective of early Byzantium, see A. Cameron, 'Images of Authority: Elites and Icons in Late Sixth-Century Byzantium', *Past and Present*, 84 (1979), pp. 3–35, and G. Babic, 'Les Images byzantines et leurs degrés de signification: L'Exemple de l'Hodigitria', in A. Guillou & J. Durand, eds, *Byzance et les images* (Paris, 1994), pp. 189–222.

34 M. Acheimastou-Potamianou, 'The Byzantine Wall Paintings of Vlacherna Monastery (Area of Arta)', *Actes de xve congrès internationale d'études byzantines*, ii (Athens, 1981), pp. 1–14.

35 M. Tatic-Djuric, 'L'Icône de l'Odigitria et son culte au xvie siècle', in C. Moss & K. Kiefer, eds, *Byzantine East, Latin West: Art-Historical Studies in Honor of Kurt Weitzmann* (Princeton, 1995), pp. 557–68.

36 Tafur, *Andancças é Viajes*, pp. 174–5, trans. in Letts, *Travels and Adventures ...*, pp. 141–42.

37 G. le Strange, trans., *Embassy to Tamerlane, 1403–1406* (London, 1928), pp. 84–5; Ruy Gonzalez de Clavijo, *Embajada Tamorlán*, ed. F. López Estrada, Nueva Colección de Libros Raros o Curioso, 1 (Madrid, 1943), p. 54.

38 For the fullest account by a Russian traveller, see the text known as the *Wanderer of Stephen of Novgorod*, ed. and trans. G. P. Majeska, in *Russian Travelers to Constantinople in the Fourteenth and Fifteenth Centuries*, esp. pp. 36–7. Stephen was in Constantinople in 1348 or 1349. Majeska also translated the accounts of the Russian Anonymous and Alexander, who connected the procession with the healing of the sick; see esp. pp. 364–5.

39 For the theoretical framework, see C. Geertz, 'Religion as a Cultural System', in M. Banton, ed., *Anthropological Approaches to the Study of Religions* (London, 1966), pp. 1–46. For a discussion of the rise of the Panagia in early Constantinople that balances political and theological pressures, see V. Limberis, *Divine Heiress: The Virgin Mary and the Creation of Christian Constantinople* (London and New York, 1994).

40 P. C. Finney, *The Invisible God: The Earliest Christians on Art* (Oxford, 1994).

41 M. P. Carroll, *The Cult of the Virgin Mary* (Princeton, 1986), surveys the general problems of mariolatry.

42 See K. Weitzmann, *The Icon: Holy Images Sixth to Fourteenth Century* (London, 1978), figs. IV, V and A. Grabar, *Christian Iconography: A Study of Its Origins* (London, 1969), p. 82, fig. 215.

43 See K. Weitzmann, *The Monastery of Saint Catherine at Mount Sinai: The Icons*, vol. I, *From the Sixth to the Tenth Century* (Princeton, 1976).

44 Research in this area has intensified recently, but the short statement by A. F. Shore, *Portrait Painting from Roman Egypt* (London, 1972), remains the best summary. The fact is that the classic archaeological publications by W. M. Flinders Petrie, *Hawara, Biahmu and Arsinoe* (London, 1889), *The Hawara Portfolio: Paintings of the Roman Age* (London, 1913), and *Roman Portraits and Memphis IV* (London, 1911), are so clearly written and persuasive that they have remained the magisterial interpretation of the evidence. Despite this, a number of his interpretations and datings need reconsideration. E. Doxiadis, in *The Mysterious Fayum Portrait Faces from Ancient Egypt* (London, 1995), has brought the materials together clearly and evocatively. The British Museum is currently studying its materials in preparation for a major exhibition in London.

45 R. Brilliant, *Portraiture* (London, 1991).

46 Flinders Petrie, *Hawara, Biahmu and Arsinoe*, p. 10, pl. xii, and *Roman Portraits and Memphis IV*, p. 7.

47 For a summary, see S. Walker, *Memorials to the Roman Dead* (London, 1985).

48 Supplemenary information to Flinders Petrie in Doxiadis, *The Mysterious Fayum Portrait Faces ...*, pp. 202–4.

49 On the development of prayers for the dead in the early period, see the important treatment by M. McLaughlin, *Consorting with Saints: Prayer for the Dead in Early Medieval France* (Ithaca and London, 1994).

50 Grabar, *Christian Iconography ...*, esp. pp. 83–4, works with this interpretation.

51 See P. Brown, *The Cult of Saints: Its Rise and Function in Latin Christianity* (Chicago, 1981), p. 106, quoting Jerome, epistle 103.13 from W. H. Fremantle, trans., *St Jerome: Letters and Select Works*, in P. Schaff & H. Wace, eds, *A Select Library of Nicene and Post-Nicene Fathers* (London and New York, 1893).

52 *Byzance: L'Art byzantin dans les collections publiques françaises*, exhibition catalogue: Musée de Louvre, Paris (Paris, 1992), p. 145, cat. no. 99.

53 See M. Davies, *The Early Italian Schools before 1400*, rev. Dillian Gordon (London, 1988), p. 44, nos 3931, 3932, 5399. This reprints the entries from the 1961 catalogue, which were based on the catalogue of 1929.

54 R. Nelson, 'The Italian Appreciation and Appropriation of Illuminated Manuscripts, ca. 1200–1450', *Dumbarton Oaks Papers*, 49 (1995), pp. 209–35.

55 Brown, *The Cult of Saints*, also discusses the viewing of saint's relics in the context of the new environment created by early Christians.

56 H. M. Cole, *Icons: Ideals and Power in the Art of Africa* (Washington, D.C., 1989).

57 For iconoclasm as a battle between Reason and Superstition, see the scholarly study of E. J. Martin, *A History of the Iconoclastic Controversy* (London, 1930); reprint. edn (1978).

58 See Babic, 'Les Images byzantines . . .' , pp. 189–222.
59 See E. Kitzinger, 'The Cult of Images in the Age before Iconoclasm' (1954), reprinted in W. E. Kleinbauer, ed., *The Art of Byzantium and the Medieval West: Selected Studies by Ernst Kitzinger* (Bloomington, 1976), pp. 91–150.
60 The best guide is M. Bal, *Reading 'Rembrandt': Beyond the Word-Image Opposition* (Cambridge, 1991).
61 See H. Maguire, 'Originality in Byzantine Art Criticism', in A. R. Littlewood, ed., *Originality in Byzantine Literature, Art and Music* (Oxford, 1995), chap. 9, pp. 101–14.
62 Recent publications have shown increasing success in this type of analysis. See, for example, the work of K. Corrigan, especially *Visual Polemics in the Ninth-Century Psalters*. L. Brubaker, in 'When Pictures Speak: The Incorporation of Dialogue in the Ninth-Century Miniatures of Paris. Gr. 510', *Word and Image*, 12 (1996), pp. 94–109, sets out a clear case for a full interpretation of a particular manuscript being dependent on a knowledge of the identity and circumstances of the donor and the intended viewer.
63 Lisa Tickner, *The Spectacle of Women: Imagery of the Suffrage Campaign 1907–14* (London, 1987).
64 Various approaches to the analysis of iconography are set out and explored in Cassidy, ed., *Iconography at the Crossroads*. The role of Panofsky in the development of what he called iconology remains central.
65 Bal, *Reading 'Rembrandt'*, esp. pp. 99, 119.
66 For Byzantine interpretations of the garden, see M. H. Thomson, *The Symbolic Garden* (North York, Ontario, 1989).
67 See H. Maguire, *Art and Eloquence in Byzantium* (Princeton, 1981), pp. 46–52.
68 See on this icon the comments of D. Mouriki in her essay in K. A. Manafis, ed., *Sinai: Treasures of the Monastery of St Catherine* (Athens, 1990), p. 108, nn. 36–8.
69 See John Forrester, *The Seductions of Psychoanalysis* (Cambridge, 1990), esp. pp. 49ff.

3 GOD/MAN

1 N. Gendle, 'The Role of the Byzantine Saint in the Development of the Icon Cult', in S. Hackel, ed., *The Byzantine Saint* (London, 1981), pp. 181–6, is helpful in counteracting an excessive emphasis on the importance of the portraits of Christ over saints in the interpretation of the debates during iconoclasm.
2 See T. F. Mathews, *Art and Architecture in Byzantium and Armenia* (Aldershot, 1995), esp. Study XII, 'The Sequel to Nicaea II in Byzantine Church Decoration' (from *Perkins Journal of Theology*, 41 [1988], pp. 11–21).
3 J. Elsner, 'Image and Iconoclasm in Byzantium', *Art History*, 11 (1988), pp. 471–91, and C. Murray, 'Artistic Idiom and Doctrinal Development', in R. Williams, ed., *The Making of Orthodoxy: Essays in Honour of Henry Chadwick* (Cambridge, 1989), pp. 288–308.
4 See Cyril Mango, *The Brazen House: A Study of the Vestibule of the Imperial Palace of Constantinople* (Copenhagen, 1959), esp. pp. 125ff., and Marie-France Auzépy, 'La Destruction de l'icône du Christ de la Chalcé par Leo III: Propogande on réalité?', *Byzantion*, 60 (1990), pp. 445–92. The history of this icon after 787 is documented. What is not clear is whether iconoclasm began with the removal of an icon

of Christ from this gate, or whether that story is a piece of later mythology.

5 Patriarch Methodios (before his death on 14 June 847) had written an epigram to celebrate the image (see Mango, *The Brazen House . . .*, pp. 126–7).

6 *Byzantium: Treasures of Byzantine Art and Culture from British Collections*, exhibition catalogue edited by D. Buckton: British Museum, London (London, 1994), cat. no. 140, pp. 129–30 (by R. Cormack).

7 On these issues, see P. Zanker, *The Power of Images in the Age of Augustus* (Ann Arbor, 1988).

8 A. Kazhdan & H. Maguire, 'Byzantine Hagiographical Texts as Sources on Art', *Dumbarton Oaks Papers*, 45 (1991), pp. 1–22.

9 See J. Wilkinson, *Jerusalem Pilgrims before the Crusades* (Warminster, 1977), pp. 79–89, esp. ch. 23.

10 *Ibid.*, ch. 44.

11 For a perspective on the landscapes of desire, see S. Stewart, *On Longing: Narratives of the Miniature, the Gigantic, the Souvenir, the Collection* (Durham, N.C. 1993).

12 J. Eade and M. J. Sallnow, *Contesting the Sacred: The Anthropology of Christian Pilgrimage* (London, 1991), esp. G. Bowman, 'Christian Ideology and the Image of a Holy Land', pp. 98–121, esp. p. 120. Also S. Coleman and J. Elsner, *Pilgrimage: Past and Present in the World Religions* (London, 1995).

13 See Wilkinson, *Jerusalem Pilgrims before the Crusades*, pp. 93–116, esp. chs. 9, 10.

14 J. Pelikan, *Imago Dei: The Bysantine Apologia for Icons* (New Haven and London, 1990).

15 See R. Dodwell, *The Pictorial Arts of the West 800–1200* (London, 1993), esp. pp. 179–80, and Belting, *Likeness and Presence . . .*, esp. pp. 64–73, 323–5.

16 For Italian processions, see Belting, *Likeness and Presence . . .*, esp. p. 325, and the fully documented study of the Roman materials by G. P. Wolf, *Salus Populi Romani: Studien zur Geschichte des römischen Kultbildes im Mittelalter* (Weinheim, 1990).

17 See Belting, *Likeness and Presence . . .*, esp. pp. 311ff. and doc. 4, pp. 498–502.

18 See J. F. Baldovin, *The Urban Character of Christian Worship: The Origins, Development, and Meaning of Stational Liturgy* (Rome, 1987). For the west, see B. A. Hanawalt & K. L. Reyerson, eds, *City and Spectacle in Medieval Europe* (Minneapolis and London, 1994).

19 J. Nesbitt and J. Wiita, in 'A Confraternity of the Comnenian Era', *Byzantinische Zeitschrift*, 86 (1975), pp. 360–84, discuss the perambulations of the Naupaktetissa icon in central Greece in the eleventh century.

20 The practice of moving images is not limited to the Christian world, and it inherited a complex previous set of traditions. See C. A. Faraone, *Talismans and Trojan Horses: Guardian Statues in Ancient Greek Myth and Ritual* (Oxford, 1992). A slightly different issue is raised in J. Curran, 'Moving Statues in Late Antique Rome: Problems of Perspective', *Art History*, 17 (1994), pp. 46–58.

21 See L. Ouspensky and V. Lossky, *The Meaning of Icons*, 2nd edn (Crestwood, N.Y., 1989), pp. 59–68.

22 For a seventeen-century commentary on all this, see Leo Allatios, *The Newer Temples of the Greeks*, trans., annotated, and intro. by A. Cutler (University Park and London, 1969).

23 For the chancel arrangement of the early church, see T. Matthews,

The Early Churches of Constantinople: Architecture and Liturgy
(University Park, 1971).

24 See A. W. Epstein, 'The Middle Byzantine Sanctuary Barrier:
Templon or Iconostasis?', *Journal of the British Archaeological
Association*, 134 (1981), pp. 1–28; C. Walter, *Studies in Byzantine
Iconography* (London, 1977), Study III, 'The Origins of the
Iconostasis'; and M. Cheremeteff 'The Transformation of the
Russian Sanctuary Barrier and the Role of Theophanes the Greek',
in A. Leong, ed., *The Millenium: Christianity and Russia (A.D. 988–
1988)* (Crestwood, N.Y., 1990), pp. 107–40.

25 G. Henderson, 'Emulation and Invention in Carolingian Art', in R.
McKitterick, *Carolingian Culture: Emulation and Innovation*
(Cambridge, 1994), pp. 248–73, esp. p. 252, n. 27; the source is Bede,
Historia ecclesiastica gentis anglorum, vol. I, ch. 25, in C. Plummer,
Venerabilis Baedae Historiam Ecclesiasticum Gentis Anglorum (Oxford,
1896), p. 46.

26 The liturgical year began with the festival of the Annunciation,
according to W. Tronzo, 'The Medieval Object-Enigma and the
Problem of the Cappella Palatina in Palermo', *Word and Image*, 9
(1993), pp. 197–228.

27 Bishop Kallistos of Diokleia, 'Teaching the Faith: The Meaning of
the Divine Liturgy for the Byzantine Worshipper', in R. Morris, ed.,
Church and People in Byzantium (Birmingham, 1988), pp. 7–28.

28 See E. Duffy, *The Stripping of the Altars* (London, 1994), on the
Catholic nostalgia for their ritual, torn away in the Reformation.

29 For a full analysis, see Miri Rubin, *Corpus Christi: The Eucharist in
Late Medieval Culture* (Cambridge, 1991).

30 A strong position, stated by A. Momigliano in 'Popular Religious
Beliefs and Late Roman Historians', *Studies in Church History*, VIII
(Cambridge, 1971), pp. 1–18, has been fundamental in later
discussions: see esp. Brown, *The Cult of Saints* ... A. Cameron
discusses the dichotomy in *Christianity and the Rhetoric of Empire:
The Development of Christian Discourse* (Berkeley, 1991). This
reasoning was not accepted by R. Van Dam, in *Saints and Their
Miracles in Late Antique Gaul* (Princeton, 1993).

31 Kitzinger, 'The Cult of Images in the Age before Iconoclasm',
pp. 91–150, esp. pp. 119, 146.

32 G. De Nie, *Views from a Many-Windowed Tower: Studies of Imagination
in the Work of Gregory of Tours* (Amsterdam, 1987).

33 Van Dam, *Saints and Their Miracles in Late Antique Gaul*, p. 228,
translating *Vita Martini*, 2,1.

34 See C. M. N. Eire, *War against the Idols: The Reformation of Worship
from Erasmus to Calvin* (Cambridge, 1986), p. 7: 'Neither am I
implicitly assuming some sort of trickle-down theory proposing
that the élites always and everywhere predetermine the behavior of
the common people by doing their thinking for them.'

35 See J. Haldon, 'Everyday Life in Byzantium: Some Problems of
Approach', *Byzantine and Modern Greek Studies*, 10 (1986), pp. 51–72.

36 L. James and R. Webb, 'To Understand Ultimate Things and Enter
Secret Places: Ekphrasis and Art in Byzantium', *Art History*, 14
(1991), pp. 1–17.

37 B. Shoshan, *Popular Culture in Medieval Cairo* (Cambridge, 1993).
This should however be set against P. Sanders, *Ritual, Politics and
the City in Fatimid Cairo* (Albany, N.Y., 1994).

38 It is firmly denied by Cameron, in *Christianity and the Rhetoric of
Empire* ..., pp. 224–7.

39 See M. Carruthers, *The Book of Memory: A Study of Memory in*

Medieval Culture (Cambridge, 1990), esp. pp. 221–3: Gregory, *Letter* XI, 10 (*Corpus Christianorum Series Latina*, 140A, p. 874). Among various discussions, particularly helpful is L. G. Duggan, 'Was Art Really the "Book of the Illiterate"?', *Word and Image*, 5 (1989), pp. 227–51.

40 On these issues, see C. W. Bynum, *Jesus as Mother: Studies in the Spirituality of the High Middle Ages* (Berkeley, 1982).

41 See H. Belting, *Bild und Publikum im Mittelalter* (Berlin, 1981), and *idem*, 'An Image and Its Function in the Liturgy: The Man of Sorrows in Byzantium', *Dumbarton Oaks Papers* 34–35 (1981), pp. 1ff.

42 See W. A. Christian, *Local Religion in Sixteenth-Century Spain* (Princeton, 1981), and Eire, *War against the Idols* ..., pp. 13ff.

43 See Badone, ed., *Religious Orthodoxy and Popular Faith in European Society*, esp. Dubisch, 'In a Different Place ...', pp. 113–39.

44 Eire, *War against the Idols* ..., tracks a partial motivation for the Reformation as dissatisfaction with the packages of piety on offer. J. Haldon, in *Byzantium in the Seventh Century: The Transformation of a Culture* (Cambridge, 1990), looks at the development of icons before iconoclasm in the formal terms proposed by Kitzinger. How far stylistic change can be tracked is a problem, but sociological change in this period may have stimulated artistic modes. The expansion of church and monastic control over art might have stimulated dignified and modest modes considered more suitable to these groups. On the methodology, see V. L. Zolberg, *Constructing a Sociology of the Arts* (Cambridge, 1990), esp. pp. 175–6.

45 The literature is as immense as it is often unrewarding; I. Wilson, *The Turin Shroud* (London, 1978), covers much of the evidence.

46 For a 'feminist' account of one of the images, see E. Kuryluk, *Veronica and Her Cloth: History, Symbolism and the Structure of a 'True' Image* (Oxford, 1991); for a broader view, see H. van Os, *The Art of Devotion in the Late Middle Ages in Europe 1300–1500* (Amsterdam, 1994).

47 Try H. Kersten & E. R. Gruber, *The Jesus Conspiracy: The Turin Shroud and the Truth about the Resurrection* (Shaftesbury, Dorset, 1994).

48 See H. David Sox, *The Image on the Shroud* (London, 1981); K. E. Stevenson & G. R. Habermas, *Verdict on the Shroud* (London, 1982); and *La Sindone: Scienza e fede* (Bologna, 1983).

49 The full dossier, based on manuscript material in the Bibliothèque Nationale, Collection de Champagne, vol. 154, is published in the *Appendice* of Ulysse Chevalier *Étude critique sur l'origine du St Suaire de Lirey-Chambéry-Turin* (Paris, 1900). A translation of the Latin of the memorandum was published by H. Thurston, in 'The Holy Shroud and the Verdict of History', *Month*, 101 (1903), pp. 17–29.

50 J. B. Scott, 'Seeing the Shroud: Guarini's Reliquary Chapel in Turin and the Ostension of a Dynastic Relic', *Art Bulletin*, 77 (1995), pp. 609–37.

51 See Wilson, *The Turin Shroud*, and *idem*, *The Evidence of the Shroud* (London, 1986).

52 Robert of Clari, *The Conquest of Constantinople*, trans. E. H. McNeil (New York, 1936), esp. pp. 104, 112.

53 By Dr Alan and Mrs Mary Whanger of Durham, North Carolina.

54 See J. Sumption, *Pilgrimage* (London, 1975), esp. pp. 36ff; also Coleman & Elsner, *Pilgrimage* ...

55 R. I. Moore, 'Guibert of Nogent and His World', in H. Mayr-Harting & R. I. Moore, eds, *Studies in Medieval History Presented to R. H. C. Davis* (London, 1985), pp. 107–17.

56 See *Byzance: L'Art byzantin dans les collections publiques français*, pp. 333–5, cat. no. 48.

57 R. Cormack, *Writing in Gold* (London, 1985), pp. 132ff.

58 B. Baldwin, 'Images of Christ and Byzantine Beliefs', *Aevum*, 58 (1984), pp. 144–8.

59 See H. L. Kessler, 'Medieval Art as Argument', in Cassidy, ed., *Iconography at the Crossroads*, pp. 59–70.

60 Cormack, *Writing in Gold*.

61 J. Lowden, *Illuminated Prophet Books* (University Park and London, 1988), p. 52.

62 Both quotations come from the fifth- or sixth-century writings of Pseudo-Dionysius; see J. -P. Migne, *Patrologiae cursus completus, Series graeca*, vol. III, 473, C, 4–6; 373, B.

63 See C. Barber, 'The Koimesis Church, Nicaea: The Limits of Representation on the Eve of Iconoclasm', *Jahrbuch der österreichischen Byzantinistik*, 41 (1991), pp. 43–60.

64 See Anna Kartsonis, *Anastasis: The Making of an Image* (Princeton, 1986), and M. Mullett, 'Writing in Early Mediaeval Byzantium', in R. McKitterick, ed., *The Uses of Literacy in Early Medieval Europe* (Cambridge, 1990), pp. 156–85.

65 For the context of the discussion, see A. Cameron, 'The Language of Images: The Rise of Icons and Christian Representation', in D. Wood, ed., *The Church and the Arts*, Studies in Church History, 28 (1992), pp. 1–42. She quotes (p. 32) the statement from Theodore abu Qurrah, *De cultu imaginum*, 13, from the translation by Sidney Griffiths.

66 R. Cormack, 'The Emperor at St Sophia: Viewer and Viewed', in A. Guillou & J. Durand, eds, *Byzance et les images* (Paris, 1994), pp. 223–53. Mathews, in *The Clash of Gods* ..., invites a review of the construction of the imagery of Christ in early Christian art and plays down the idea that Christ was perceived through the symbols of imperial art. Whatever the outcome of this interesting debate, the situation in later Byzantine art is different.

67 See A. K. Bowman, *Egypt after the Pharaohs* (Oxford, 1990), p. 80, quoting from P. Cair. Masp. 67002.

68 I. Ševčenko, 'The Illuminators of the Menologium of Basil II', *Dumbarton Oaks Papers*, 16 (1962), pp. 245–76, esp. pp. 272–3, for a suggested translation of the poem (the Greek published by Delehaye); and A. Cutler, *The Aristocratic Psalters in Byzantium* (Paris, 1984), esp. pp. 115ff.

4 MATURITY AND IDENTITY

1 For the basic literature, see R. Cormack, 'Interpreting the Mosaics of S. Sophia at Istanbul', in *The Byzantine Eye* (London, 1989), Study VIII.

2 The case for an interpretation of monuments of this period depending on knowledge of the donor and the precise circumstances is made by L. Brubaker, in 'When Pictures Speak ...', pp. 94–109.

3 The whole discussion must now take into account the inscriptions around the doorway of the Vatopedi monastery, which overlap with and expand the text in St Sophia; see T. Steppan, 'Die Mosaiken der Athosklosters Vatopaidi: Stilkritische und ikonographische Überlegungen', *Cahiers archéologiques*, 42 (1994), pp. 87–122.

4 See D. I. Pallas, 'Christ as the Holy Wisdom: The Iconographical

Fortunes of a Theological Notion', *Deltion tis Christianikis Archaiologikis Etaireias*, 15 (1989–90), pp. 119–44 (in Greek), which points out that in churches of Christ as Holy Wisdom the dedicatory icon is normally Christ Pantocrator. The idea that Holy Wisdom was the mother of the child martyrs Faith, Hope, and Charity is a distorted interpretation of I Corinthians 13:3.

5 J. O. Rosenqvist, *The Life of St. Irene, Abbess of Chrysobalanton: A Critical Edition with Introduction, Translation, Notes and Indices* (Uppsala, 1986).

6 See Kazhdan & Maguire, 'Byzantine Hagiographical Texts as Sources on Art', pp. 1–22.

7 See G. Dagron, 'Holy Images and Likeness', *Dumbarton Oaks Papers*, 45 (1991), pp. 23–33.

8 Studied by K. Weitzmann; see *The Miniatures of the Sacra Parallela: Parisinus Graecus 923* (Princeton, 1979).

9 J. Osborne, 'A Note on the Date of the Sacra Parallela (Parisinus Graecus 923', *Byzantion*, 51 (1981), pp. 316–17. See also Corrigan, *Visual Polemics in the Ninth-Century Byzantine Psalters*.

10 J. Patrich, *Sabas, Leader of Palestinian Monasticism* (Washington, D.C., 1995).

11 The events leading up to the conversion are described in the *Russian Primary Chronicle*; see S. H. Cross & O. P. Sherbowitz-Wetzor, *The Russian Primary Chronicle: Laurentian Text* (Cambridge, Mass., 1973), esp. pp. 110–11.

12 See Majeska, *Russian Travelers to Constantinople in the Fourteenth and Fifteenth Centuries*; for the suggestion of a contrast between Russians and westerners, see p. 207.

13 See J. Matthews, *The Roman Empire of Ammianus* (London, 1989), esp. pp. 231ff.; the text is from Ammianus 16.10.7ff.

14 See Xenophon, *Cyropaedia* 8.1.40–2, as the literary source of this text.

15 E. R. A. Sewter, trans., *The Chronographia of Michael Psellus* (London, 1953), p. 166.

16 See F. A. Wright, *The Works of Liudprand of Cremona* (London, 1930), and B. Scott, *Liutprand of Cremona: Relation de Legatione Constantinopolitana* (Bristol, 1993).

17 See A. Karpozilos, *The Letters of Ioannes Mauropous Metropolitan of Euchaita* (Greek text, translation, and commentary) (Thessaloniki, 1990), esp. pp. 102ff. for Letter to the Emperor 26.

18 See *Byzance: L'Art byzantin dans les collections publiques françaises*, pp. 333–5, cat. no. 248.

19 As perhaps the picture gallery of the Elder Philostratus in Naples; see A. Fairbanks, *Philostratus* (Cambridge, Mass., 1979).

20 See Belting, *Likeness and Presence*, esp. ch. 13, ' "Living Painting": Poetry and Rhetoric in a New Style of Icons in the Eleventh and Twelfth Centuries'. See also A. P Kazhdan & A. W. Epstein, *Change in Byzantine Culture in the Eleventh and Twelfth Centuries* (Berkeley, 1985).

21 See Belting, *Likeness and Presence*, Appendix, item 23B, pp. 519–21. The most recent edition of this text is by P. Gautier, 'Le Typikon de la Théotokos Kécharitôméne', *Revue des études byzantines*, 43 (1985), pp. 5ff.

22 See Belting, *Likeness and Presence*, Appendix, doc. 28, pp. 528–9. The source is P. Gautier, 'Un sermon inédit de M. Psellos sur la crucifixion', *Byzantina*, 14 (1987).

23 M. Mullett & A. Kirby, *The Theotokos Evergetis and Eleventh-Century Monasticism* (Belfast, 1994), and M. Angold, *Church and Society in Byzantium under the Comneni: 1081–1261* (Cambridge, 1995).

24 This can be paralleled in the west and supports Belting's emphasis on shared experiences; see also R. C. Trexler, *Public Life in Renaissance Florence* (Ithaca and London, 1980).

25 R. Morris, *Monks and Laymen in Byzantium 843–1118* (Cambridge, 1995).

26 See C. Mango, 'Les Monuments de l'architecture du xɪe siècle et leur signification historique et sociale', *Travaux et mémoires*, 6 (1976), pp. 351–64.

27 J. Nesbitt & J. Wiita, 'A Confraternity of the Comnenian Era', *Byzantinische Zeitschrift*, 86 (1975), pp. 360–84.

28 H. Belting, 'An Image and Its Function in the Liturgy: The Man of Sorrows in Byzantium', *Dumbarton Oaks Papers*, 34–5 (1980–1), pp. 1–16.

29 See Kazhdan & Epstein, *Change in Byzantine Culture in the Eleventh and Twelfth Centuries*, and Angold, *The Byzantine Empire* . . .

30 For a translation with notes, see John Climacus, *The Ladder of Divine Ascent*, trans. C. Luibheid & N. Russell (New York and London, 1982), in the series *Classics of Western Spirituality*.

31 See J. R. Martin, *The Illustration of the Heavenly Ladder of John Climacus* (Princeton, 1954).

32 See Weitzmann, *The Icon*, p. 88, and Mouriki in Manafis, *Sinai* . . ., esp. p. 107.

33 See K. Corrigan, 'Constantine's Problems: The Making of the Heavenly Ladder of John Climacus, Vat. gr. 394', *Word and Image*, 12 (1996), pp. 61–93. She shows that Constantine was both scribe and painter and was commissioned to make an individual product for the patron Nikon (perhaps celebrating his appointment as abbot).

34 For illustrations, see Martin, *The Illustration of the Heavenly Ladder of John Climacus*, figs. 66, 217.

35 See *Pratum* 45, 2900ʙ and 180, 3082ᴀ, discussed in Y. Hirschfeld, *The Judaean Desert Monasteries in the Byzantine Period* (New Haven and London, 1992), esp. p. 144.

36 See J. M. Hussey, *Church and Learning in the Byzantine Empire* (London, 1937).

37 R. Kieckhefer, *Unquiet Souls: Fourteenth–Century Saints and Their Religious Milieu* (Chicago, 1984), esp. p. 12.

38 See Peter Brown, 'A Dark Age Crisis: Aspects of the Iconoclastic Controversy', reprinted in a revised version in *Society and the Holy in Late Antiquity*, pp. 251–301.

39 Although E. Leach, in 'Melchisedech and the Emperor: Icons of Subversion and Orthodoxy', reprinted in E. Leach & D. A. Aycock, *Structuralist Interpretations of Biblical Myth* (Cambridge, 1983), gives a confident interpretation.

40 See, for example, L. Garland, ' "And his bald head shone like a full moon . . .": An Appreciation of the Byzantine Sense of Humour as Recorded in Historical Sources of the Eleventh and Twelfth Centuries', *Parergon*, 8 (1990), pp. 1–31; and L. Garland, 'Political Power and the Populace in Byzantium prior to the Fourth Crusade', *Byzantinoslavica*, 53 (1992), pp. 17–52.

41 See, Mango & Hawkins, 'The Hermitage of St Neophytos and Its Wall Paintings', pp. 120–206, esp. p. 170.

42 The same impression is given by the papers in R. Ousterhout & L. Brubaker, eds, *The Sacred Image: East and West* (Urbana and Chicago, 1995).

1 Kipling published *Ballad of East and West* in the December 1889 edition of *MacMillan's Magazine*. It appeared in book form in *Barrack-Room Ballads and Other Verses* (London, 1892).

2 The document was published by M. Cattapan, in 'Nuovi elenchi e documenti dei pittori in Creta dal 1300 al 1500', *Thesavrismata*, 9 (1972), pp. 202–35, esp. pp. 211–13.

3 See P. Lock, *The Franks in the Aegean 1204–1500* (London, 1995).

4 See A. Weyl Carr, 'Byzantines and Italians on Cyprus: Images from Art', *Dumbarton Oaks Papers*, 49 (1995), pp. 237–67.

5 Alexander Kazhdan, in *Authors and Texts in Byzantium* (Aldershot, 1993), Study xv, 'The Fate of the Intellectual in Byzantium', reviews the conditions of cultural life in Constantinople.

6 N. M. Panagiotakes, 'The Italian Background of Early Cretan Literature', *Dumbarton Oaks Papers*, 49 (1995), pp. 237–67.

7 M. Chatzidakis, 'Classicisme et tendances populaires au xive siècle: Les Recherches sur l'évolution de style', *xive congrès international des études byzantines* (Bucharest, 1971), pp. 97–134.

8 See P. I. Piompinos, *Greek Hagiographers up to 1821* (in Greek) (Athens, 1984), and M. Chatzidakis, *Greek Painters after the Fall (1450–1830)* (in Greek), vol. I (Athens, 1987).

9 See A. Cutler, 'Artists', in *The Oxford Dictionary of Byzantium* (Oxford, 1991), vol. I, pp. 196–201.

10 This question is discussed in R. S. Nelson, *Theodore Hagiopetrites: A Late Byzantine Scribe and Illuminator* (Vienna, 1991).

11 See S. Kalopissi-Verti, *Dedicatory Inscriptions and Donor Portraits in Thirteenth-Century Churches of Greece* (Vienna, 1992), and 'Painters in Late Byzantine Society: The Evidence of Church Inscriptions', *Cahiers archéologiques*, 40 (1992), pp. 139–58.

12 S. Pelekanides, *Kalliergis of All Thessaly the Best Painter* (in Greek) (Athens, 1973), pp. 7–12. The patriarch who dedicated the church was probably Niphon I (1310–14). The syntax of l. 6 is difficult. See also G. Ch. Chionidis, *History of Veria* (in Greek), vol. II, *The Byzantine Period* (Thessaloniki, 1970).

13 See N. P. Ševčenko, 'Holy Figures and the Faithful', in Guillou and Durand, eds, *Byzance et les images*, pp. 257–85, for a further appreciation of Kalliergis and a hint that he was even mentioned in a poem in Constantinople.

14 For a discussion about the nature of epigrams written by the Constantinopolitan poet in this period, see A. M. Talbot, 'Epigrams of Manuel Philes on the Theotokos tes Peges and Its Art', *Dumbarton Oaks Papers*, 48 (1994), pp. 135–65.

15 A. Xyngopoulos, *Thessalonique and la peinture macédonienne* (Athens, 1955), and *idem, The Wallpaintings of St Nicholas Orphanou at Thessaloniki* (Athens, 1964).

16 P. Miljkovic-Pepek, *L'Oeuvre des peintres Michel et Eutych* (in Serbo-Croat) (Skopje, 1967), and H. Hallensleben, *Die Malerschule des Königs Milutin* (Gießer, 1963).

17 A. Xyngopoulos, *Manuel Panselinos* (Athens, 1956), and P. Hetherington, *The 'Painter's Manual' of Dionysius of Fourna* (London, 1974).

18 See Bynum, *Jesus as Mother . . .*, esp. pp. 82–109, 'Did the Twelfth Century Discover the Individual?'

19 However, the best recent collection of studies about Venetian Crete touches little on the visual material (or music); see D. Holton, ed., *Literature and Society in Renaissance Crete* (Cambridge, 1991).

20 See *Venetiae quasi alterum Byzantium: From Candia to Venice: Greek Icons in Italy, 15th–16th Centuries*, exhibition catalogue by N. Chatzidakis: Correr Museum, Venice (Athens, 1993). Pp. 1–3 discuss a number of painters on Crete.

21 K. Weitzmann, *Studies in the Arts at Sinai* (Princeton, 1982), p. 356.

22 A. Martindale has argued that much work even by major artists was of an ephemeral nature; see *The Rise of the Artist* (London, 1972). This make it questionable whether the claim of a Cretan artist that he came from Candia is a 'guarantee of the quality of their work', as in Chatzidakis, *Venetiae quasi alterum Byzantium . . .*, p. 3.

23 See J. Wolff, *The Social Production of Art* (London, 1981).

24 S. Ćurčić & D. Mouriki, eds, *The Twilight of Byzantium* (Princeton, 1991), hardly touches on the icon in the late Byzantine period.

25 See Annabel Jane Wharton, *Art of Empire: Painting and Architecture of the Byzantine Periphery* (University Park and London, 1988), for the notion of 'province'. In the case of the monuments and icons of Crete, essential groundwork is set out in numerous publications of M. Borboudakis; see esp. 'Art during the Venetokratia' (in Greek), in N. Panayotakis, ed., *Crete* (Iraklion, 1988), pp. 230–88. See also M. Borboudakis, K. Gallas, & K. Wessel, *Byzantinisches Kreta* (Munich, 1983).

26 Robert of Clari, *The Conquest of Constantinople*, esp. pp. 88ff.

27 For the background, see C. A. Faraone, *Talismans and Trojan Horses: Guardian Statues in Ancient Greek Myth and Ritual* (Oxford, 1992).

28 See V. P. Goss & C. V. Bornstein, eds, *The Meeting of Two Worlds: Cultural Exchange between East and West during the Period of the Crusades* (Kalamazoo, 1986).

29 See Cyril Mango, 'Chypre, carrefour du monde byzantin', Study XVII in *Byzantium and Its Image* (London, 1984).

30 Holton, ed., *Literature and Society in Renaissance Crete*, p. 1.

31 See H. van der Wee, 'Structural Changes in European Long-Distance Trade and Particularly in the Re-export Trade from South to North 1350–1750', in J. D. Tracy, *The Rise of Merchant Empires* (Cambridge, 1990).

32 In 1419, the painter Nikolaos Filanthropinos had been imprisoned on his return for travelling to Constantinople with the priest Michael Kalofrenas and meeting the patriarch. See C. Maltezou, 'The Historical and Social Context', in Holton, *Literature and Society in Renaissance Crete*, p. 27.

33 See the record of the island by G. Gerola, *Monumenti veneti nell'isola di Creta*, 4 vols (Venice, 1905–32), which describes the architectural environment at the end of the nineteenth century.

34 See esp. M. Vassilaki, 'The Painter Angelos Akotantos: His Work and His Will (1436)' (in Greek), *Thesavrismata*, 18 (1981), pp. 290–98. For a summary of information, see Chatzidakis, *Greek Painters after the Fall (1450–1830)*, vol. I, p. 160.

35 Angelos belongs to the same period as the westernising tomb painting in the outer narthex of the Kariye Camii in Constantinople; see P. A. Underwood, *The Kariye Djami* (New York, 1967), vol. III, figs 548–9 (Tomb G).

36 Western artists in Crete are documented in the archives. They include an artist with the name Antonella da Messina who was in Candia in 1445–6 (the famous Italian artist with this name lived c. 1430–79); see M. Cattapan, 'Nuovi eleuchi e documenti dei pittori in Creta dal 1300 al 1500', *Thesavrismata*, 9 (1972), pp. 205–35. Less enigmatic are documented western artists in Crete in the sixteenth

century. For example, one family of Parisian sculptors, Bernard Moles and his two sons, Georges and Jean, were commissioned between 1550 and 1563 to work in Candia; see Kanot Fatourou-Hesychakis, 'Philosophical and Sculptural Interests of Domenicos Theotocopoulos in Crete', in N. Hadjinicolaou, ed., *El Greco of Crete: Proceedings of the International Symposium — Iraklion, Crete, 1–5 September, 1990* (Iraklion, 1995), pp. 45–68, esp. p. 62, n. 39.

37 See M. Acheimastou-Potamianou, ed., *From Byzantium to El Greco: Greek Frescoes and Icons* (Athens, 1987), p. 170, cat. no. 35.

38 See *ibid.*, cat. nos 32 (Byzantine Museum, Athens) and 36 (Zakynthos Museum).

39 A selective translation of the texts about Angelos and Theofan is found in Mango, *The Art of the Byzantine Empire 312–1453.*

40 For a discussion of the letter sent to Cyril of Tver, see J. Børtnes, *Visions of Glory: Studies in Early Russian Hagiography* (Oslo and Atlantic Highlands, N.J., 1988), esp. p. 177. Epifanij died about 1420.

41 The full passage reads:

> Iaia of Cyzicos, who remained single all her life, worked at Rome in the youth of Marcus Varro, both with the brush and the cestrum on ivory. She painted chiefly portraits of women and also a large picture of an old woman at Naples and a portrait of herself, executed with the help of a mirror. No artist worked more rapidly than she did, and her pictures had such merit that they sold for higher prices than those of Sopolis and Dionysios, well-known contemporary painters, whose works fill our galleries.

See Pliny the Elder, *Natural History* XXXV.147–8.

42 For Byzantine strategies and conventions of letter-writing, see M. Mullett, 'Byzantium: A Friendly Society?', *Past and Present*, 118 (1988), pp. 3–24.

43 The most influential discussion of the attribution is in V. N. Lazarev, *Theofan Grek and His School* (Moscow, 1961), with figs 113–19. He decided against an attribution to Theofan, in my opinion wrongly.

44 The proposal that these icons came from other churches after the fire of 1547 does not disprove an attribution to Theofan, and in any case depends on a literal reading of a primary text. See I. Y. Kachalova, N. A. Mayasova, & L. A. Shchennikov, *The Annunciation Cathedral of the Moscow Kremlin* (Moscow, 1990).

45 N. Oikonomides, 'The Holy Icon as an Asset', *Dumbarton Oaks Papers*, 45 (1991), pp. 35–44.

46 See n. 32 above.

47 Collections of art on Crete are documented in the archives. The earliest list of a collection of Italian paintings in Candia is dated 1601 and mentions the sale of a Titian (see N. M. Panayotakis, 'The Cretan Period of the Life of Domenikos Theo to Kopoulous' (in Greek), in *Aphieroma ston Niko Svorono*, vol. II (Rethymon, 1986). M. Constantinoudaki, in *Kretika Cronika*, 26 (1986), pp. 246–61, esp. p. 254, mentions Antonios Kallergis (1521–55), who kept in his house a collection of statues and Italian and Flemish paintings, as well as icons; see also N. Chatzidakis, 'The Adoration of the Magi: An Icon by a Greek Painter of the Early Renaissance' (in Greek), in *Euphrosynon: Aphieroma ston Manoli Chatzidaki*, vol. II (Athens, 1992), pp. 713–41, esp. p. 733, n. 102.

48 See J. F. Cherry, 'Beazley in the Bronze Age? Reflections on Attribution Studies in Aegean Prehistory', in R. Laffineur & J. L. Crowley, eds, *EIKON: Aegean Bronze Age Iconography: Shaping a*

Methodology, published as *Aegeum* 8 (Liège, 1992), pp. 123–44. He starts with a quotation attributed to Berenson: 'If, as Napoleon is supposed to have said, history is a fable agreed upon, connoisseurship is a guess that passes unopposed' (B. Berenson, *Aesthetics and History* [1948], p. 221). Cherry is concerned that the identification of artists in pre-Medieval periods is simply anachronistic in its construction of masters, pupils, and a class of privileged producers. See also the approach of M. Beard paraphrased by Cherry on p. 129: 'There is a circularity in discussing the artist's "personality" in terms of his product, if that product is *all* we have as evidence.' 'There is nothing that one could say about the pot-painters that could not be said about the pots themselves.' See M. Beard, 'Adopting an Approach', in T. Rasmussen & N. Spivey, eds, *Looking at Greek Vases* (Cambridge, 1991), pp. 12–35.

49 See *After Byzantium: The Survival of Byzantine Sacred Art* (Athens, 1996).
50 See the editorial on 'Art History, Connoisseurship and Scientific Literacy' in *International Journal of Museum Management and Curatorship*, 7 (1988), pp. 5–10.
51 R. Wollheim, *Painting as an Art* (London, 1987). See also M. W. Conkey & C. A. Hastorf, *The Uses of Style in Archaeology* (Cambridge, 1990).
52 C. Maltezou, 'The Historical and Social Context', in Holton, *Literature and Society in Renaissance Crete*, esp. p. 32, discusses documentation about artists (*sgourafoi*), leases of workshops, commissions, and prices.
53 See Hadjinicolaou, ed., *El Greco of Crete* ...
54 Among publications presenting the state of the evidence, see M. Constantoudaki, 'Domenicos Théotocopoulos (El Greco) de Candie à Venise: Documents inédits (1566–1568)', *Thesavrismata*, 12 (1975), pp. 292–308; N. M. Panayotakis, 'Un nuovo documento del periodo cretese di Dominikos Theotokopulos', in Hadjinicolaou, ed., *El Greco of Crete* ..., pp. 133–40 (in this legal arbitration of 6 November 1566 he is not called a *maistro*); and, in the same volume, M. Constantinoudaki-Kitromilides, 'Italian Influences in El Greco's Early Work: Some New Observations', pp. 97–118.
55 C. Baltoyianni, 'The Place of Domenicos Theotocopoulos in 16th-Century Cretan Painting, and the Icon of Christ from Patmos', in Hadjinicolaou, ed., *El Greco of Crete* ..., pp. 75–96.
56 M. Acheimastou-Potamianou, in 'Domenicos Theotocopoulos: *The Dormition of the Virgin*, a Work of the Painter's Cretan Period', in Hadjinicolaou, ed., *El Greco of Crete* ..., pp. 29–44, argues for a date in his Cretan period.
57 See M. Vassilaki, 'Three Questions on the Modena Triptych', in Hadjinicolaou, ed., *El Greco of Crete* ..., pp. 119–32; and, in the same volume, C. Gardner von Teuffel, 'El Greco's View of Mount Sinai as Independent Landscape', pp. 161–72.
58 Georgios Klontzas, a contemporary of El Greco, who worked on Crete, also produced related versions of the Sinai landscape (in the Spada and Yorkshire triptychs); see *East Christian Art*, exhibition catalogue by Y. Petsopoulos: Bernheimer Fine Arts, London (London, 1987), cat. nos 74–5, 88–95.
59 I. Ševčenko, 'The Decline of Byzantium Seen Through the Eyes of Its Intellectuals', *Dumbarton Oaks Papers*, 15 (1961), pp. 169–86, shows that some Byzantine intellectuals could accept western superiority in some respects.

60 In 1614, his library contained 131 books (including Greek classics, works by Pseudo-Dionysios, and Latin poetry).

61 G. De Gregorio, 'Per uno studio della cultura scritta a Creta sotto il dominio veneziano: I codici greco-latini del secolo XIV', *Scrittura e Civiltá*, 17 (1993), pp. 103–201, covers the case of an Italian notary who produced a bilingual codex of the dialogues of Gregory the Great in 1312 with the assistance of a Greek cleric in the service of the Latin archbishop of Candia. I owe this reference to the kindness of Alan Stahl (American Numismatic Society).

62 Quoted by C. Maltezou, in 'The Historical and Social Context', in Holton, ed., *Literature and Society in Renaissance Crete*, pp. 33–4.

63 See A. E. Laiou, 'Quelques observations sur l'économie et la société de Crète vénetienne (ca. 1270–ca. 1305)', in *Bisanzio e l'Italia: Raccolta di studi im memoria di Agostino Pertusi* (Milan, 1982), pp. 177–98, and *idem*, 'Venetians and Byzantines: An Investigation of Forms of Contact in the Fourteenth Century,' *Thesavrismata*, 22 (1992), pp. 24–43.

64 These families may already have spoken Greek at home. Stefano learnt Greek in an Orthodox church (just as Greeks could learn Latin from Franciscans). After 1453, there was a school in Candia run by Uniate Greeks, and academies for Greek-Latin interchange.

65 The issues are presented by S. McKee, in 'Households in Fourteenth-Century Venetian Crete', *Speculum*, 70 (1995), pp. 27–67.

66 D. Krekic, in 'On the Latino-Slavic Cultural Symbiosis in Late Medieval and Renaissance Dalmatia and Dubrovnik', *Viator*, 26 (1995), pp. 321–32, argues that in this multilingual region, Italian was the agreed language of trade.

67 The important study by M. Georgopoulou, 'Late Medieval Crete and Venice: An Appropriation of Byzantine Heritage', *Art Bulletin*, 77 (1995), pp. 479–96, sees the manipulation of art by Venetian rulers as an aggressive attempt by Venice to present itself as the lawful successor of Byzantium on Crete.

68 *Icons of Cretan Art*, no. 87.

69 *Ibid.*, pp. 556–7, cat. no. 206 (by M. Acheimastou-Potamianou).

70 For the power of such images, see J. Hamburger, 'The Visual and the Visionary: The Image in Late Medieval Monastic Devotions', *Viator*, 20 (1989), pp. 161–82.

71 See S. Spanakis, 'The Will of Andrea Cornarou' (in Greek), *Cretika Chronika*, 9 (1955), pp. 424, 427.

72 See *Venetiae quasi alterum Byzantium* ..., pp. 76–80, no.16. Chatzidakis supports the published view of M. Vassilaki that a series of combined images of Saints Peter and Paul from the middle of the fifteenth century might reflect support for the union of the churches of east and west. Chatzidakis suggests that one icon of Peter and Paul, now in Florence, represents them holding the church of Sta Maria del Fiore in that city, where the unification council of 1438/9 took place.

73 See Kitzinger in Kleinbauer, *The Art of Byzantium and the Medieval West* ...

74 See Buckton, *Byzantium* ..., cat. no. 191 (by R. Cormack).

75 The most stringent review of current scholarship and thinking is by J. Folda: *The Art of the Crusaders in the Holy Land, 1089–1187* (Cambridge, 1995).

76 P. Brown, 'Eastern and Western Christendom in Late Antiquity: A Parting of the Ways', in *Society and the Holy in Late Antiquity*, pp. 166–95.

77 In general, see *Africa: The Art of a Continent*, exhibition catalogue ed.

by Tom Phillips: Royal Academy of Arts, London (London, 1995), and M. E. Heldman, *The Marian Icons of the Painter Fre Seyon: A Study in Fifteenth-Century Ethiopian Art, Patronage and Spirituality* (Wiesbaden, 1994).

78 M. Heldman & S. C. Munro-Hay, *African Zion: The Sacred Art of Ethiopia* (New Haven and London, 1994), pp. 188–9, cat. no. 88.

79 Since the documents are not complete, we cannot assume the work was done! For documentation, see Maria Constantoudaki-Kitromilides, in Acheimastou-Potamianou, ed., *From Byzantium to El Greco ...*, pp. 51–3, and Chatzidakis, *From Candia to Venice ...*, p. 2, n. 7, for further documentation.

80 Cattapan, 'Nuovi elenchi e documenti ...', pp. 202–35, esp. pp. 211–13, 215, docs 4–9.

81 Maria Constandinoudaki, 'Evidence of Artistic Works at Candia in Documents of the 16th and 17th Centuries' (in Greek), *Thesavrismata*, 12 (1975), pp. 35–136.

82 A complication is the appearance of the term *alla fiamangella*: in what way does this refer to Flanders? For the popularity of Cretan icons there, see C. Harbison, 'Miracles Happen: Image and Experience in Jan van Eyck's *Madonna in a Church'*, in Cassidy, *Iconography at the Crossroads*, pp. 158–66.

83 See M. Spanaki, 'Byzantinism in Contemporary Icon Production', *Byzantine and Modern Greek Studies*, 17 (1993), pp. 163–69, and Dubisch, *In a Different Place ...*

84 Cameron, 'The Language of Images ...', in Wood, ed., *The Church and the Arts*, pp. 1–42, sets out the integral place of icons in early Byzantine society.

General Bibliography

(in chronological order of publication)

1659 W. von Gumppenberg, *Atlas marianus*, 2 vols, Ingolstadt, 1659.

1760 F. Corner, *Apparitionum et celebriorum imaginum*, Venice, 1760.

1755 C. Flaminio, *Creta Sacra: Sive de episcopis utriusque ritus Graeci et Latini in insula Cretae*, Venice, 1755.

1845 A. Didron, *Manuel d'iconographie chrétienne grecque et latine*, Paris, 1845.

1849 R. Curzon, *Visits to Monasteries in the Levant*, London, 1849.

1852 G. L. Gatteri, *La storia veneta*, Venice, 1852.

1873 J. Beavington Atkinson, *An Art Tour to Northern Capitals of Europe*, London, 1873.

1899 G. V. Dobschütz, *Christusbilder: Texte und Untersuchungen zur Geschichte der altchristlichen Literatur*, Leipzig, 1899.
C. Enlarte, *L'Art gothique et la Renaissance en Chypre*, Paris, 1899 (now available as *Gothic Art and the Renaissance in Cyprus*, trans. and ed. D. Hunt, London, 1987).
E. Gerland, 'Kreta als venezianische Kolonie (1204–1669)', *Historisches Jahrbuch* (1899), 1–24.

1905 G. Gerola, *Monumenti veneti nell'isola di Creta*, 4 vols, Venice, 1905–32.

1909 Dionysius of Fourna, *Hermeneia*, ed. A. Papadopoulos-Kerameus, St Petersburg, 1909.

1910 G. Millet, *Monuments byzantins de Mistra*, Paris, 1910.

1916 G. Millet, *L'Iconographie de l'evangile*, Paris, 1916.

1925 F. H. Marshall, *Old Testament Legends from a Greek Poem on Genesis and Exodus by Georgios Chumnos*, Cambridge, 1925.

1927 N. P. Kondakov, *The Russian Icon*, trans. E. H. Minns, Oxford, 1927.

1930 R. Byron & D. Talbot Rice, *The Birth of Western Painting*, London, 1930.

1933 S. Bettini, *La pittura di icone Cretese-Veneziana e i Madonneri*, Padua, 1933.

1952 L. Ouspensky & W. Lossky, *Der Sinn der Ikonen*, Bern, 1952 (Eng. edn: *The Meaning of Icons*; rev. edn, 1982; latest edn, 1989).

1954 J. Huizinga, *The Waning of the Middle Ages*, New York, 1954.

1956 G. & M. Soteriou, *Icons of Mount Sinai* (in Greek), album, Athens, 1956; text, 1958.

1957 H. Buchthal, *Miniature Painting in the Latin Kingdom of Jerusalem*, Oxford, 1957.
A. Grabar, *L'Iconoclasme byzantin*, Paris, 1957 (2nd edn, 1984).
A. Xyngopoulos, *A Sketch of the History of Religious Painting after 1453* (in Greek), Athens, 1957.

1959 C. Mango, *The Brazen House: A Study of the Vestibule of the Imperial Palace of Constantinople*, Copenhagen, 1959.
F. Thiriet, *La Romanie vénitienne au moyen-âge*, Bibliothèque des Ecoles Français d'Athènes et de Rome, 195, Paris, 1959.

1961 V. J. Djuric, *Icônes de Yougoslavie*, Belgrade, 1961.
V. N. Lazarev, *Theophanes the Greek and His School* (in Russian), Moscow, 1961.
M. I. Manousakas, 'The Will of Angelos Akotantos (1436), an Unknown Cretan Painter' (in Greek), *Deltion tis Christianikes Archaiologikes Etaireias* IV/2 (1961), 139–50.

1962 M. Chatzidakis, *Icônes de Saint-Georges des Grecs et de la collection de l'Institut Hellénique de Venise*, Venice, 1962.
H. Hager, *Die Anfänge des italienischen Altarbildes*, Munich, 1962.
H. E. Wethey, *El Greco and His School*, Princeton, 1962.

1963 V. I. Antonova & N. E. Mneva, *Catalogue of Early Russian Painting* (in Russian), Moscow, 1963.
K. Weitzmann, 'Thirteenth-Century Crusader Icons on Mount Sinai', *Art Bulletin*, 45 (1963), 179–203.

1964 W. Miller, *The Latins in the Levant*, New York, 1964.

1965 M. Llewellyn Smith, *The Great Island: A Study of Crete*, London, 1965.
I. D. Pallas, *Die Passion und Bestattung Christi in Byzanz*, Munich, 1965.
S. Ringbom, *Icon to Narrative: The Rise of the Dramatic Close-up in Fifteenth-Century Devotional Painting*, Abo, 1965.
K. Weitzmann *et al.*, *Icons*, London 1965.

1966 C. Geertz, 'Religion as a Cultural System' (often reprinted, for example, in M. Banton, *Anthropological Approaches to the Study of Religion*, London, 1966).
P. A. Underwood, *The Kariye Djami*, New York, 1966.
K. Weitzmann, 'Icon Painting in the Crusader Kingdom', *Dumbarton Oaks Papers*, 20 (1966), 50–83.

1968 D. Talbot Rice & T. Talbot Rice, *Icons: The Natasha Allen Collection: Catalogue*, Dublin, 1968.

1969 A. Cutler, *Leo Allatios: The Newer Temples of the Greeks*, University

Park and London, 1969. A translation of the text written in 1643.

A. Papageorgiou, *Icons of Cyprus*, Paris, 1969.

1970 S. Dufrenne, *Les Programmes iconographiques des églises byzantines de Mistra*, Paris, 1970.

K. Kreidl-Papadopoulos, 'Die Ikonen im Kunsthistorischen Museum in Wien,' *Jahrbuch der Kunsthistorischen Sammlungen in Wien*, 66 (1970), 49–134.

1971 J. Meyendorff, 'Spiritual Trends in Byzantium in the Late Thirteenth and Early Fourteenth Centuries', in *Art et société à Byzance sous les Paléologues*, Venice, 1971, 53–71.

K. Thomas, *Religion and the Decline of Magic*, London, 1971.

C. Walter, 'The Origin of the Iconostasis', *Eastern Churches Review*, 3 (1971), 251–65 (reprinted in his *Studies in Byzantine Iconography*, London, 1977).

1972 F. Braudel, *The Mediterranean and the Mediterranean World in the Age of Philip II*, London, 1972.

M. Cattapan, 'Nuovi elenchi e documenti dei pittori in Creta dal 1300 al 1500', *Thesavrismata*, 9 (1972), 202–35.

A. E. Laiou, *Constantinople and the Latins: The Foreign Policy of Andronicus II 1282–1328*, Cambridge, Mass., 1972.

C. Mango, *The Art of the Byzantine Empire 312–1453*, Englewood Cliffs, N.J., 1972.

A. Rizzi, 'Le icone bizantine e postbizantine delle chiese veneziane', *Thesavrismata*, 9 (1972), 250–91.

R. C. Trexler, 'Florentine Religious Experience: The Sacred Image', *Studies in the Renaissance*, 19 (1972), 7–14.

1973 M. Cattapan, 'I pittori Andrea e Nicola Rizo da Candia', *Thesavrismata*, 10 (1973), 238–82.

M. Constantoudaki, 'Painters from Chandia in the First Half of the 16th Century as Attested in Notarial Archives' (in Greek), *Thesavrismata*, 10 (1973), 291–380.

D. J. Geanakoplos, *Byzantium and the Renaissance*, Cambridge, Mass., 1973.

K. D. Kalokyris, *The Byzantine Wall Paintings of Crete*, New York, 1973.

A. D. Paliouras, 'Painting at Chandia from 1550–1600' (in Greek), *Thesavrismata*, 10 (1973), 101–23.

1974 F. De'Maffei, *Icona, pittore e arte al concilio Niceno II*, Rome, 1974.

P. Hetherington, *The 'Painter's Manual' of Dionysius of Fourna*, London, 1974.

W. H. McNeill, *Venice: The Hinge of Europe 1081–1997*, Chicago, 1974.

J. Wilde, *Venetian Art from Bellini to Titian* (Oxford, 1974).

1975 M. Borboudakis, *Icons of Chania* (in Greek), Athens, 1975.

M. Constantoudaki, 'Dominicos Théotocopoulos (El Greco) de Candie à Venise: Documents inédits (1566–1568)', *Thesavrismata*, 12 (1975), pp. 292–308.

——, 'Testimonies of Pictorial Works at Candia in Documents of the 16th and 17th Century', *Thesavrismata*, 12 (1975), 35–136.

J. Sumption, *Pilgrimage: An Image of Medieval Religion*, London, 1975.

P. A. Underwood, *The Kariye Djami IV: Studies in the Kariye Djami*, Princeton, 1975.

1976 M. Chatzidakis, *Etudes sur la peinture postbysantine*, London, 1976. (These collected studies cover work from 1940–75.)

D. J. Geanakoplos, *Interaction of the 'Sibling' Byzantine and Western Cultures in the Middle Ages and Italian Renaissance (330–1600)*, New Haven and London, 1976.

E. Kitzinger, *The Art of Byzantium and the Medieval West: Selected Studies*, ed. W. E. Kleinbauer, Bloomington, 1976.

B. Uspensky, *The Semiotics of the Russian Icon*, Lisse, 1976.

K. Weitzmann, *The Monastery of Saint Catherine at Mount Sinai: The Icons from the Sixth to the Tenth Century*, Princeton, 1976.

1977 A. Bank, *L'Art byzantin dans les musées de l'Union Soviétique*, St Petersburg, 1977. (There is also an English edition.)

M. Cattapan, 'I pittore Pavia, Rizo, Zafuri da Candia e Papadopulo dalla Canea', *Thesavrismata*, 14 (1977), 199–238.

M. Constantoudaki, 'New Documents on the Painters of Chandia (16th Century) from the Archive of the Duke and Notaries of Chandia' (in Greek), *Thesavrismata*, 14 (1977), 157–98.

C. Murray, 'Art in the Early Church', *Journal of Theological Studies*, n.s., 28 (1977), pp. 303–45.

J. Riley-Smith, *What Were the Crusades?*, London, 1977.

K. M. Setton & H. W. Hazard, eds, *A History of the Crusades: IV: Art and Architecture of the Crusader States*, Wisconsin and London, 1977.

1978 G. V. Antourakes, *Painted Byzantine Churches of Crete: I: Sfakia, Apokoronas, Rethimnon* (in Greek), Athens, 1978.

S. Margaritis, *Crete and the Ionian Islands under the Venetians*, Athens, 1978.

E. W. Said, *Orientalism*, London, 1978.

K. Weitzmann, *The Icon: Holy Images: Sixth to Fourteenth Century*, London, 1978.

1979 M. Chatzidakis, 'L'Evolution de l'icone aux 11e–13e siècles et la transformation du templon', *Actes du XVe congrès international d'études byzantines*, vol. 1, Athens, 1979, 333–71.

C. Mango, 'On the History of the Templon and the Martyrion of St. Artemios at Constantinople', *Zograf*, 10 (1979), 40–3.

1980 H. Belting, 'An Image and Its Function in the Liturgy: The Man of Sorrows in Byzantium', *Dumbarton Oaks Papers*, 34–5 (1980–1), 1–16.

C. Mango, *Byzantium: The Empire of New Rome*, London, 1980.

L. Ouspensky, *La Théologie de l'icône dans l'église orthodoxe*, Paris, 1980.

1981 H. Belting, *Das Bild und sein Publikum im Mittelalter*, Berlin, 1981.

P. Brown, *The Cult of Saints*, London, 1981.

S. Hackel, ed., *The Byzantine Saint*, London, 1981.

E. Kitzinger, 'The Hellenistic Heritage in Byzantine Art Reconsidered', *Jahrbuch der Österreichischen Byzantinistik*, XXXI/2 (1981), 657–75.

Kunstsammlungen der Stadt Recklinghausen, Ikonen-Museum,
Recklinghausen, 1981.

H. Maguire, *Art and Eloquence in Byzantium*, Princeton, 1981.

E. Muir, *Civic Ritual in Renaissance Venice*, Princeton, 1981.

V. M. Teteriantnikov, *Icons and Fakes: Notes on the George R. Hann Collection*, trans. R. D. Bosley, 3 vols, New York, 1981.

M. Vassilaki-Mavrakakis, 'The Painter Angelos Akatantos', *Thesavrismata*, 18 (1981), 290–8.

1982 J. L. Boojamra, *Church Reform in the Late Byzantine Empire*, Thessaloniki, 1982.

P. Brown, *Society and the Holy in Late Antiquity*, London, 1982.

N. Chatzidaki, *L'Art des icônes en Crète et dans les îles après Byzance*, Charleroi, 1982.

A. Kazhdan & A. Cutler, 'Continuity and Discontinuity in Byzantine History', *Byzantion*, 52 (1982), 429–78.

N. Labreque-Pervouchine, *L'Iconostase: Une évolution historique en Russie*, Montreal, 1982.

A. E. Laiou, 'Quelques observations sur l'économie et la société de Crète vénitienne (ca. 1270–ca. 1305)', in *Bisanzio e l'Italia: Raccolta di studi in memoria di Agostino Pertusi*, Milan, 1982, 177–98.

I. F. Sanders, *Roman Crete: An Archaeological Survey and Gazeteer of Late Hellenistic, Roman and Early Byzantine Crete*, Warminster, 1982.

J. Steer, *Alvise Vivarini: His Art and Influence*, Cambridge, 1982.

K. Weitzmann, *Studies in the Arts at Sinai*, Princeton, 1982.

—— *et al., The Icon*, London, 1982.

1983 M. Borboudakis, K. Gallas, & K. Wessel, *Byzantinisches Kreta*, Munich, 1983.

N. Chatzidaki, *Icons of the Cretan School 15th–16th Centuries*, exhibition catalogue, Benaki Museum, Athens, 1983.

S. Wilson, ed., *Saints and Their Cults: Studies in Religious Sociology, Folklore and History*, Cambridge, 1983.

1984 R. Cormack & S. Mihalarias, 'A Crusader Painting of St. George: *Maniera Greca* or *Lingua Franca*?', *Burlington Magazine*, 126 (1984), 132–41.

O. Demus, 'Zum Werk eines venezianischen Malers auf dem Sinai', in *Byzanz und der Westen: Studien zur Kunst des Europäischen Mittelalters*, Vienna, 1984, 131–42.

D. Mouriki, 'The Wallpaintings of the Church of the Panagia at Moutoullas, Cyprus', in *Byzanz und der Westen ...* , 171–213.

S. Sinding-Larsen, *Iconography and Ritual: A Study of Analytical Perspectives*, Oslo, 1984.

C. Walter, 'Expressionism and Hellenism: A Note on Stylistic Tendencies in Byzantine Figurative Art from Spätantike to the Macedonian "Renaissance" ', *Revue des etudes byzantines*, 42 (1984), 265–87.

K. Weitzmann, 'Crusader Icons and Maniera Greca', in *Byzanz und der Westen...*, 143–70.

1985 M. Chatzidakis, *Icons of Patmos*, Athens, 1985.

R. Cormack, *Writing in Gold*, London, 1985.

D. Freedberg, *Iconoclasts and Their Motives*, Maarssen, The Netherlands, 1985.

M. Kenna, 'Icons in Theory and Practice', *History of Religions*, 24 (1985), 345–68.

E. Tonkin, 'Masks and Powers', *Man*, 14 (1985), 236–48.

Z. N. Tsirpanles, *Catasticum ecclesiarum et monasterium communis 1248–1548* (in Greek), Ioannina, 1985.

1986 C. Baltoyanni, *Icons of the D. Ekonomopoulos Collection*, Athens, 1986.

C. M. N. Eire, *War against the Idols: The Reformation of Worship from Erasmus to Calvin*, Cambridge, 1986.

V. P. Goss, ed., *The Meeting of Two Worlds: Cultural Exchange between East and West during the Period of the Crusades*, Kalamazoo, 1986.

B. Hamilton, *Religion in the Medieval West*, London, 1986.

A. G. Kalligas & H. A. Kalligas, *Monemvasia*, Athens, 1986.

W. J. T. Mitchell, *Iconology: Image, Text, Ideology*, Chicago, 1986.

N. K. Moran, *Singers in Late Byzantine and Slavonic Painting*, Leiden, 1986.

D. Mouriki, 'Thirteenth–Century Icon Painting in Cyprus', *Griffon*, n.s., 1–2 (1985–6), 9–80.

V. Nunn, 'The Encheirion as Adjunct to the Icon in the Middle Byzantine Period', *Byzantine and Modern Greek Studies*, 10 (1986), 73–102.

N. M. Panagiotakis, *The Cretan Period of the Life of Domenikos Theotokopoulos* (in Greek), Athens, 1986.

1987 M. Acheimastou-Potamianou, ed., *From Byzantium to El Greco: Greek Frescoes and Icons*, Athens, 1987.

M. Balard, A. E. Laiou, & C. Otten-Froux, *Les Italiens à Byzance: Edition et présentation de documents*, Paris, 1987.

M. Chatzidakis, *Hellenic Painters after the Fall of Constantinople (1450–1830) with an Introduction on the History of the Painting of the Period* (in Greek), vol. 1, Athens, 1987.

J. Herrin, *The Formation of Christendom*, Oxford, 1987.

C. Luibheid, trans., *Pseudo-Dionysius: The Complete Works*, London, 1987.

R. C. Trexler, *The Christian at Prayer: An Illustrated Prayer Manual Attributed to Peter the Chanter (d. 1197)*, Binghamton, 1987.

1988 G. Babić, *Icons*, Belgrade, 1988. (Important for its documentation and bibliography.)

S. Borsari, *Venezia e Bisanzio nel XII secolo: I rapporti economici*, Venice, 1988.

J. Børtnes, *Visions of Glory: Studies in Early Russian Hagiography*, Oslo, 1988.

D. M. Nicol, *Byzantium and Venice*, Cambridge, 1988.

E. Vandamme, ed., *Golden Light: Masterpieces of the Art of the Icon*, Antwerp, 1988.

G. Vikan *et al.*, *Icon*, Washington, D.C., and Baltimore, 1988.

1989 J. L. Abu-Lughod, *Before European Hegemony: The World System A.D. 1250–1350*, Oxford, 1989.

R. Cormack, *The Byzantine Eye*, London, 1989.

D. Freedberg, *The Power of Images*, Chicago, 1989.

J. Hamburger, 'The Visual and the Visionary: The Image in Late Medieval Monastic Devotions', *Viator*, 20 (1989), 161–82.

A. Kofou, *Crete: All the Museums and Archeological Sites*, Athens, 1989.

R. S. Nelson, 'The Discourse of Icons, Then and Now', *Art History*, 12 (1989), 144–57.

D. M. Nicol, 'A Layman's Ministry in the Byzantine Church: The Life of Athanasios of the Great Meteoron', Studies in Church History, 26, *The Ministry: Clerical and Lay*, Oxford, 1989, 141–54.

E. Smirnova, *Moscow Icons 14th–17th centuries*, Oxford, 1989.

M. Vassilaki, 'A Cretan Icon of Saint George', *Burlington Magazine*, 131 (1989), 208–14.

H. Wybrew, *The Orthodox Liturgy: The Development of the Eucharistic Liturgy in the Byzantine Rite*, London, 1989.

1990 M. Barasch, *Imago hominis*, Vienna, 1990, esp. 'The Frontal Icon'.

H. Belting, *Bild und Kult: Eine Geschichte des Bildes vor dem Zeitalter der Kunst*, Munich, 1990.

M. Chatzidakis & D. Sofianos, *The Grand Meteoron—History and Art*, Athens, 1990.

M. Cheremeteff, 'The Transformation of the Russian Sanctuary Barrier and the Role of Theophanes the Greek', in A. Leong, ed., *The Millenium: Christianity and Russia 988–1988*, Crestwood, N.Y., 1990, 107–40.

N. Hadjinicolaou, *El Greco of Crete*, Iraklion, 1990.

F. Lewis, 'From Image to Illustration: The Place of Devotional Images in the Book of Hours', in G. Duchet-Suchaut, ed., *Iconographie médiévale: Image, texte, contexte*, Paris, 1990, 29–48.

K. A. Manafis, ed., *Sinai: Treasures of the Monastery of Saint Catherine*, Athens, 1990.

J. Pelikan, *Imago Dei: The Byzantine Apologia for Icons*, New Haven and London, 1990.

A. Steinberg & J. Whylie, 'Counterfeiting Nature: Artistic Innovation and Cultural Crisis in Renaissance Venice', *Comparative Studies in Society and History*, 32 (1990), 54–88.

N. P. Tanner, S. J., *Decrees of the Ecumenical Councils*, 2 vols, Georgetown, 1990.

N. Van Dorn, 'The Importance of Greeting the Saints: The Appreciation of the Coptic Art by Laymen and Clergy', in H. Hondelinke, ed., *Coptic Art and Sculpture*, Cairo, 1990, 101–18.

M. Vassilaki, 'Some Cretan Icons in the Walters Art Gallery', *Journal of the Walters Art Gallery*, 48 (1990), 75–92.

T. Verdon & J. Henderson, *Christianity and the Renaissance: Image and Religious Imagination in the Quattrocento*, Syracuse, N.Y., 1990.

P. L. Vocotopoulos, *Icons of Corcyra* (in Greek), Athens, 1990.

1991 M. Bal, *Reading 'Rembrandt': Beyond the Word-Image Opposition*, Cambridge, 1991.

P. Binski, *Medieval Craftsmen: Painters*, London, 1991.

R. Cormack, 'Reading Icons', *Valör. Konstvetenskapliga Studier*, 4 (1991), 1–28.

S. Ćurčić & D. Mouriki, *The Twilight of Byzantium*, Princeton, 1991.

D. Holton, ed., *Literature and Society in Renaissance Crete*, Cambridge, 1991.

L. James & R. Webb, 'To Understand Ultimate Things and Enter Secret Places: Ekphrasis and Art in Byzantium', *Art History*, 14 (1991), 1–17.

E. Kuryluk, *Veronica and Her Cloth: History, Symbolism, and the Structure of a 'True' Image*, Oxford, 1991.

J. Riley-Smith, ed., *The Atlas of the Crusades*, London, 1991.

M. Rubin, *Corpus Christi: The Eucharist in Late Medieval Culture*, Cambridge, 1991.

N. Teteriatnikov, 'The Role of the Devotional Image in the Religious Life of Pre-Mongolian Russia', in W. C. Brumfield & M. M. Velimirovic, eds, *Christianity and the Arts in Russia*, Cambridge, 1991, 30–45.

A. Weyl Carr & L. J. Morrocco, *A Byzantine Masterpiece Recovered: The Thirteenth-Century Murals of Lysi, Cyprus*, Austin, Tx., 1991.

I. Wilson, *Holy Faces, Secret Places: An Amazing Quest for the Face of Jesus*, New York, 1991.

A. D. Wright, 'The Venetian Mediterranean Empire after the Council of Trent', in Studies in Church History, Subsidia 9, *The Church and Sovereignty c. 590–1918*, Oxford, 1991, 467–77.

1992 M. Barasch, *Icon: The History of an Idea*, New York, 1992.

K. Corrigan, *Visual Polemics in the Ninth-Century Byzantine Psalters*, Cambridge, 1992.

A. Cutler & R. Browning, 'In the Margins of Byzantium? Some Icons in Michael Psellos', *Byzantine and Modern Greek Studies*, 16 (1992), 21–32.

B. Davezac, ed., *Four Icons in the Menil Collection*, Houston, 1992.

A. E. Laiou, 'Venetians and Byzantines: Investigation of Forms of Contact in the Fourteenth Century', *Thesavrismata*, 22 (1992), 29–43.

C. Smith, *Architecture in the Culture of Early Humanism: Ethics, Aesthetes, and Eloquence 1400–1470*, Oxford 1992.

1993 N. Chatzidaki, *Venetiae quasi alterum Byzantium: From Candia to Venice: Greek Icons in Italy 15th–16th Centuries*, exhibition catalogue, Correr Museum, Venice (Athens, 1993).

M. Borboudakis, ed., *Icons of Cretan Art*, exhibition catalogue (Iraklion, 1993).

Ikonen: Bilder in Gold: Sakrale Kunst aus Griechland, exhibition catalogue, Krems-Stein (Graz).

D. Jacoby, 'The Venetian Presence in the Latin Empire of Constantinople (1204–1261)', *Jahrbuch der Österreichischen Byzantinistik*, 43 (1993), 141–201.

1994 H. Belting, *Likeness and Presence: A History of the Image before the Era of Art*, Chicago, 1994.

D. Buckton, ed., *Byzantium: Treasures of Byzantine Art and Culture*, exhibition catalogue, British Museum, London (London, 1994).

A. Guillou & J. Durand, eds, *Byzance et les images*, Paris, 1994.

M. McLaughlin, *Consorting with Saints: Prayer for the Dead in Early Medieval France*, Ithaca and London, 1994.

1995 M. Georgopoulou, 'Late Medieval Crete and Venice: An Appropriation of Byzantine Heritage', *Art Bulletin*, 77 (1995), 479–96.

R. Ousterhout & L. Brubacker, *The Sacred Image East and West*, Urbana and Chicago, 1995.

R. N. Swanson, *Religion and Devotion in Europe, c.1215–c.1515*, Cambridge, 1995.

List of Illustrations

all dimensions are in centimetres

1. Detail of illus 7, showing the Panagia and Child on an icon held by St Stephen. Photo: Conway Library, Courtauld Institute of Art, London.
2. Triptych of the *Panagia* (with Greek and Latin inscriptions), 13th century. St Catherine's Monastery, Sinai. Photo: Courtauld Institute of Art, London.
3. George Klontzas, Sanctuary of a Cretan church, icon, late 16th century, 81 × 63. Museum of the Old Orthodox Church, Sarajevo.
4. View of the 15th-century church of the Panagia at Méronas, Crete, from the west. Photo: Courtauld Institute of Art, London.
5. *Panagia and Child*, 8th and 9th century, apse mosaic. Church of the Koimisis at Nicaea (Iznik), Turkey (destroyed in 1922). Photo: Courtauld Institute of Art, London.
6. *St Luke Painting the Panagia and Child*, 11th century, from a manuscript of the *Homilies* of S Gregory Nazianzus. Monastery of the Holy Cross, Jerusalem. Photo: Courtauld Institute of Art, London.
7. *St Stephen the Younger holding an Icon of the Panagia, with Monastic Saints*, late 12th century, wallpainting on the north wall of the main church, Enkleistra of S Neophytos, Paphos, Cyprus. Photo: Courtesy of the Centre for Byzantine Studies, Dumbarton Oaks, Washington, DC.
8. *Panagia Hodigitria*, c. 1400, icon, 93 × 53. Church of the Panagia, Méronas, Crete. Photo: courtesy of Mr M. Borboudakis, Ephor of Byzantine Antiquities, Crete.
9. Devotions before the Icon of the *Panagia Hodigitria*, c. 1300, manuscript, Hamilton Psalter, Ms 78 A.9., fol. 39*v*. Staatliche Museen Berlin. Photo: Courtauld Institute of Art, London.
10. Domenikos Theotokopoulos ('El Greco'), *St Luke Painting the Virgin and Child*, 16th century, icon, 41 × 33. Benaki Museum, Athens.
11. *Triumph of Orthodoxy*, c. 1400, icon, 39 × 31. Courtesy of the Trustees of the British Museum, London.
12. Detail from upper register of illus. 11.
13. Detail from lower register of illus. 11.
14. Domenikos Theotokopoulos ('El Greco'), *View of Mt Sinai*, 16th century, icon. Iraklion Historical Museum, Crete.
15. The display of the *Hodigitria* icon in Constantinople, 13th century; copy of a wall painting in the Church of Vlachernae, Arta, Greece. Photo: Byzantine Museum, Athens.
16. The Emperor John I Tzimiskes (969–76) entering Constantinople, 12th century, from a manuscript of the *History* of Skylitzes, Bibl. Nac., vitr. 26.2, fol. 172*v* a. Biblioteca Nacional, Madrid.
17. *Mummy Portrait of a Bearded Man, Serapis, and Isis*, 3rd century pagan triptych, 39 × 19 (Serapis), 40 × 19 (Isis), 36 × 37.5 (mummy portrait). J. Paul Getty Museum, Malibu, CA.
18. *Panagia and Child*, 6th century, icon. Museum of Western and Oriental Arts, Kiev. Photo: author.

19 Framed portrait of a woman, from Hawara, 1st century AD, 45.5 × 41. British Museum, London.

20 Mummy portrait of Artemidorus, c. 100 AD, length of mummy 167 cm. British Museum, London.

21 *St Mark*, 6th century, icon, 32.5 × 15.3. Bibliothèque Nationale de France, Paris (Cabinet des Medailles).

22 *Artist Painting an Icon*, from a 9th-century manuscript of the *Sacra Parallela*, Cod. Paris B.N. Gr. 923, fol. 328v. Bibliothèque Nationale de France, Paris.

23 Duccio, *Virgin and Child*, early 14th century, central panel of a triptych, 42.5 × 34.5. National Gallery, London.

24 *'It's the way they draw these wretched tables'*, undated cartoon by 'Harvey' in an Australian magazine, *The Bulletin*.

25 *St Peter trampling Simon Magus and Patriarch Nikephoros (with an icon of Christ) trampling the Iconoclast Patriarch John the Grammarian*, from a 9th-century manuscript, the Khludov Psalter, Cod. 129, fol. 51v. Moscow State Historical Museum.

26 *Christ*, 10th century, ivory, 13.8 × 9.7. Fitzwilliam Museum, Cambridge. Photo: © Fitzwilliam Museum, University of Cambridge.

27 Pictorial Map of the Holy Land, 6th century, floor mosaic. Madaba, Jordan. Photo: Courtauld Institute of Art, London.

28 *Panagia and Child with Apostles*, 6th century, wool tapestry, 178 × 110. Cleveland Museum of Art, Leonard C. Hanna bequest.

29 *Christ*, 12th century, central panel of a triptych. Tivoli Cathedral, Italy. Photo: Instituto Centrale per il Catalogo e la Documentazione, Ministero Beni Culturali e Ambientali, Rome.

30 *Christ*, icon from the Sancta Sanctorum, (?)6th century with a later silver cover. Church of S Giovanni in Laterano, Rome. Photo: Courtauld Institute of Art, London.

31 *Panagia and Child*, (?)6th century, 117 × 79, Church of Sta Maria Maggiore (the so-called *Salus Populi Romani*), Rome. Photo: Instituto Centrale per il Catalogo e la Documentazione, Ministero Beni Culturali e Ambientali, Rome.

32 W. S. George's watercolours of the 6th-century mosaics of the *Panagia and Child with Saints and Donors* and *St Demetrios in front of the ciborion*, since destroyed, formerly in the Church of St Demetrios, Thessaloniki. Photo: Courtauld Institute of Art, London.

33 *Funeral of (?)St Isidore*, 16th century, icon. Byzantine Museum, Athens.

34 George Klontzas, Sanctuary of a Cretan church, 16th century, manuscript (Paterikon), Vatican Library gr 2137, fol. 4r, 27 × 20.5.

35 *Templon* screen, Protaton Church, Karyes, Mt Athos, Greece, 11th century and later. Photo: Courtauld Institute of Art, London.

36 *Templon* screen, 12th century, church at Episkopi, Santorini, Greece. Photo: Courtauld Institute of Art, London.

37 *Panagia Eleousa*, 12th century, icon, 73 × 46. Monastery of St Neophytos, Paphos, Cyprus. Photo: Courtauld Institute of Art, London.

38 *Christ*, 12th century, icon, 73 × 46 companion piece to illus. 37. Monastery of St Neophytos, Paphos, Cyprus. Photo: Courtauld Institute of Art, London.

39 George Klontzas, Corpus Christi procession in Candia, 1590–92, from the *Historia ab origine mundi*, Bibl. Marc. gr. VII 22 coll 1466, fol. 134v. Biblioteca Nazionale Marciana, Venice.

40 *The Mandylion arriving at Constantinople*, 12th century, from a manuscript of the *History* of Skylitzes, Bibl. Nac., vitr. 26.2, fol. 131 a. Biblioteca Nacional, Madrid.

41 *The Turin Shroud*, (?)14th century, 110 × 436. Chapel of the Holy Shroud, Cathedral Church of S Giovanni, Turin.
42 London *Evening Standard*, front page, 26 August, 1988. Photo: Courtauld Institute of Art, London.
43 Poster for the ostension of 4 May, 1674, 29.7 × 22.
44 Front and back of the *Turin Shroud*, (?)14th century, 110 × 436. Chapel of the Holy Shroud, Cathedral Church of S. Giovanni, Turin. Photo: Courtauld Institute of Art, London.
45 *Ostension of the Sudarium*, woodcut from *Mirabilis Urbis Romae*, 1511, approx 29.7 × 22.
46 *Christ*, 6th century, mosaic of apse, Church of Hosios David (Church of the Latomos), Thessaloniki, Greece. Photo: Courtauld Institute of Art, London.
47 *Basil II*, from a Psalter, *c.* 1000, Bibl. Marciana gr. 17 (421) fol. 3r, 39.5 × 30.5. Biblioteca Marciana, Venice. Photo: Conway Library, Courtauld Institute of Art, London.
48 View of the central doorway of St Sophia, Constantinople, showing the mosaic (illus 49) in the lunette. Photo: Courtauld Institute of Art, London.
49 *The Emperor before Christ*, 9th or 10th century, mosaic in the central lunette of the narthex, St Sophia, Constantinople. Photo: Courtauld Institute of Art, London.
50 *Panagia and Child with Angels and Saints*, 6th century, detail from an icon, 68.5 × 49.7. St Catherine's Monastery, Sinai.
51 Angelos Akotantos (*fl.* 1436–*c.* 1457), *Panagia Kardiotissa*, mid-15th century, icon, 121 × 96.5. Byzantine Museum, Athens.
52 *Annunciation*, late 12th century, icon, 61 × 42.2. St Catherine's Monastery, Sinai.
53 Detail showing *King Abgar Receiving the Mandylion of Edessa*, upper part of a right triptych wing, 10th century. St Catherine's Monastery, Sinai.
54 *Christ*, 6th century, icon, 84 × 45.5. St Catherine's Monastery, Sinai.
55 *The Maries at the Tomb*, on a gold reliquary for a fragment of stone from the Holy Sepulchre, 12th century, 42.6 × 32. Musée du Louvre, Paris.
56 *Christ*, 14th century, icon, 93 × 61. Crypt of the Church of Alexander Nevsky, Sofia, Bulgaria. Photo: Courtauld Institute of Art, London.
57 *Heavenly Ladder of John Climacos*, 12th century, icon. St Catherine's Monastery, Sinai.
58 *St John of Damascus* from a manuscript of the *Sacra Parallela*, 9th century, Cod. Paris B.N.Gr. 923, fol. 208r, 35.6 × 26.5. Bibliothèque Nationale de France, Paris.
59 *The Crucifixion with the Iconoclast Patriarch John the Grammarian whitewashing an Icon*, from a 9th-century manuscript, the Khludov Psalter, Cod. 129, fol. 67r. Moscow State Historical Museum.
60 *Panagia and Child*, 12th century, icon of Vladimir, 104 × 69. Kremlin Museum, Moscow.
61 *Panagia*, *c.* 1200, bilateral icon, 115 × 77.5. Byzantine Museum, Kastoria, Greece. Photo: Courtauld Institute of Art, London.
62 Other side of illus 61, the *Akra Tapeinosis* ('Man of Sorrows'). Photo: Courtauld Institute of Art, London.
63 The Emperor Justinian and his Court, *c.* 548, mosaic, Church of S Vitale, Ravenna, Italy. Photo: Courtauld Institute of Art, London.
64 The *Panagia Hodigitria* icon (illus. 8) *in situ* in 1996, Méronas, Crete. Photo: Courtauld Institute of Art, London.

65 Mid-17th-century view of Candia (Iraklion), Crete.
66 Theofan Grek, *Virgin of the Don, c.* 1400, front of a bilateral icon, 86 × 68. State Tretiakov Gallery, Moscow.
67 *Christ and the Samaritan Woman*, second half of the 15th century, icon, 38.5 × 48. Kanellopoulos Museum, Athens.
68 Angelos Akotantos, *Christ Enthroned*, mid-15th century, icon, 105.5 × 59. Zakynthos Museum.
69 Andreas Ritzos, *I.H.S.*, 15th century, icon, 44.5 × 63.7. Byzantine Museum, Athens.
70 (?)Angelos Akotantos, *David and Solomon*, mid-15th century, icon, 27 × 19. Private collection, Athens. Photo: Courtesy of the author.
71 (?)Angelos Akotantos, *St George and Mercurios*, mid-15th century, icon, 27 × 19. Private collection, Athens. Photo: Courtesy of the author.
72 Domenikos Theotokopoulos ('El Greco'), *Koimisis of the Virgin*, 16th century, icon, 61.4 × 52.2. Church of the Koimisis, Syros, Greece.
73 Domenikos Theotokopoulos ('El Greco'), *The Adoration of the Magi*, 16th century, icon, 40 × 45. Benaki Museum, Athens.
74 *St George and the Young Man from Mytilene*, mid-13th century, icon, 27 × 19. Courtesy of the Trustees of the British Museum, London.
75 *Koimisis with SS Francis and Dominic*, 15th century, triptych, 50 × 73. State Pushkin Museum, Moscow.
76 Nicolò Brancaleon, (signed 'Marqoryos Afrengi', his *nom de plume*), *St George and Scenes of his Martyrdom, c.* 1500, triptych, 62 × 72. Collection of the Institute of Ethiopian Studies, Addis Ababa.